CUBAN CARS

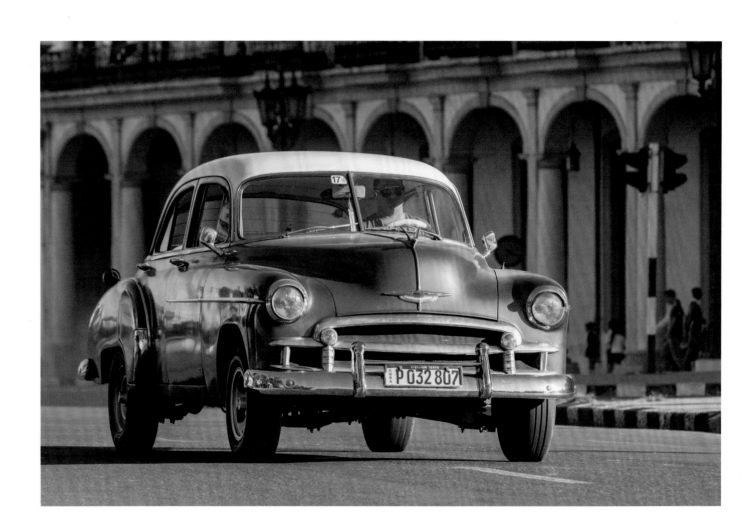

CUBAN CARS
LES BELLES VOITURES CUBAINES

KARL-HEINZ RAACH

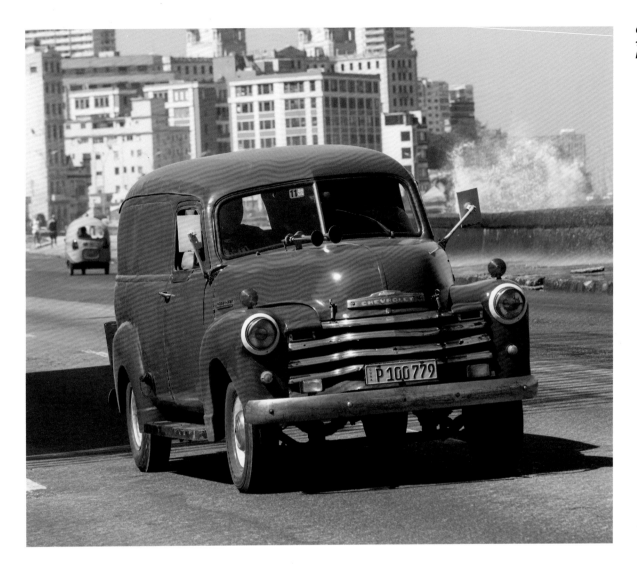

*Chevrolet,
1948, Malecón,
La Habana*

*Chevrolet,
1952, Malecón,
La Habana*

Cuba holds an unbeatable world record in terms of 'rolling gems'—in no other country in the world do so many dinosaurs of car history rattle and roar through the streets. The whole island is a kind of Jurassic Park for a special kind of dinosaur—candy pink, sky blue, sun yellow or squeaky green painted Chevrolets, Buicks, Chryslers, Fords, Plymouth or Studebakers, and Havana is the classic car hotspot.

Dans la catégorie des « joyaux sur roues », Cuba détient un record du monde imbattable : c'est le pays où vrombissent et pétaradent dans les rues le plus grand nombre de vétérans de l'histoire automobile. Toute l'île est une sorte de Jurassic Park abritant un genre très spécial de dinosaures : Chevrolet, Buick, Chrysler, Ford, Plymouth ou encore Studebaker, allant du rose bonbon au bleu ciel en passant par le jaune citron et le vert flashy. La Havane est un haut lieu des Oldtimers.

In punkto ,rollende Preziosen' hält Kuba einen unschlagbaren Weltrekord – in keinem anderen Land der Welt knattern und röhren so viele Dinosaurier der Autogeschichte über die Straßen. Die ganze Insel ist eine Art Jurassic Parc für eine spezielle Art von Dinosauriern – bonbonrosa, himmelblau, sonnengelb oder quietschend grün lackierte Chevrolets, Buicks, Chrysler, Fords, Plymouth oder Studebakers, und Havanna ist der Oldtimer-Hotspot.

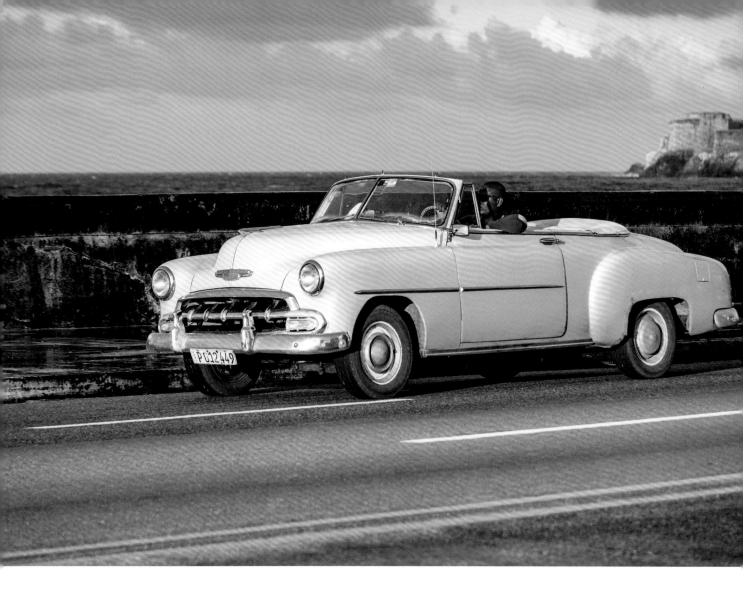

Cuba tiene un récord mundial imbatible en «joyas rodantes»; en ningún otro país del mundo hay tantos dinosaurios de la historia automovilística que hacen ruido y rugen por las calles. Toda la isla es una especie de Parque Jurásico para un tipo especial de dinosaurios: Chevrolet, Buicks, Chrysler, Ford, Plymouth o Studebaker de colores rosa caramelo, azul cielo, amarillo sol o verde chirriante, y La Habana es el punto culminante del coche clásico.

Cuba mantém-se imbatível com um recorde mundial de 'rolling gems'(preciosidades rolantes) - em nenhum outro país do mundo há tantos dinossauros da história automóvel a fazerem tanto barulho e rugido pelas ruas. Toda a ilha é uma espécie de Parque Jurássico para um tipo especial de dinossauros - rosa doce, azul celeste, amarelo solar ou Chevrolets, Buicks, Chrysler, Fords, Plymouth ou Studebakers pintados de verde alface, sendo Havana o hotspot clássico para automóveis antigos.

Cuba houdt het onverslaanbare wereldrecord op het gebied van 'rollende juwelen'. In geen enkel ander land ter wereld rammelen en brullen er zoveel dinosaurussen uit de autogeschiedenis over straat. Het hele eiland is een soort Jurassic Park voor een speciale dinosaurussoort – zuurstokroze, hemelsblauw, knalgeel of gifgroen gespoten Chevrolets, Buicks, Chryslers, Fords, Plymouths en Studebakers. Havana is de hotspot voor oldtimers.

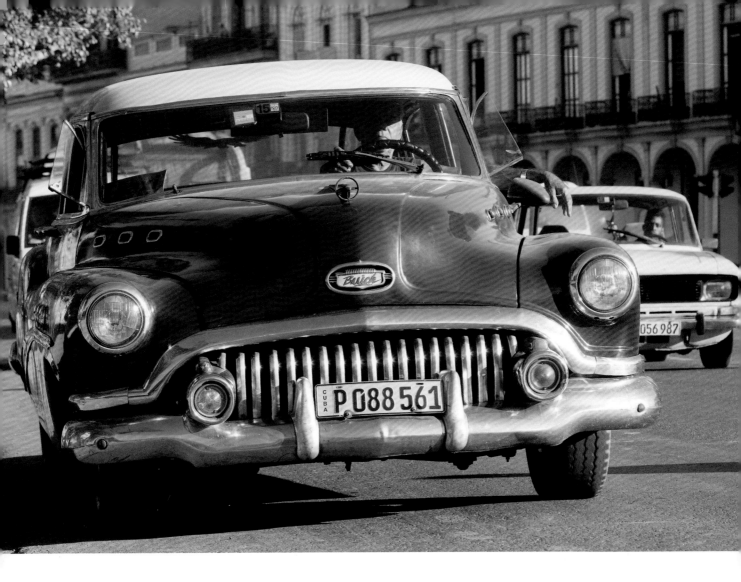

There are about 75000 of these American relics on the island. More than 10000 specimens roll through the streets of Havana (there are no exact numbers); in Santiago there are far fewer. But there are hardly any vintage cars left in their original condition, because the groaning museum pieces are contemporary witnesses and survivors of the revolution, the Cold War and the trade embargo that the USA imposed on Cuba in 1962—suddenly not a single spare part was available for the American battleships.

On trouve sur l'île environ 75 000 de ces reliques américaines, dont plus de 10 000 (il n'existe pas de chiffres précis) dans les rues de La Havane. À Santiago, il y en a nettement moins. Mais plus aucune de ces voitures anciennes n'est dans son état d'origine, car ces pièces de collection bringuebalantes sont des témoins et des rescapées de la révolution, de la Guerre froide et de l'embargo décrété par les États-Unis contre Cuba en 1962, à cause duquel il devint impossible de se procurer des pièces de rechange pour ces bolides américains.

Etwa 75000 dieser amerikanischen Reliquien gibt es auf der Insel, über die Straßen Havannas rollen gut über 10000 Exemplare (genaue Zahlen gibt es nicht), in Santiago sind es deutlich weniger. Doch im Originalzustand ist wohl so gut wie kein Oldtimer mehr, denn die ächzenden Museumsstücke sind Zeitzeugen und Überlebende der Revolution, des Kalten Krieges und des Handelsembargos, das die USA 1962 über Kuba verhängten – plötzlich war nicht ein einziges Ersatzteil für die amerikanischen Schlachtschiffe mehr zu bekommen.

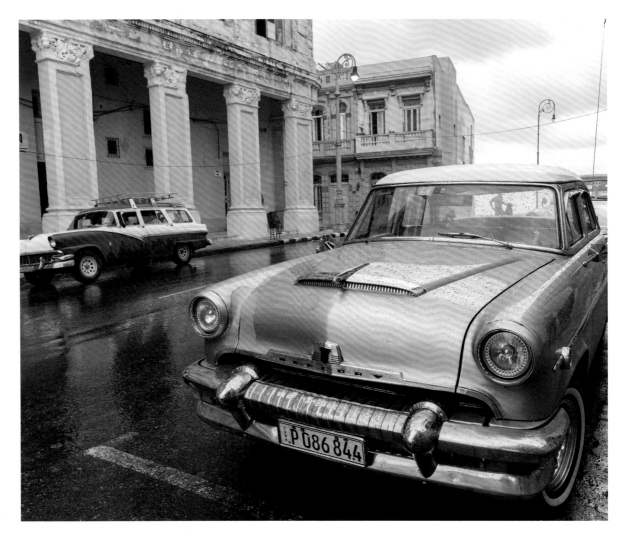

*Buick, 1952,
Paseo de Martí,
La Habana*

*Mercury,
1953, Centro,
La Habana*

Hay cerca de 75 000 de estas reliquias americanas en la isla, más de 10 000 ejemplares ruedan por las calles de La Habana (no hay números exactos); en Santiago hay bastantes menos. Pero en su estado original casi no queda ningún coche antiguo, porque las piezas de museo que gimen son testigos contemporáneos y supervivientes de la revolución, la Guerra Fría y el embargo comercial que Estados Unidos impuso a Cuba en 1962; de repente, no había ni una sola pieza de repuesto disponible para los acorazados norteamericanos.

Há cerca de 75.000 dessas relíquias americanas na ilha, rolando mais de 10.000 exemplares pelas ruas de Havana (não há números exatos), e consideravelmente menos em Santiago. Porém, no seu estado original, não resta praticamente nenhum automóvel antigo, pois de repente, deixou de haver quaisquer peças sobresselentes disponíveis para estes navios de guerra americanos, peças de museu, testemunhas contemporâneas e sobreviventes da revolução, da Guerra Fria e do embargo comercial que os EUA impuseram a Cuba em 1962.

Er zijn zo'n 75.000 van deze Amerikaanse relieken op het eiland. Er rijden er meer dan 10.000 door de straten van Havana (exacte aantallen zijn niet bekend), in Santiago zijn dat er aanzienlijk minder. Maar vrijwel geen enkele oldtimer verkeert nog in de oorspronkelijke staat, want de krakende museumstukken zijn ooggetuigen en overlevenden van de revolutie, de Koude Oorlog en het handelsembargo dat de Verenigde Staten in 1962 aan Cuba oplegde – plotseling was er geen enkel reserveonderdeel meer beschikbaar voor de Amerikaanse slagschepen.

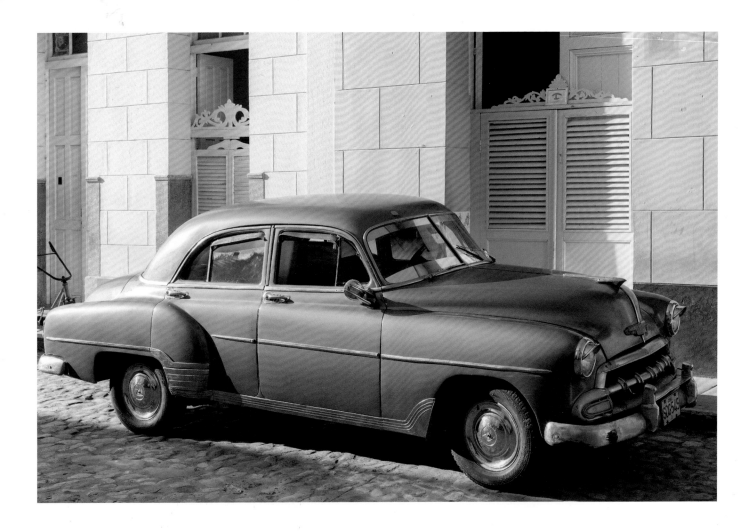

The revolutionary government allowed car owners to keep their pre-revolutionary treasures, and for decades most old cars rusted motionless in sheds or under tarpaulins—gasoline was scarce, they were astronomically expensive to drive, and spare parts were not available anyway. Only in recent years have private individuals been allowed to acquire a taxi license and use the old-timers as shared taxis or for tourists. And Cuban mechanics are the squaring the circle to inject new life into these ancient cars.

Le gouvernement révolutionnaire décida d'autoriser leurs propriétaires à conserver ces trésors d'avant la révolution, et pendant des décennies la plupart de ces vieilles voitures restèrent à rouiller dans des hangars ou sous des bâches : l'essence était rare, rouler revenait donc à des prix astronomiques, et les pièces de rechange étaient de toute façon introuvables. Depuis quelques années pourtant, les particuliers peuvent obtenir une licence de taxi et utiliser leur Oldtimer comme taxi collectif ou pour trimballer les touristes. Et les bricoleurs cubains n'hésitent pas à résoudre la quadrature du cercle pour redonner vie à ces épaves.

Die Revolutionsregierung erlaubte den Autobesitzern, ihre vorrevolutionären Schätzchen zu behalten, und über Jahrzehnte rosteten die meisten alten Autos unbewegt in Schuppen oder unter Planen vor sich hin – das Benzin war knapp, eine Fahrt also astronomisch teuer und Ersatzteile ohnehin nicht zu bekommen. Erst seit einigen Jahren dürfen Privatleute eine Taxilizenz erwerben und die Oldtimer als Sammeltaxis oder für Touristen einsetzen. Und die kubanischen Schrauber vollbringen die Quadratur des Kreises, um den Auto-Ruinen neues Leben einzuflößen.

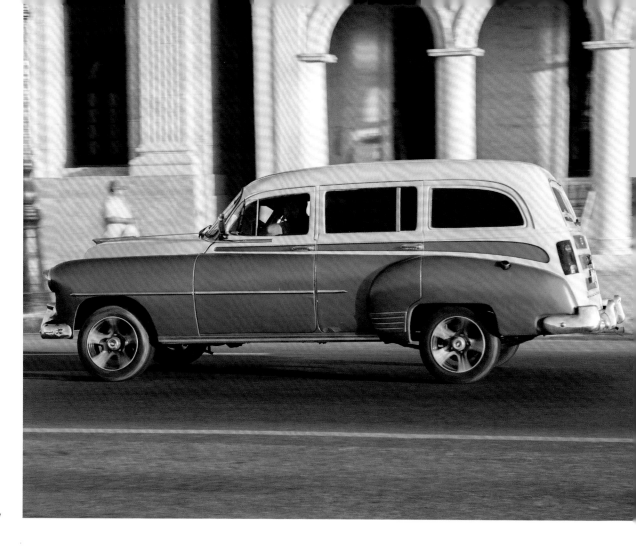

*Chevrolet, 1952,
Trinidad*

*Chrysler,
1954, Malecón,
La Habana*

El gobierno revolucionario permitió a los propietarios de automóviles conservar sus tesoros prerrevolucionarios y, durante décadas, la mayoría de los automóviles antiguos se oxidaron al permanecer inmóviles en cobertizos o bajo lonas; la gasolina era escasa, por lo que conducir resultaba exageradamente costoso, y de todos modos, no había piezas de repuesto disponibles. Solo desde hace algunos años los particulares pueden adquirir una licencia de taxi y utilizar los coches clásicos como taxis colectivos o para turistas. Y los destornilladores cubanos hacen la cuadratura del círculo para inyectar nueva vida a las ruinas del auto.

O governo revolucionário permitiu que, os proprietários destes automóveis, guardassem os seus tesouros pré-revolucionários, pelo que, e durante décadas, a maioria destes enferrujaram por estarem parados e guardados em barracões ou simplesmente debaixo de toldos - a gasolina era escassa, a circulação astronomicamente cara e as peças sobresselentes impossíveis de arranjar. Apenas há uns anos atrás passou a ser possível aos particulares adquirir uma licença de táxi e utilizá-los como táxis colectivos ou para turistas. E as chaves de fendas cubanas fazem a quadratura do círculo, para incutir uma vida nova às ruínas dos carros.

De revolutionaire regering stond autobezitters toe hun schatten van voor de revolutie te houden, en gedurende tientallen jaren stonden de meeste oude auto's roerloos weg te roesten in loodsen of onder dekzeilen. Benzine was schaars, een ritje daardoor astronomisch duur en reserveonderdelen waren toch al niet verkrijgbaar. Pas sinds enkele jaren kunnen particulieren een taxivergunning verkrijgen en de oldtimers als gedeelde taxi's of voor toeristen gebruiken. En de Cubaanse schroevendraaiers construeren de kwadratuur van de cirkel om nieuw leven in de autowrakken te blazen.

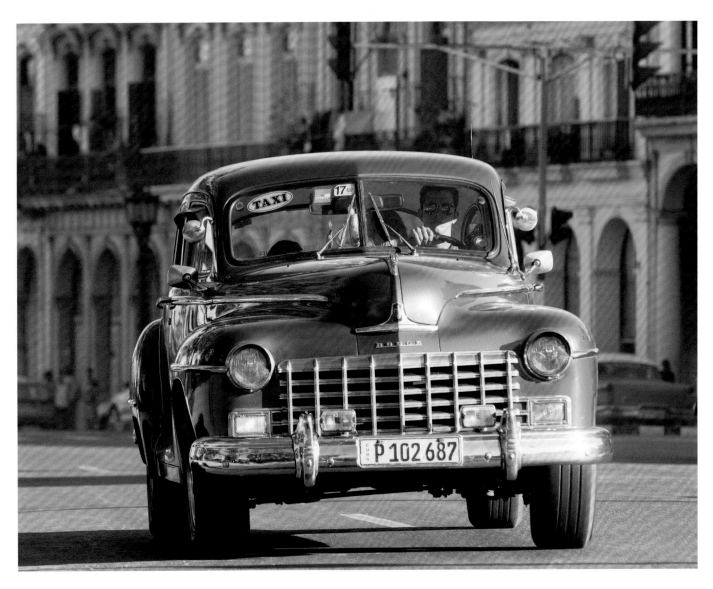

Dodge, 1948, Paseo de Martí, La Habana

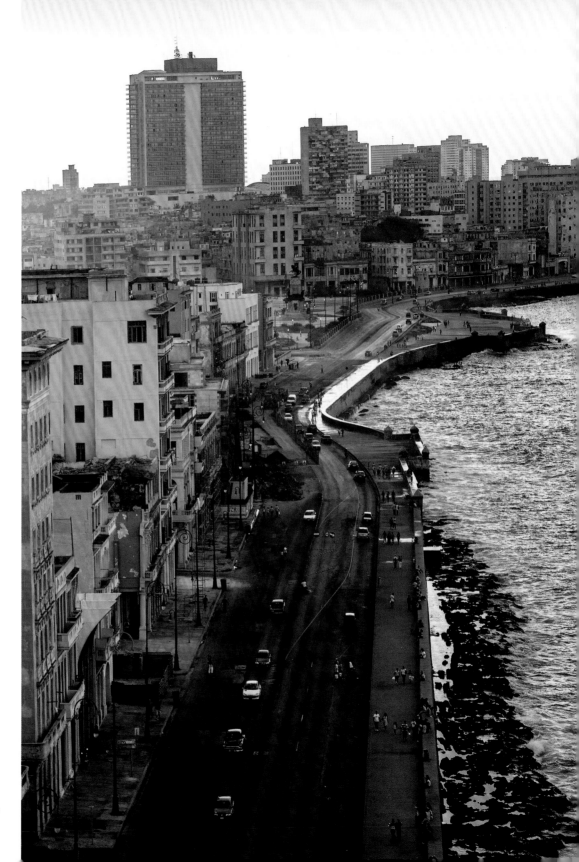

Malecón, La Habana

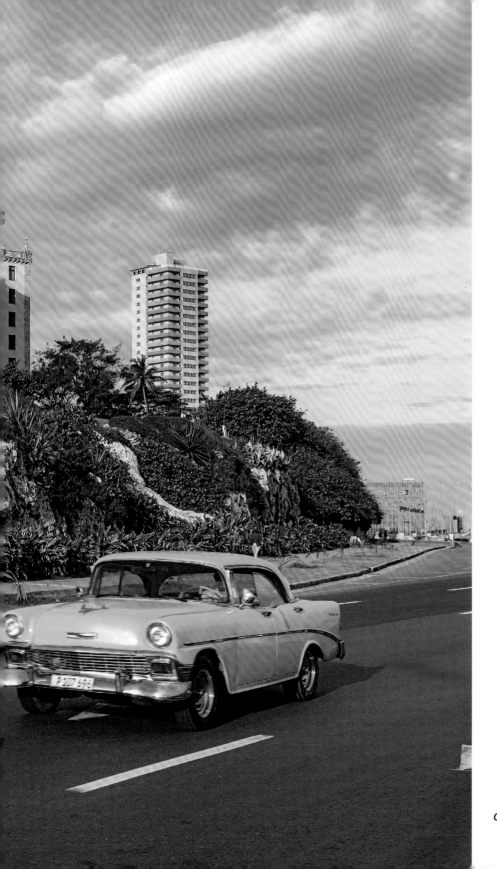

Chevrolet, 1957, Malecón, La Habana

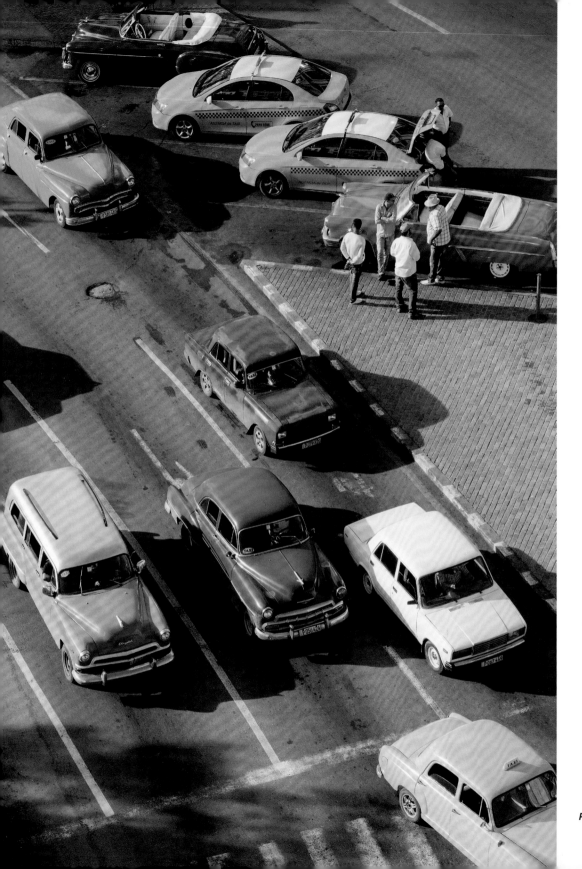

Paseo de Martí, La Habana

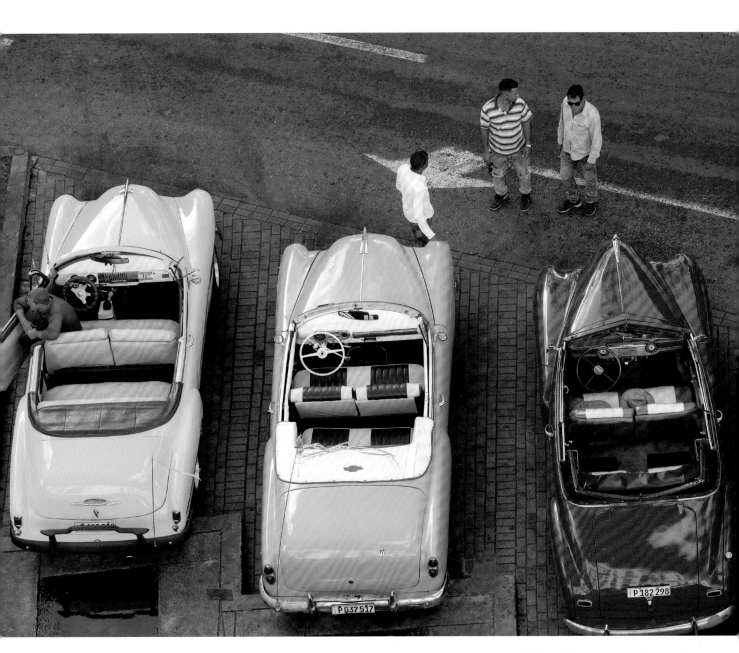

Parada de Taxis, Parque Central, La Habana

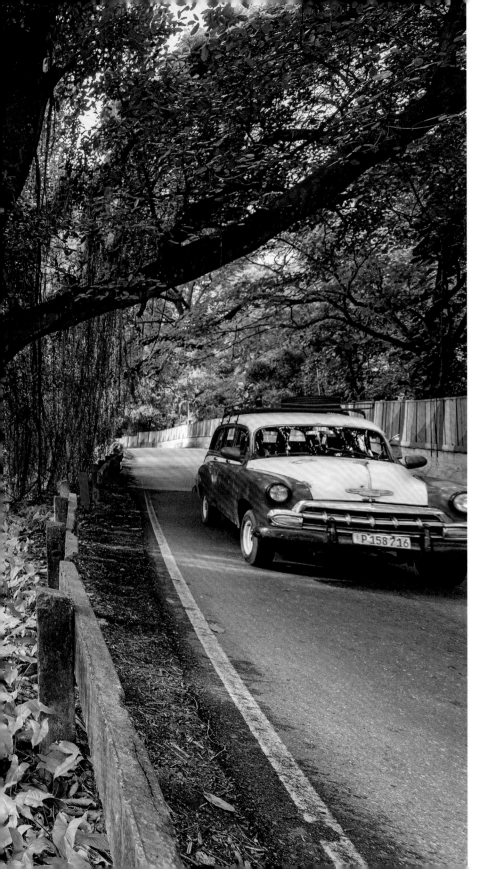

Chevrolet, 1959, Bosque de la Habana, Miramar, La Habana

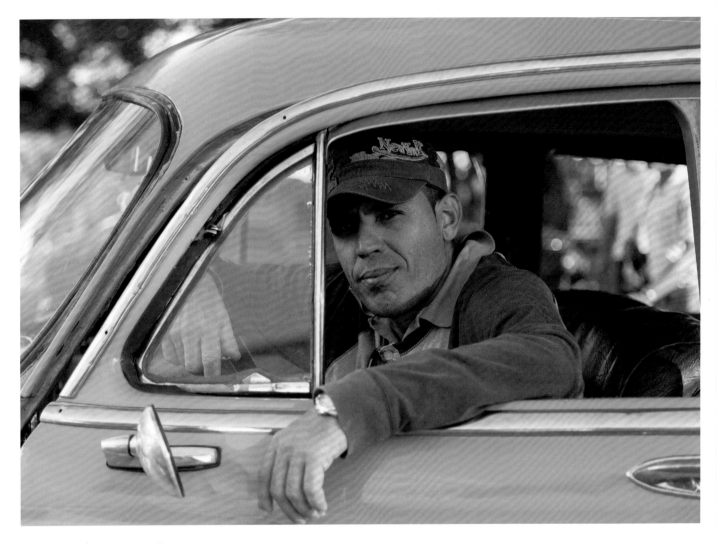

Chevrolet, 1950, Centro, La Habana

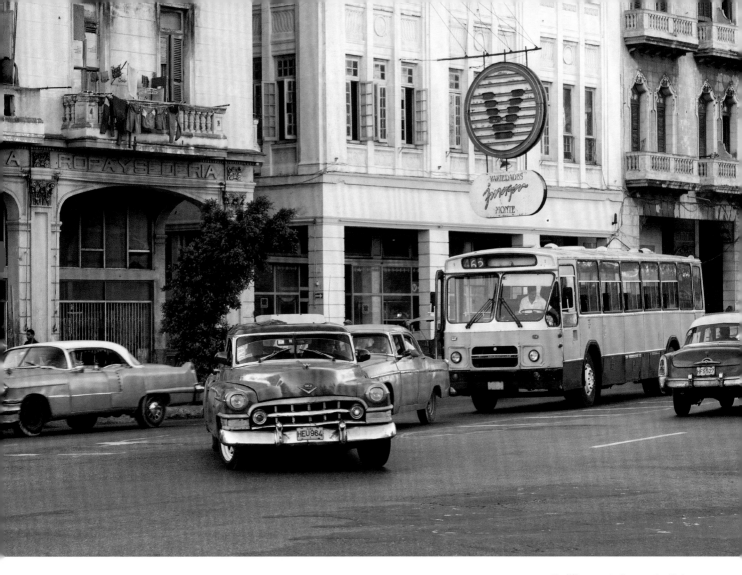

Cadillac, 1954, Centro, La Habana

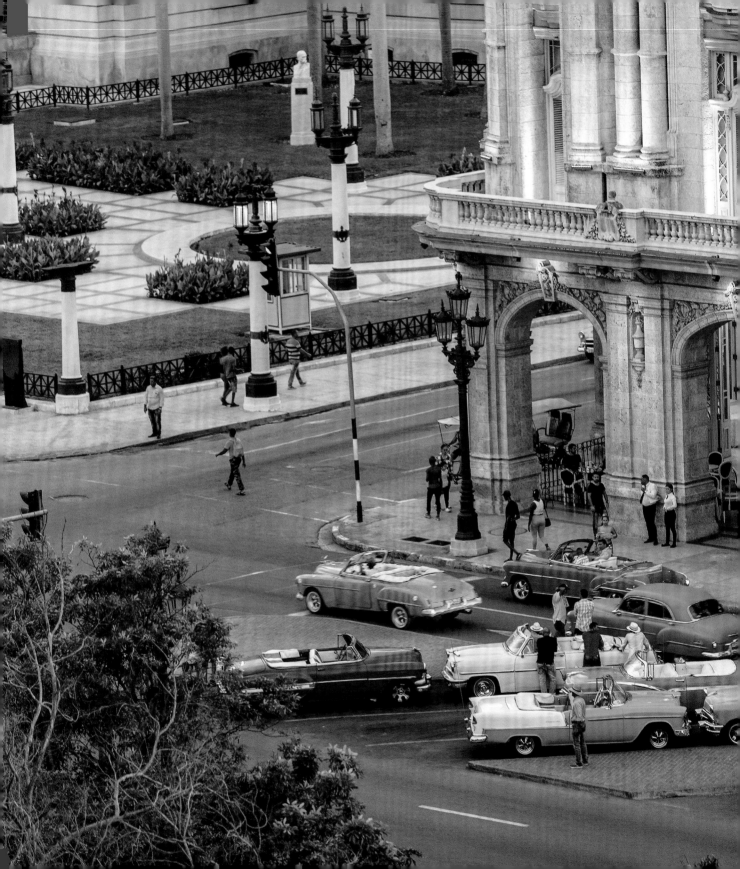

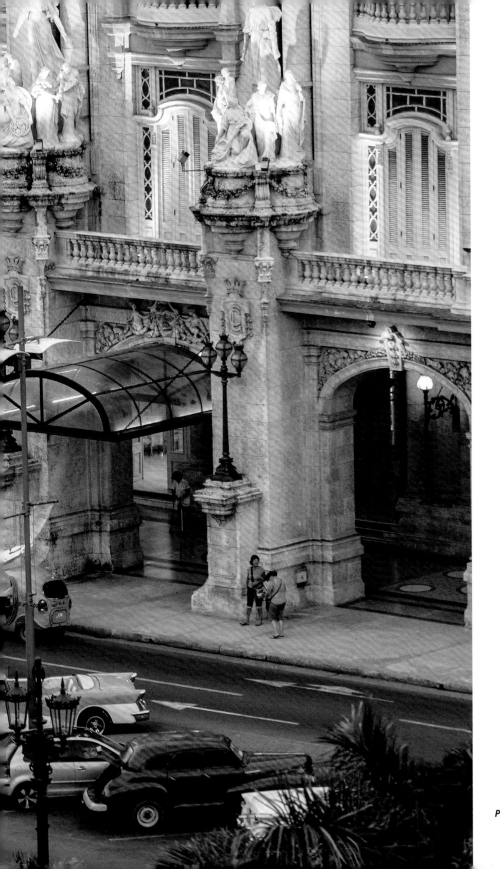

Parada de Taxis, Parque Central, La Habana

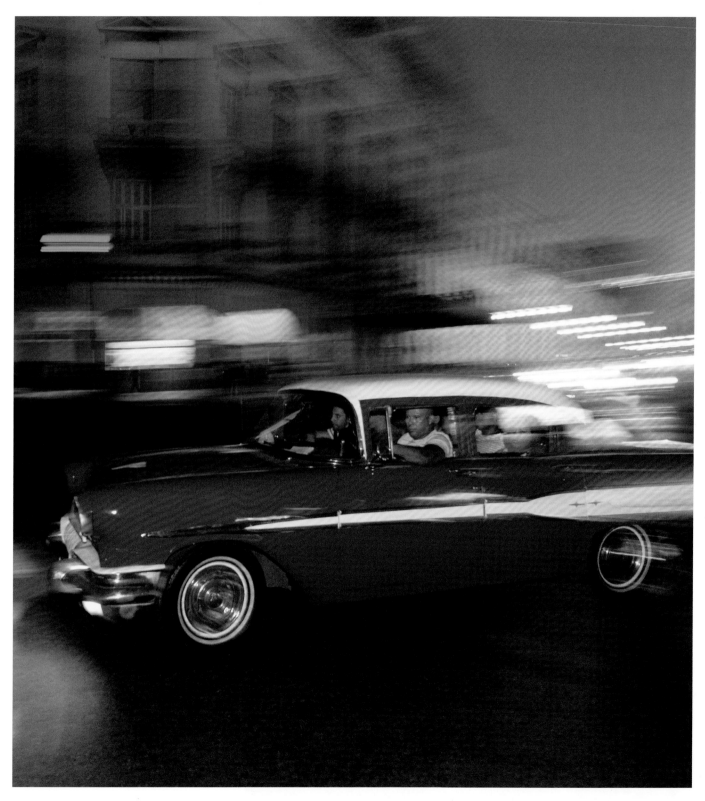

Pontiac, 1957, Paseo de Martí, La Habana

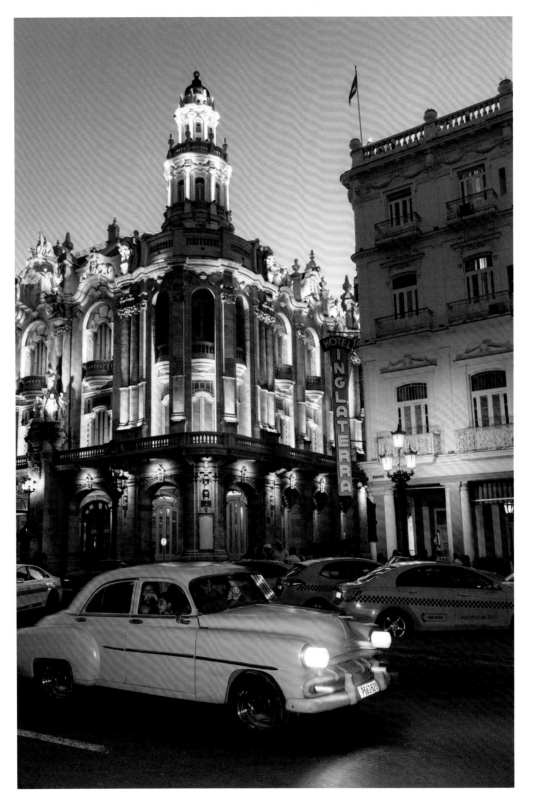

Chevrolet, 1952, Paseo de Martí, La Habana

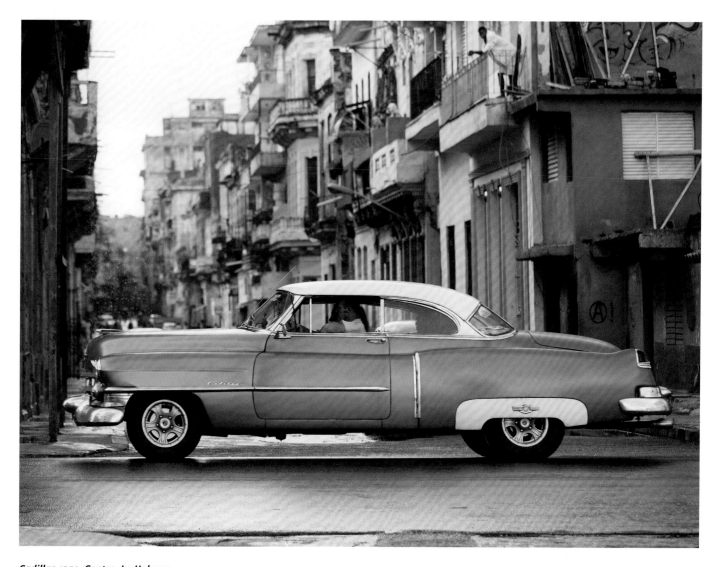

Cadillac 1950, Centro, La Habana

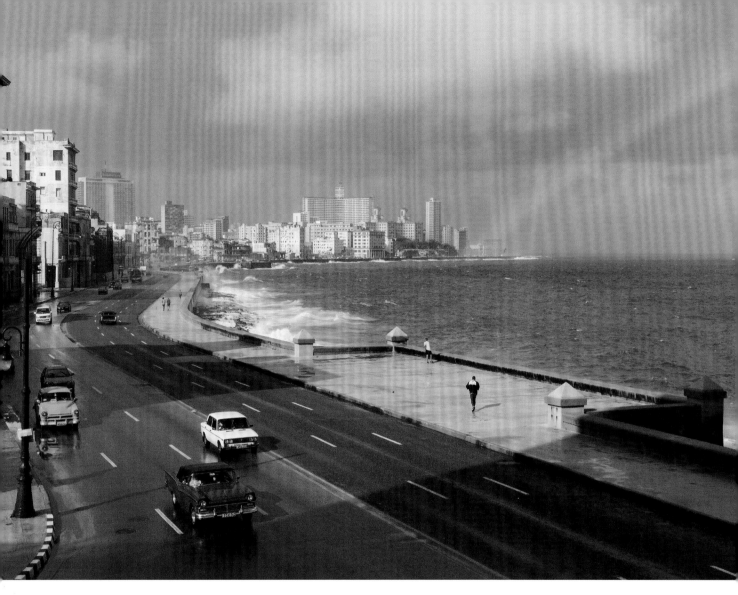

Malecón, La Habana

Buick, 1956, Malecón, La Habana

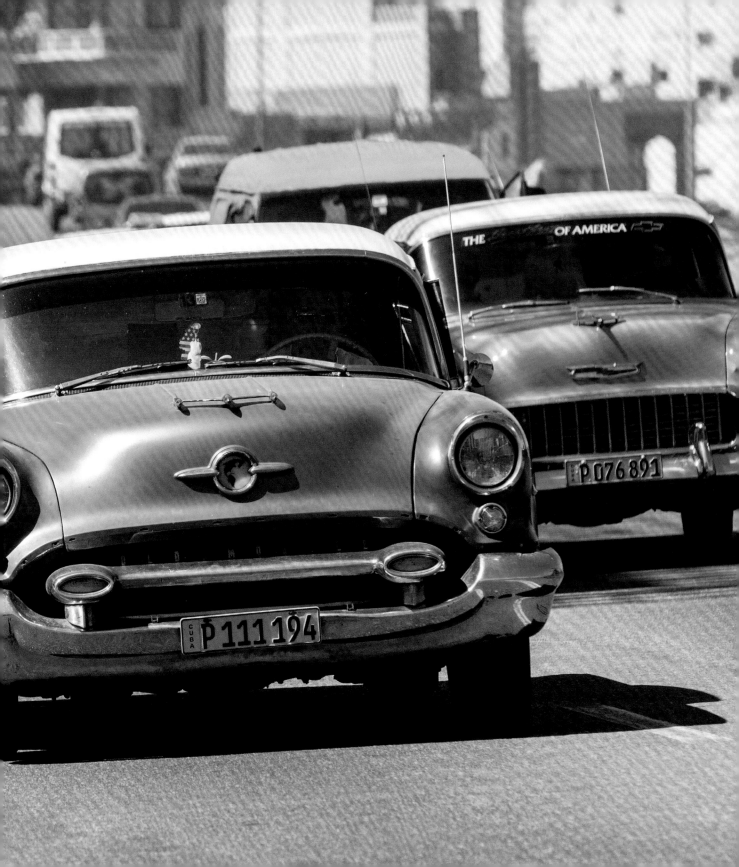

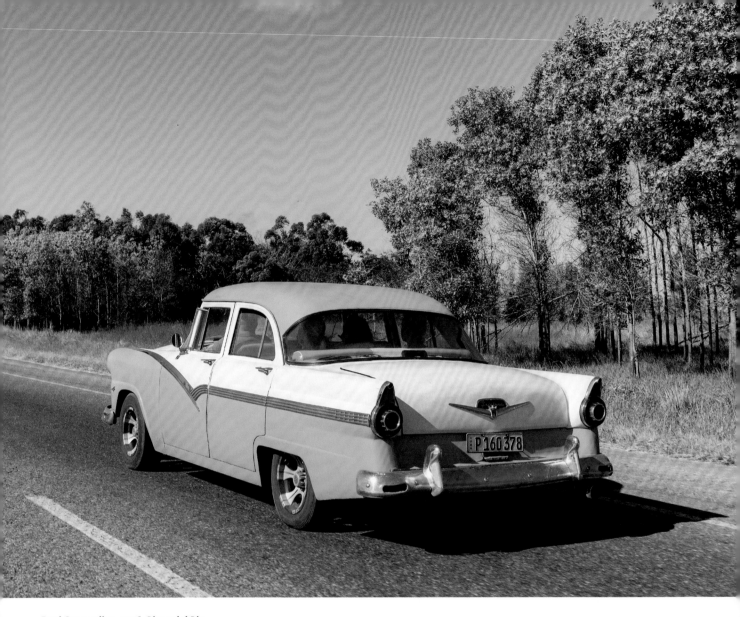

Ford Customline, 1956, Pinar del Rio

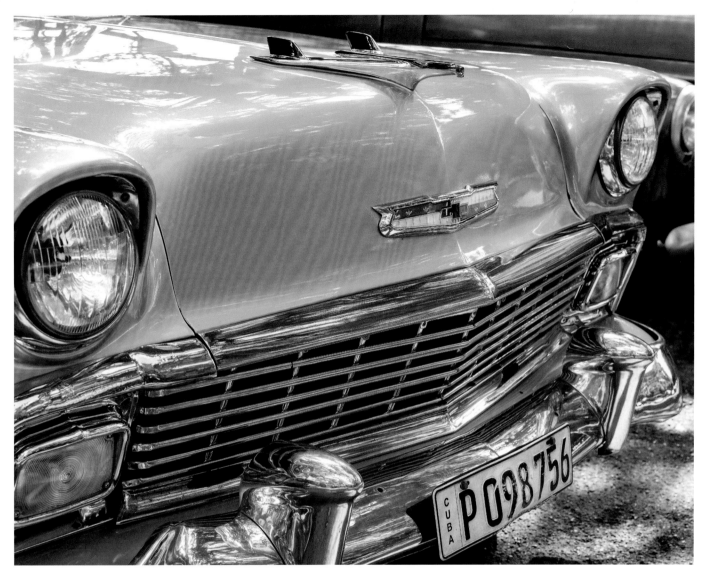

Chevrolet Bel Air, 1956, La Habana

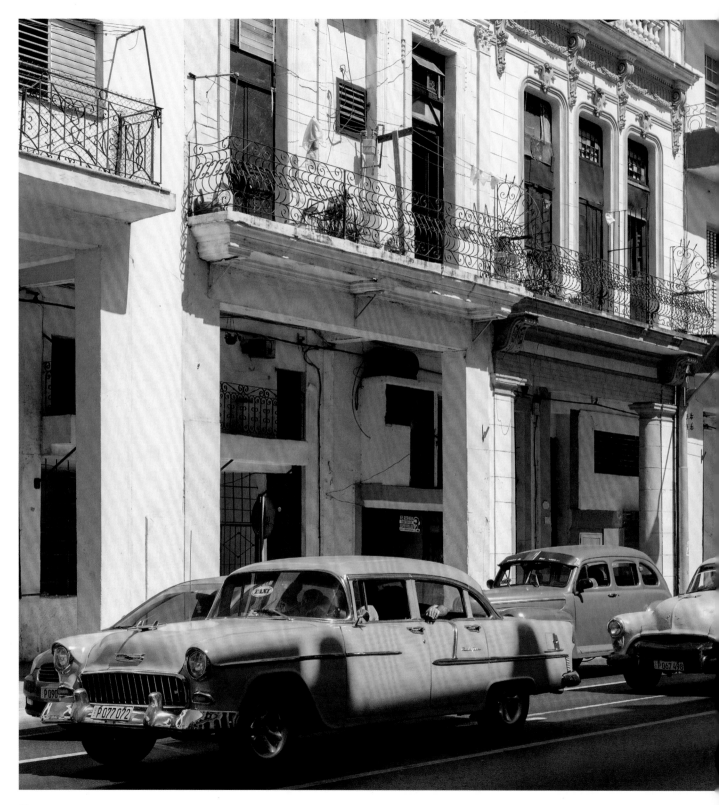

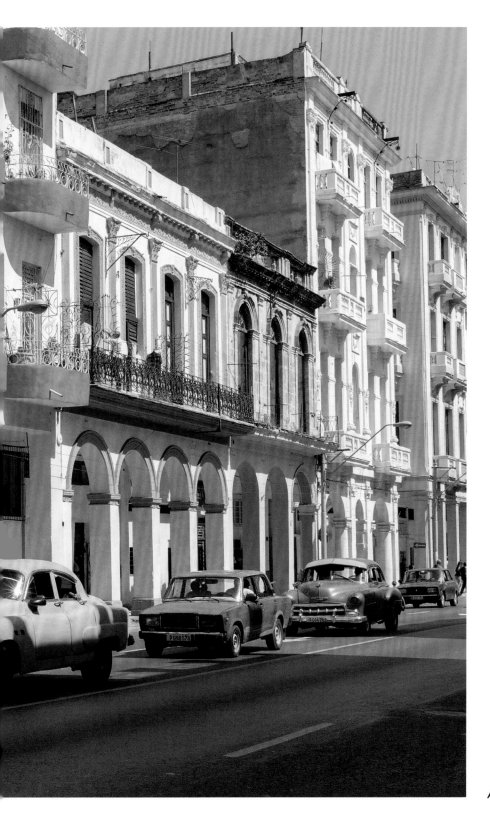

Avenida Máximo Gómez, La Habana

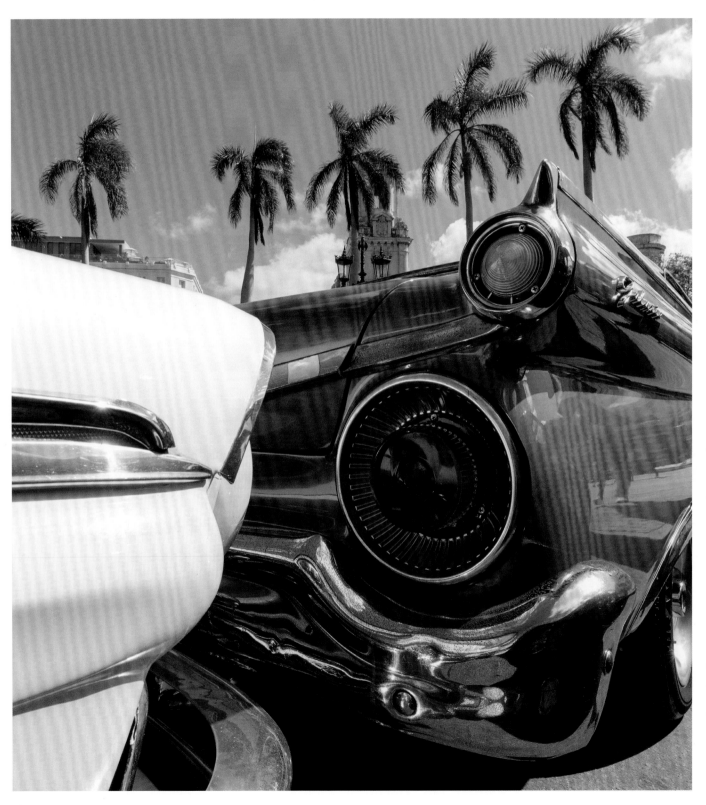

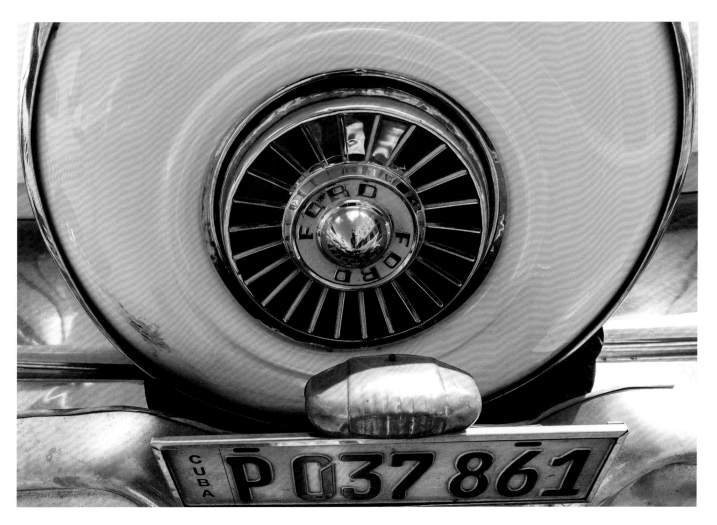

Ford Fairlane, 1958, Parque Central, La Habana

Ford, 1957/Ford 1959, Parque Central, La Habana

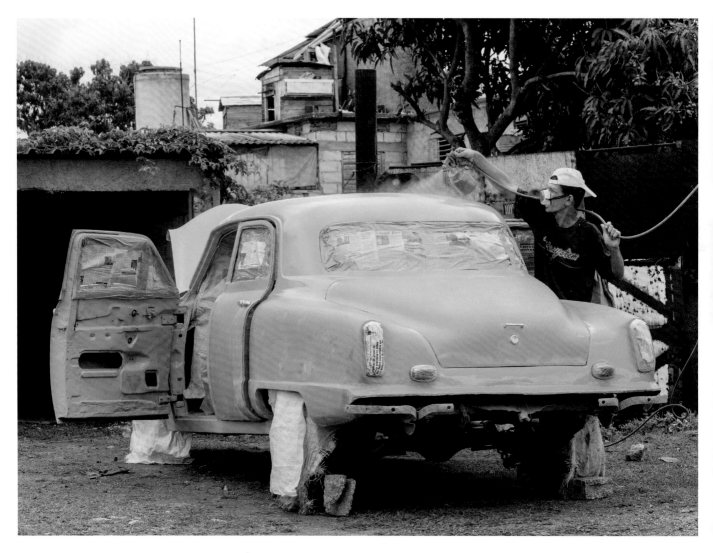

Studebaker 1951, Santa Clara

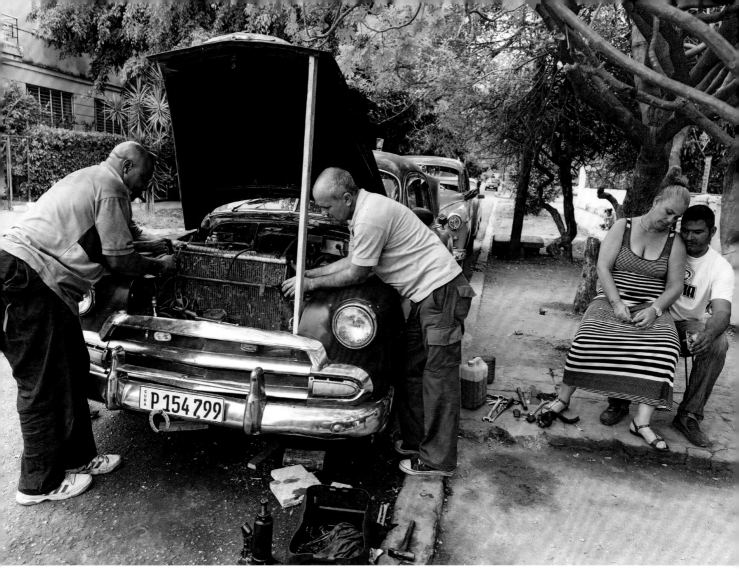

Chevrolet, 1952, Vedado, La Habana

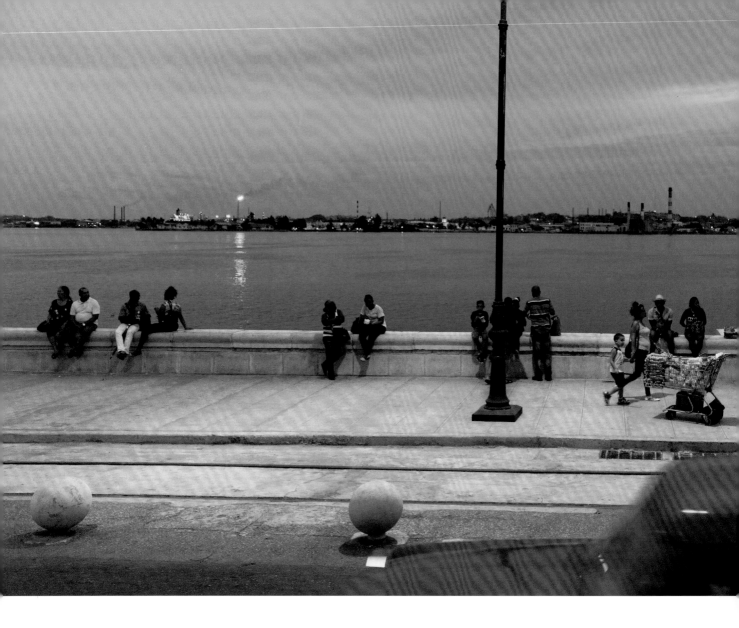

Havana lives with its face to the sea, and the Malecón, the legendary waterside promenade, is the lifeline, boulevard and public living room of the city. On the low walls sit lovers, solitary people, merchants, whole families and countless anglers. Here one meets for a chat and enjoys the evening sun, or proudly makes a lap of honor in a freshly polished vintage car.

La Havane vit face à la mer et le Malecón, la célèbre promenade qui borde le littoral, est à la fois l'artère vitale et le lieu de détente et de rencontre de la ville. Sur son parapet s'asseyent les amoureux, les promeneurs solitaires, les commerçants, les familles et même d'innombrables pêcheurs. On s'y retrouve pour bavarder et savourer le soleil du soir, ou encore pour frimer au volant de sa voiture de collection rutilante.

Havanna lebt mit dem Gesicht zum Meer und der Malecón, die legendäre Uferpromenade, ist Lebenslinie, Flaniermeile und öffentliches Wohnzimmer der Stadt. Auf dem Mäuerchen sitzen Verliebte, Einsame, Händler, ganze Familien und zahllose Angler. Hier trifft man sich zum Plausch und genießt die Abendsonne oder dreht stolz eine Ehrenrunde mit dem frisch herausgeputzten Oldtimer.

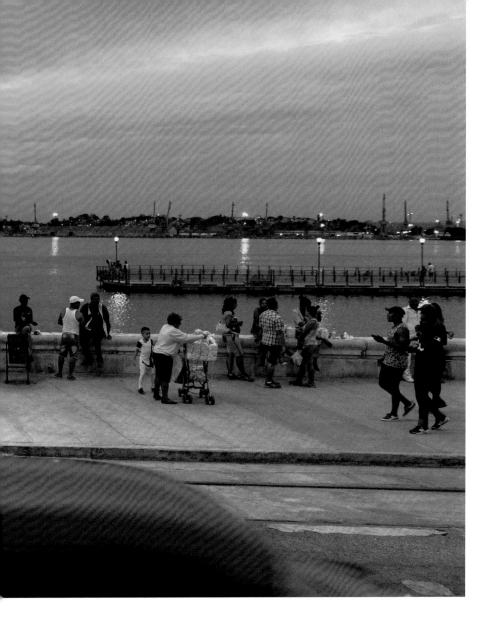

La Habana vive de cara al mar y el Malecón, el legendario paseo marítimo, es la línea de vida, el paseo marítimo y el salón público de la ciudad. En el pequeño muro se sientan amantes, gente solitaria, comerciantes, familias enteras e incontables pescadores. Aquí uno se reúne para charlar y disfruta del sol del atardecer o da una vuelta de honor con el coche vintage recién vestido.

Havana vive virada para o mar e para o Malecón, o lendário calçadão que é, ao mesmo tempo, a linha de vida, a avenida pedonal e a sala de estar pública da cidade. Nos muretes vêem-se os amantes, os solitários, comerciantes, famílias inteiras e muitos pescadores. Aqui se encontram, os passantes para uma conversa, para o desfrutar do pôr do sol ou para, orgulhosamente, dar uma volta de honra numa dessas limusinas acabadas de arranjar.

Havana leeft met zijn gezicht naar de zee en de Malecón, de legendarische boulevard langs de zee, is de levenslijn, de wandelpromenade en de openbare woonkamer van de stad. Op het muurtje zitten geliefden, alleenstaanden, kooplieden, hele families en talloze vissers. Hier ontmoet men elkaar voor een praatje en geniet men van de avondzon of maakt men trots een ererrond met de net opgetuigde oldtimer.

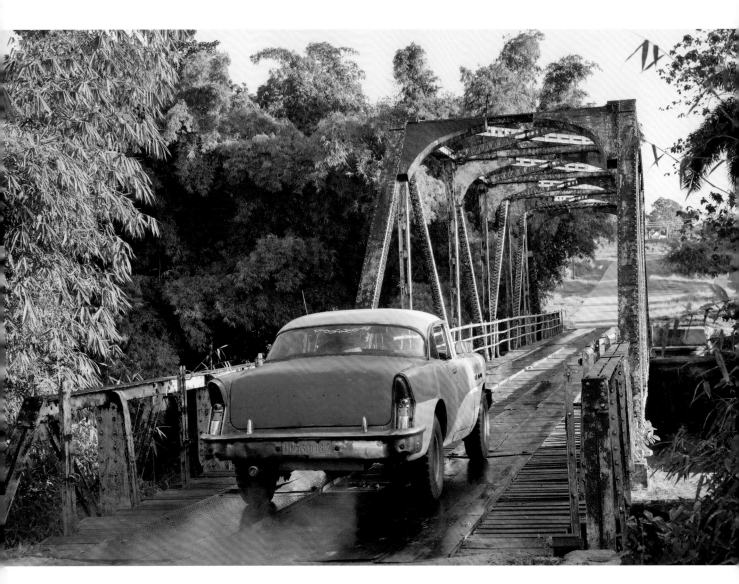

Buick, 1956, Pinar del Rio

Chevrolet Bel Air,
1956, Pinar del Rio

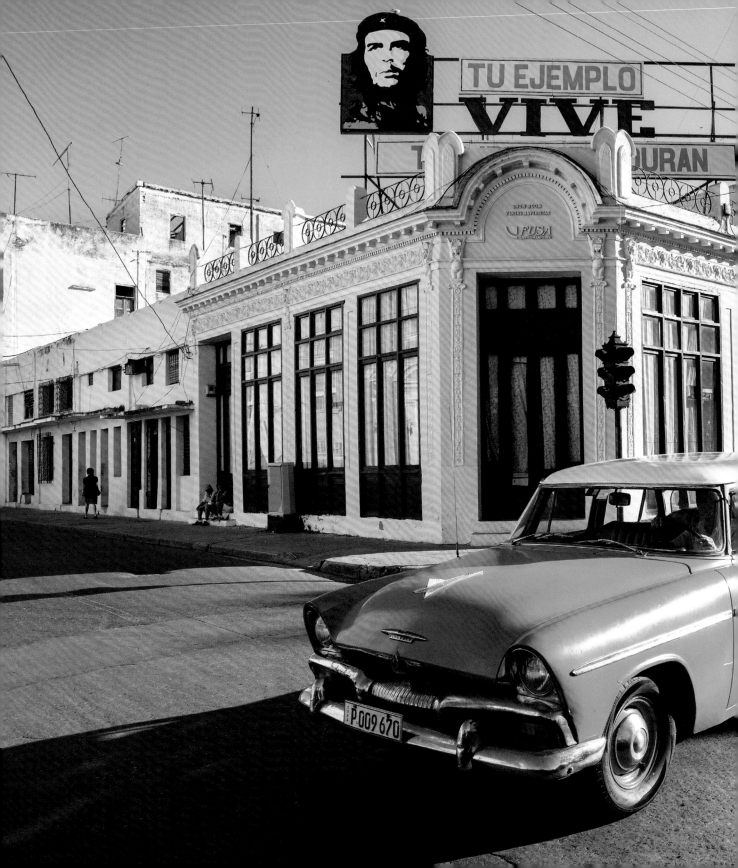

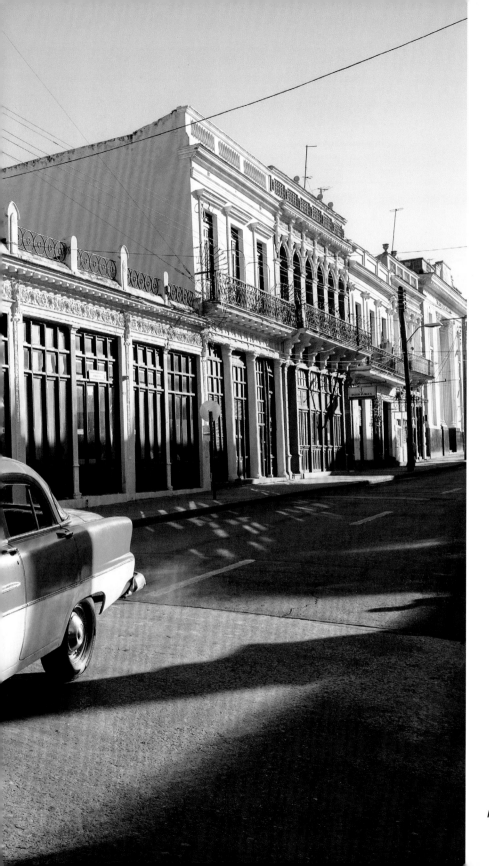

Plymouth, 1955, Cienfuegos

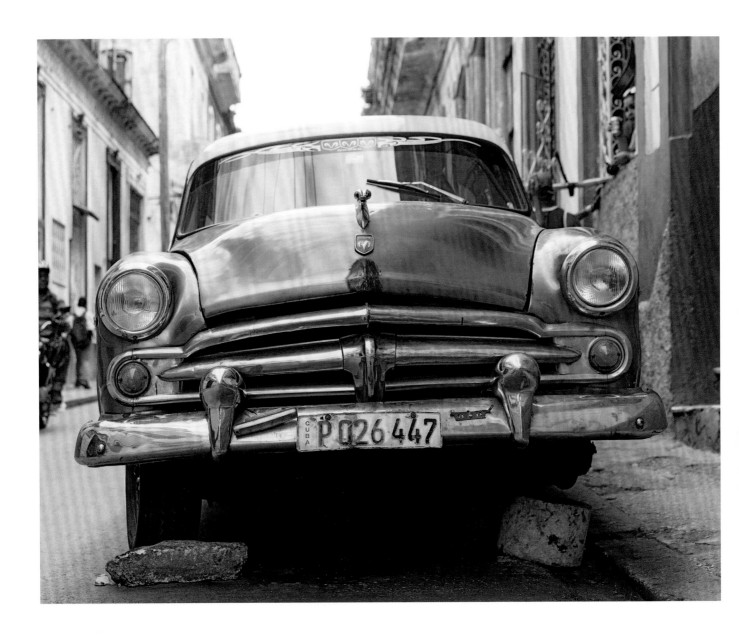

Cuban mechanics are ingenious craftsmen who, with months of work, laboriously and lovingly develop out of nothing everything that a car needs. A glance at the speedometer inspires awe, because most of these vehicles have hundreds of thousands, if not more than a million kilometers on their carefully painted bumpers.

Les mécaniciens cubains sont des artisans de génie, qui après des mois d'un travail minutieux et passionné réussissent à façonner à partir de rien tout ce dont la voiture a besoin. Un rapide coup d'œil au tableau de bord ne peut que forcer le respect, car la plupart de ces guimbardes flamboyantes ont des centaines de milliers, voire plus d'un million de kilomètres au compteur.

Die kubanischen Mechaniker sind geniale Kunsthandwerker, die in monatelanger Arbeit ebenso mühe- wie liebevoll aus dem Nichts alles zurechtfrickeln, was das Auto braucht. Und ein Blick auf den Tacho flößt Ehrfurcht ein, denn die meisten Gefährte haben Hunderttausende, wenn nicht über eine Million Kilometer auf dem sorgsam lackierten Buckel.

Dodge, 1954, Centro, La Habana

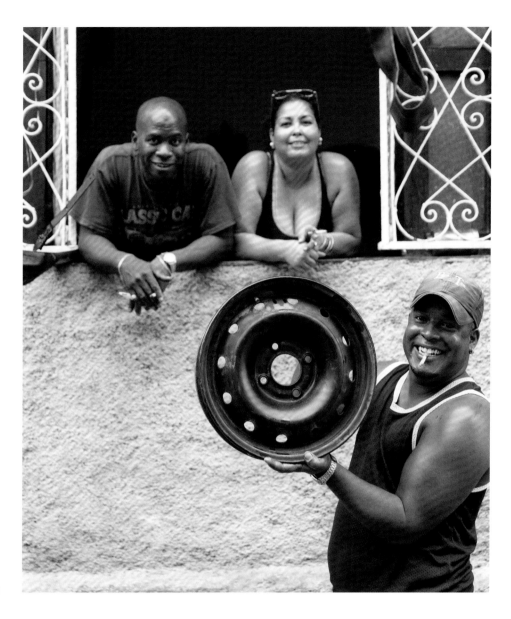

Centro, La Habana

Los mecánicos cubanos son ingeniosos artesanos que, en meses de trabajo, desarrollan de la nada, laboriosa y amorosamente, todo lo que el automóvil necesita. Y una mirada al velocímetro inspira asombro, porque la mayoría de estos compañeros tienen cientos de miles, si no más de un millón de kilómetros, a su espalda cuidadosamente pintada.

Os mecânicos cubanos são artesãos engenhosos notáveis que, em meses de trabalho, laboriosamente e amorosamete a partir do nada, „remendam" tudo aquilo que o carro precisa. E um olhar sobre o velocímetro inspira grande respeito, pois a maioria deles tem centenas de milhares, senão mais de um milhão de quilómetros, sobre aquela carroçaria cuidadosamente pintada.

De Cubaanse monteurs zijn geniale vaklieden die maandenlang moeizaam en met liefde werken om vanuit het niets alles in elkaar knutselen wat de auto nodig heeft. En een blik op de snelheidsmeter boezemt ontzag in, want de meeste voertuigen hebben honderdduizenden, zo niet meer dan een miljoen kilometers op de zorgvuldig gepoetste teller staan.

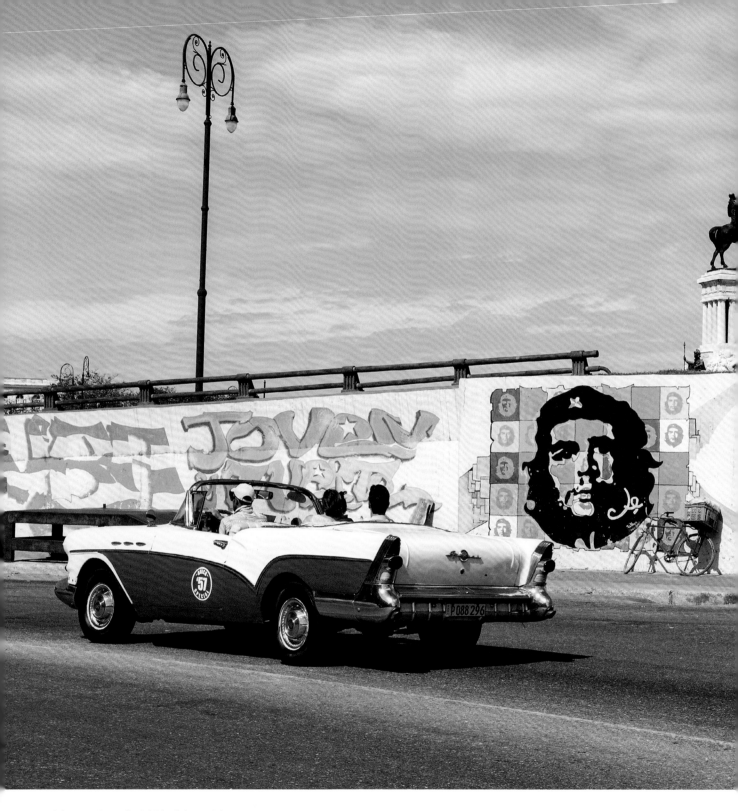

Buick, 1957, Entrada del Túnel de La Habana

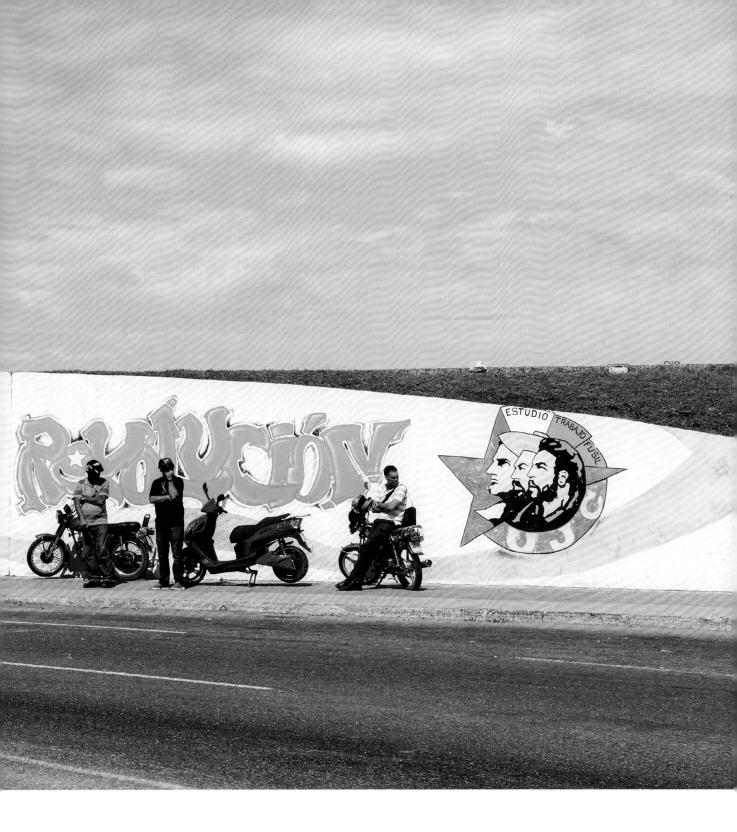

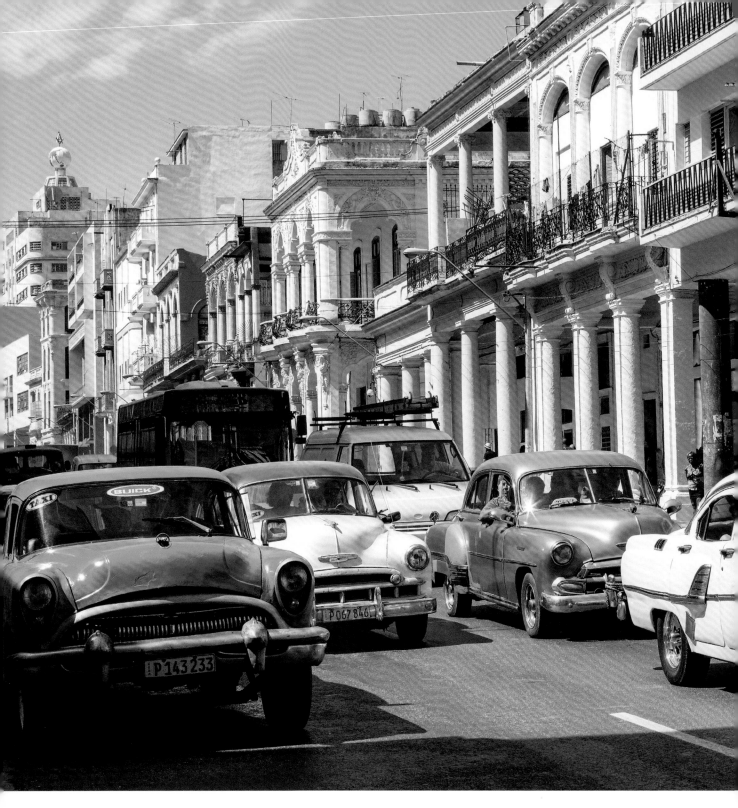

Avenida Máximo Gómez, Centro, La Habana

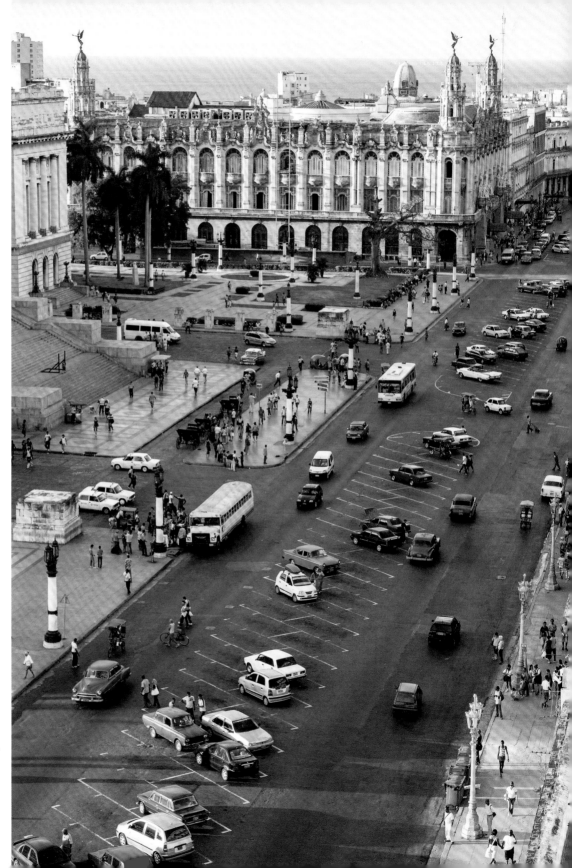

Paseo de Martí, La Habana

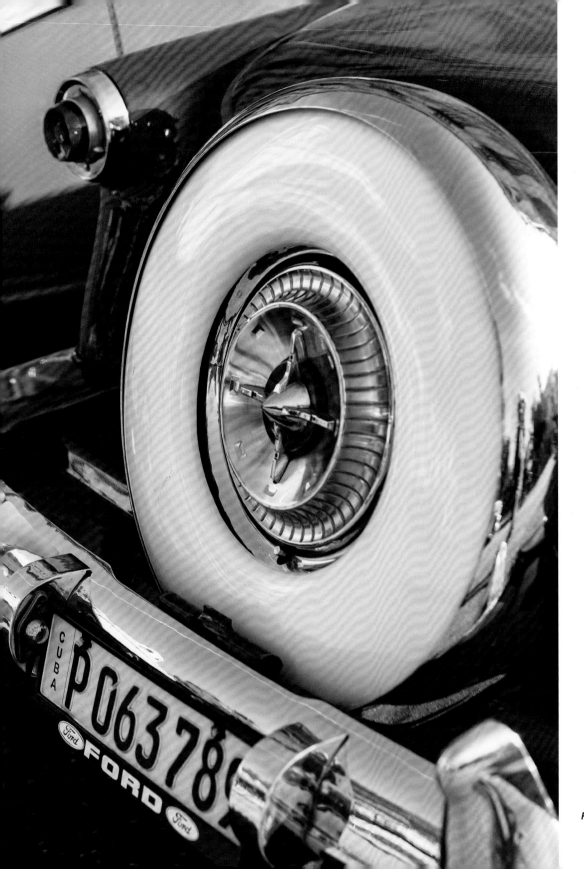

Ford, 1954, La Habana

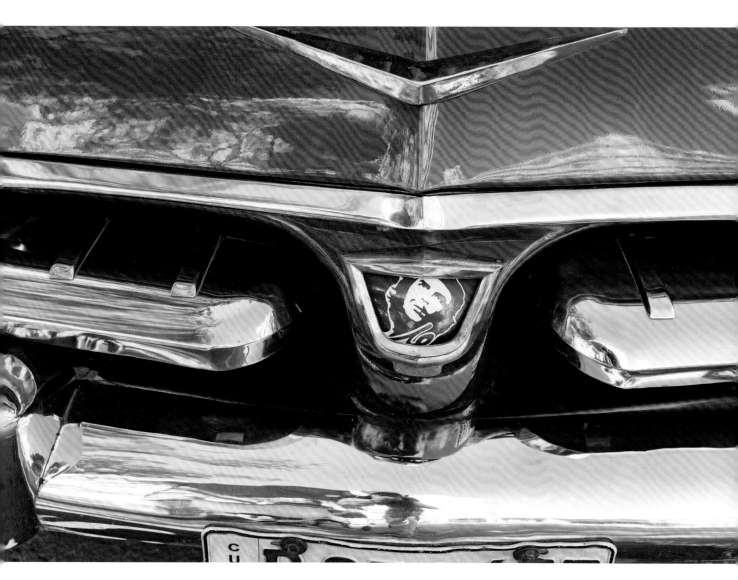

Ford, 1954, La Habana

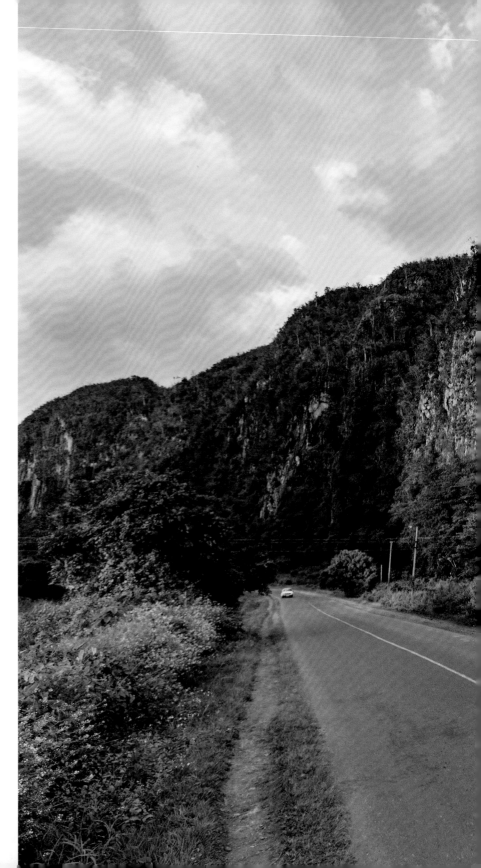

Chevrolet, 1951, Viñales

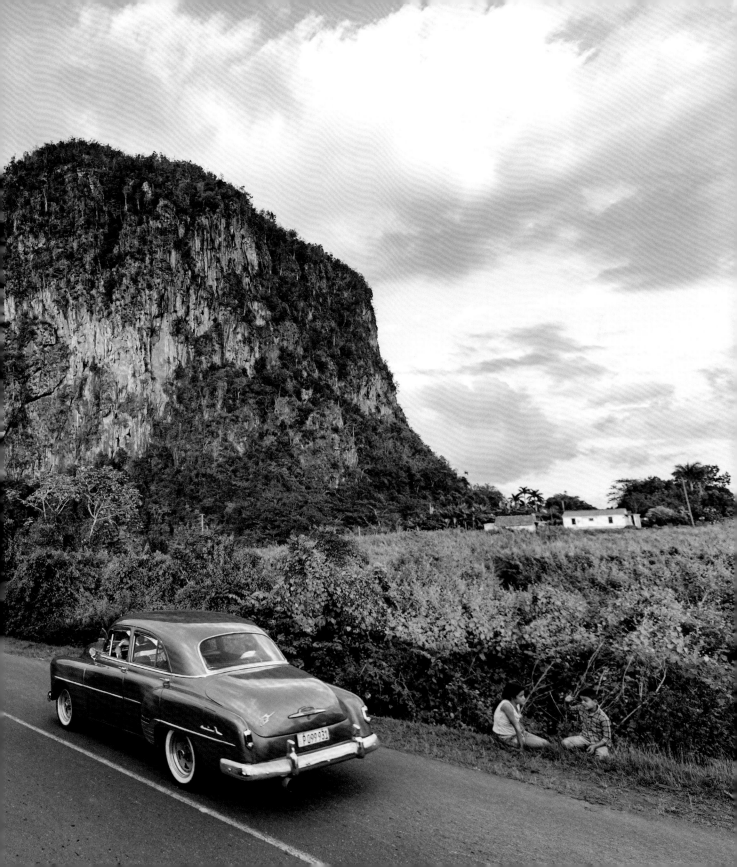

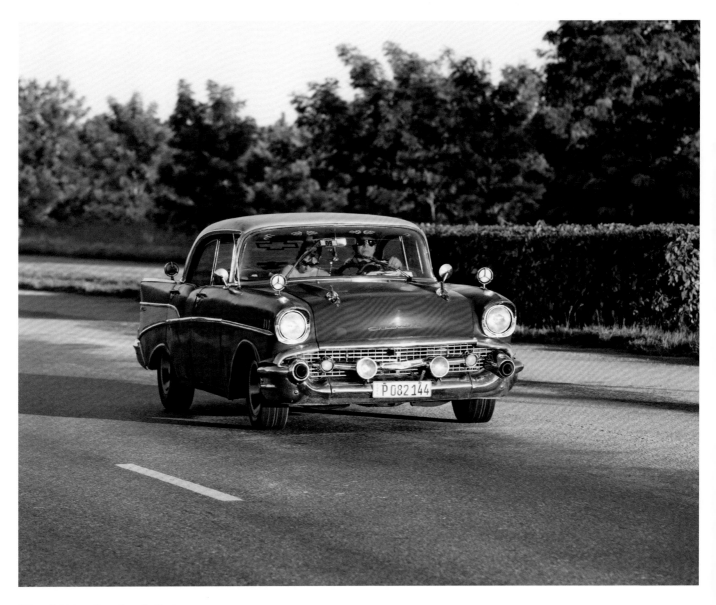

Chevrolet, 1957, Carretera Central

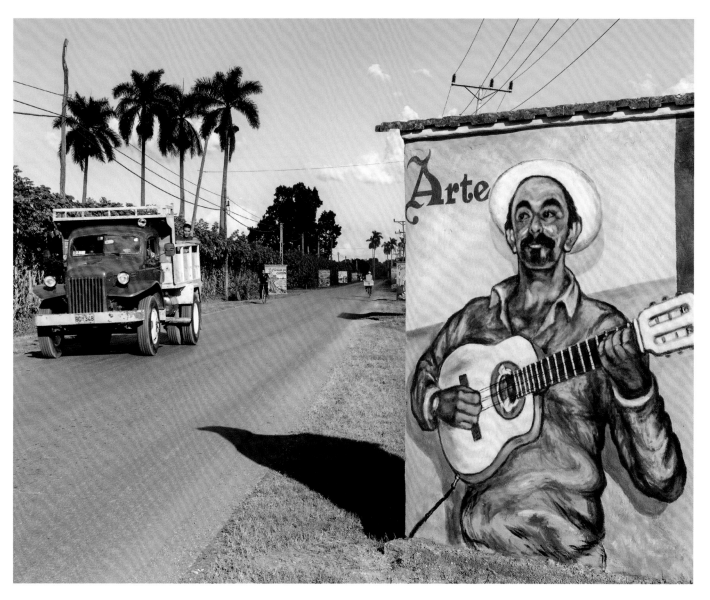

Camión, Provincia Artemisa

Chevrolet, 1952, Vedado, La Habana

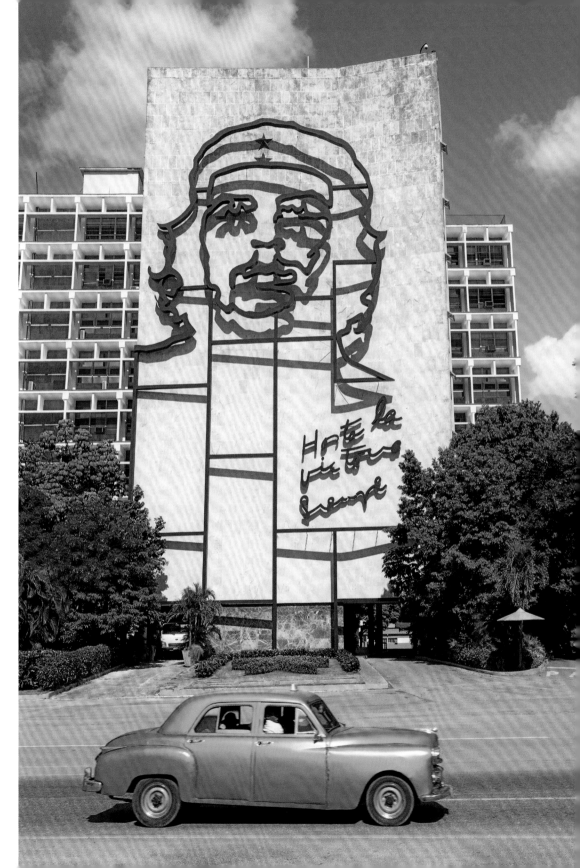

Plymouth, 1951, Plaza de la Revolución, La Habana

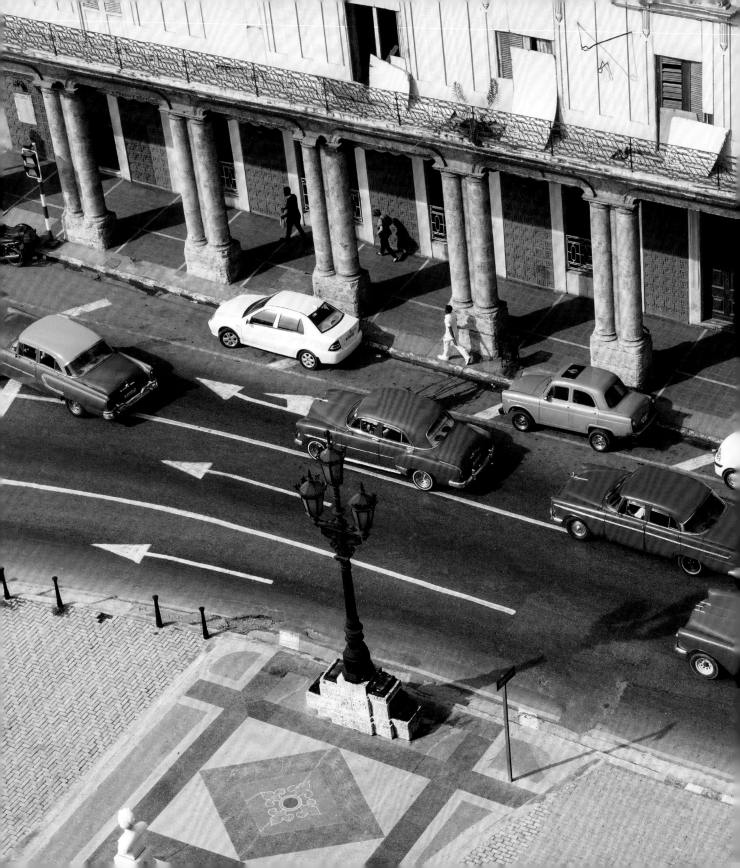

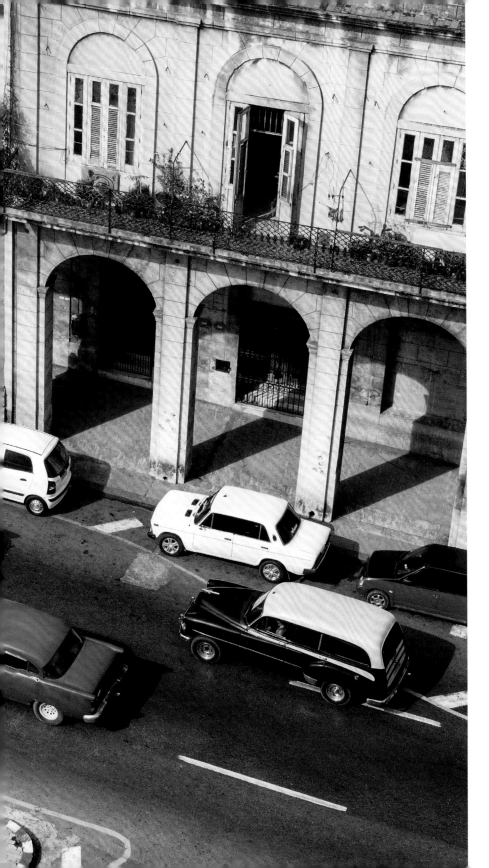

Paseo de Martí, La Habana

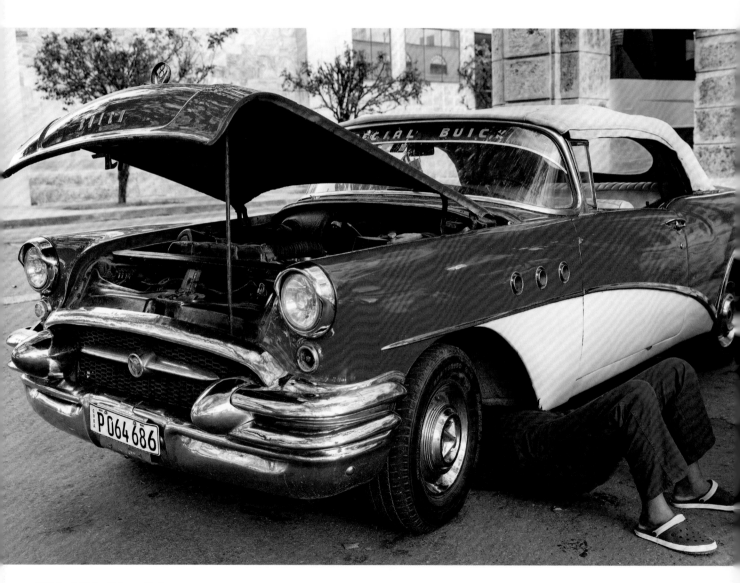

Buick, 1956, La Habana Vieja

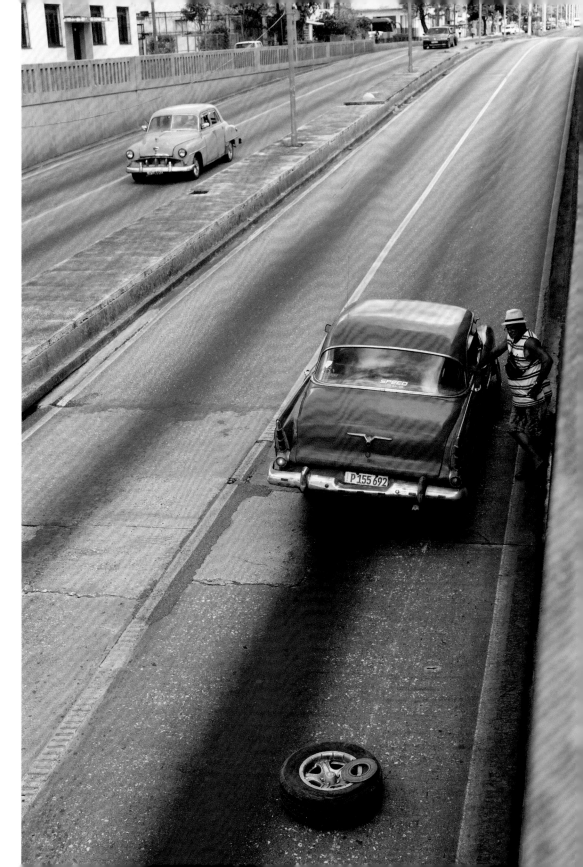

Plymouth, 1955,
Miramar, La Habana

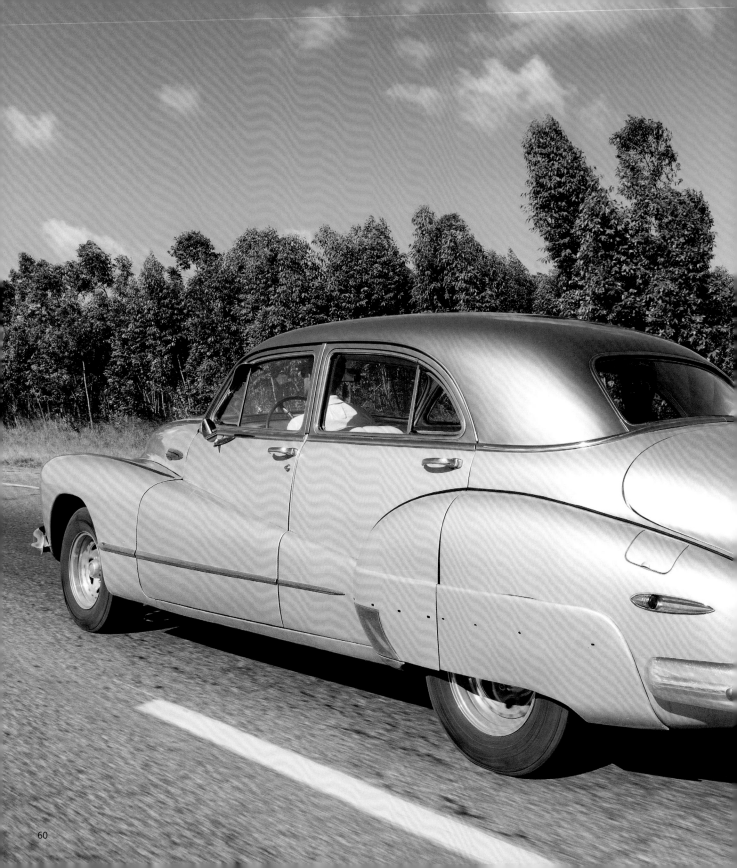

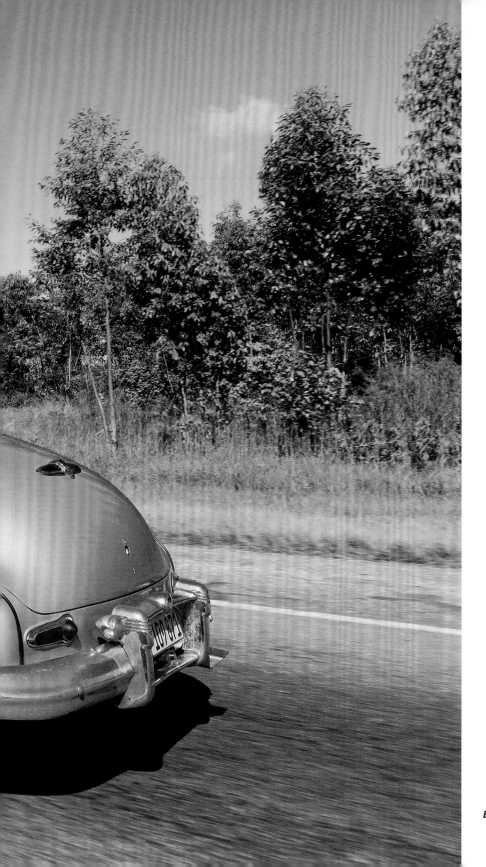

Buick Sedan, 1946, Pinar del Rio

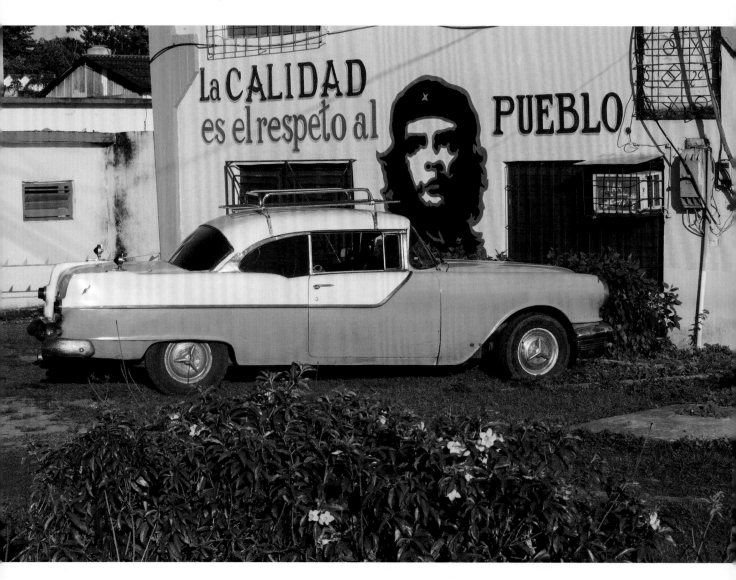

Pontiac, 1955, Pinar del Rio

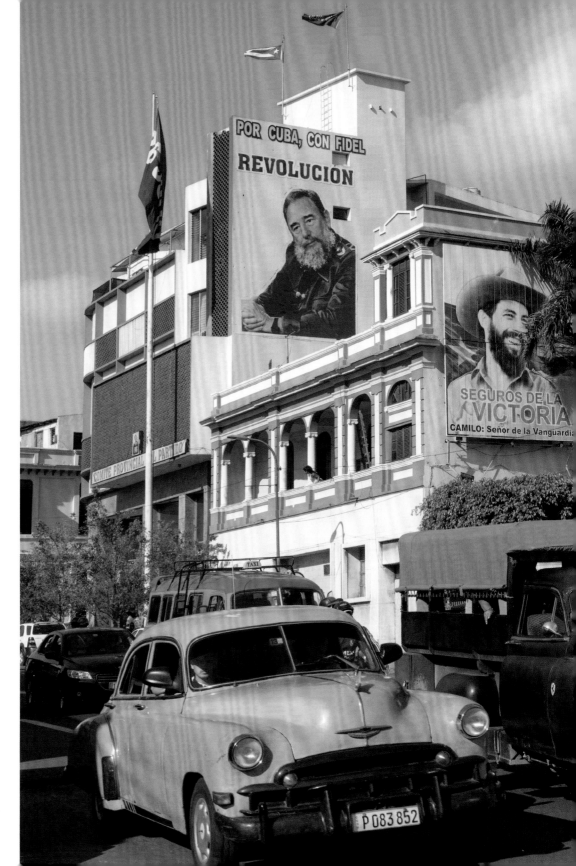

*Chevrolet, 1950,
Santiago de Cuba*

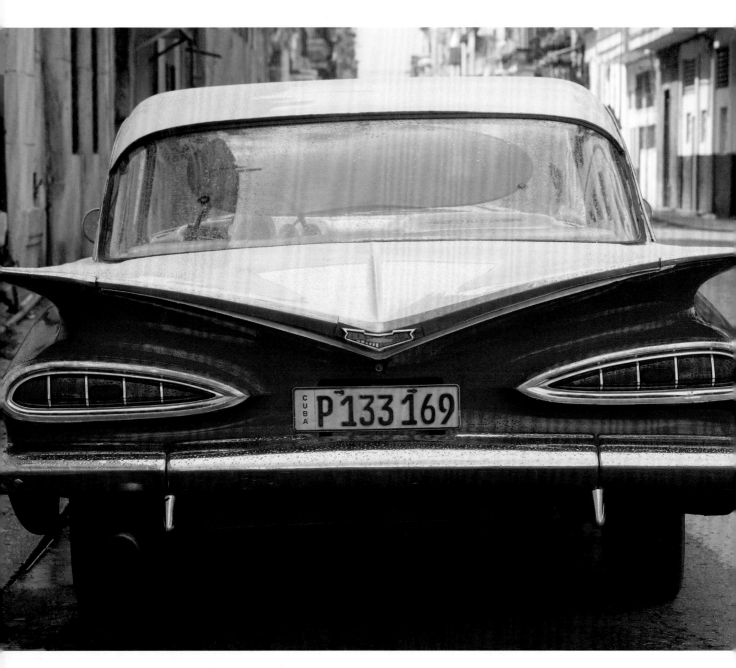

Chevrolet Impala, 1959, Centro, La Habana

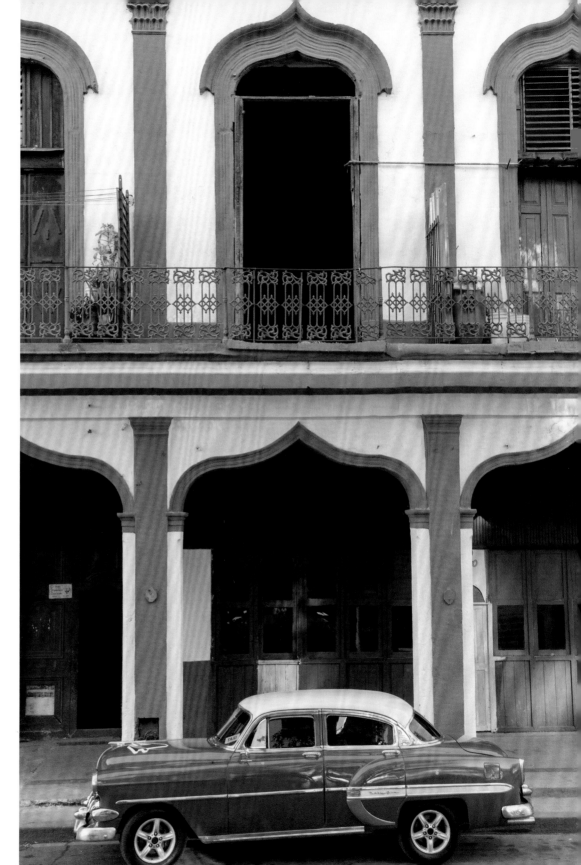

Chevrolet 1953, Paseo del Prado, La Habana

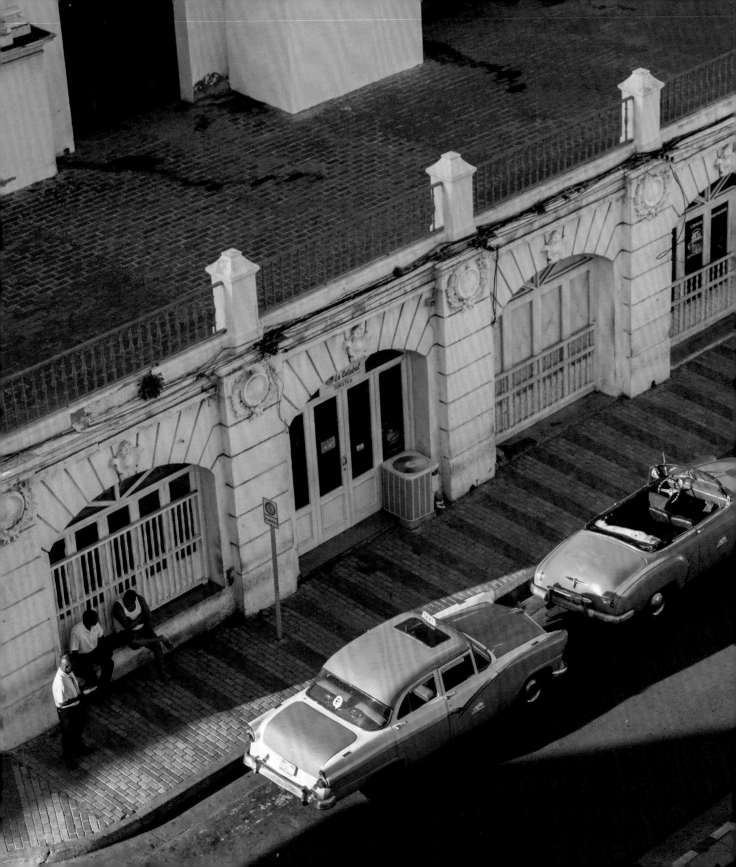

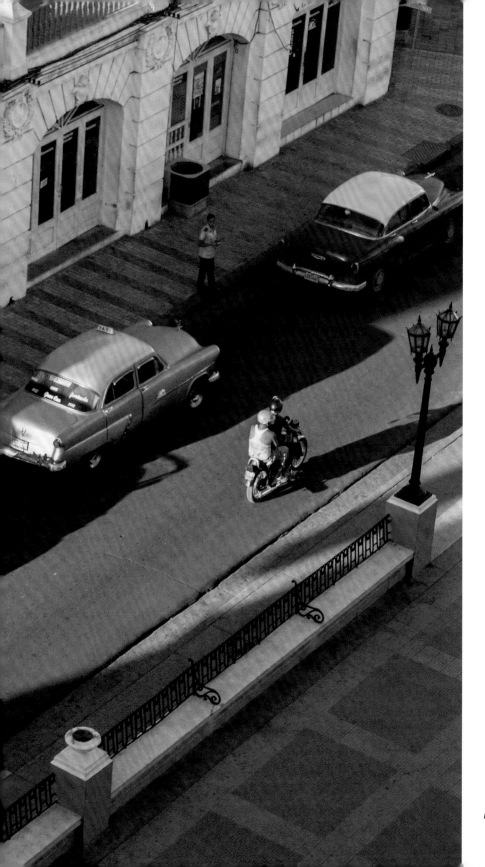

Parque Céspedes, Santiago de Cuba

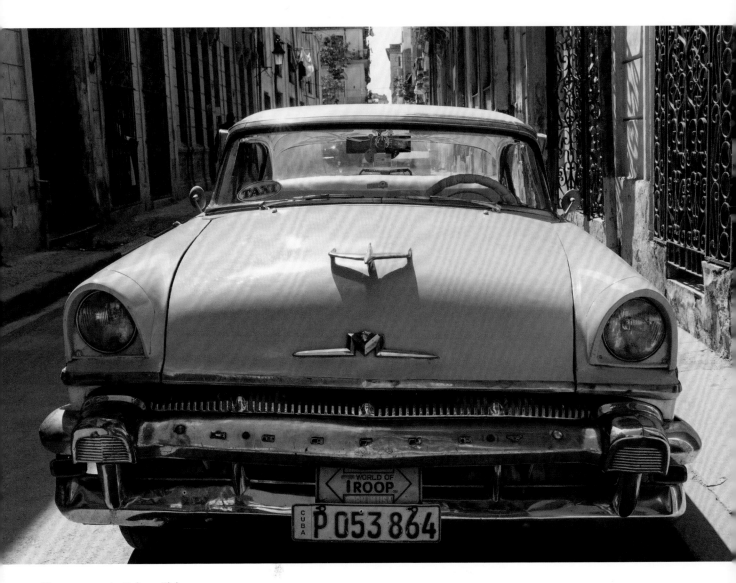

Mercury, 1955, La Habana Vieja

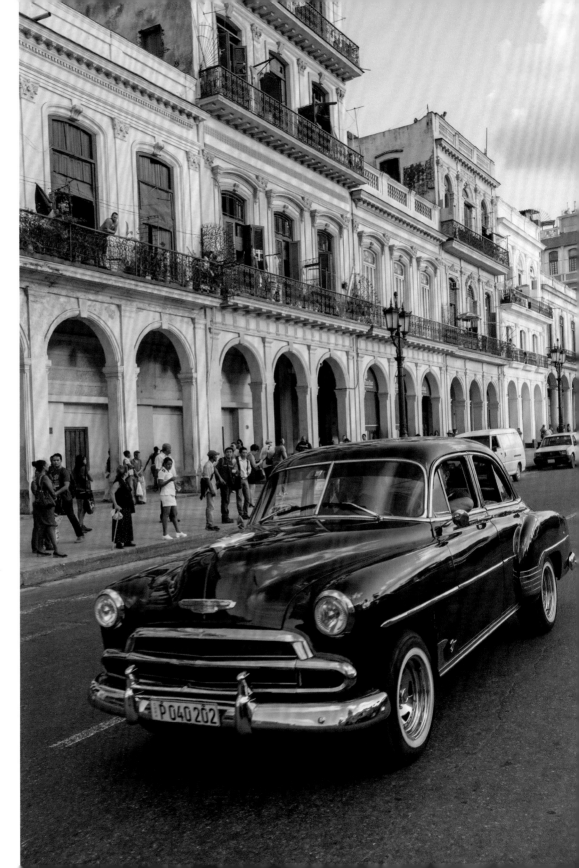

Paseo de Martí, La Habana

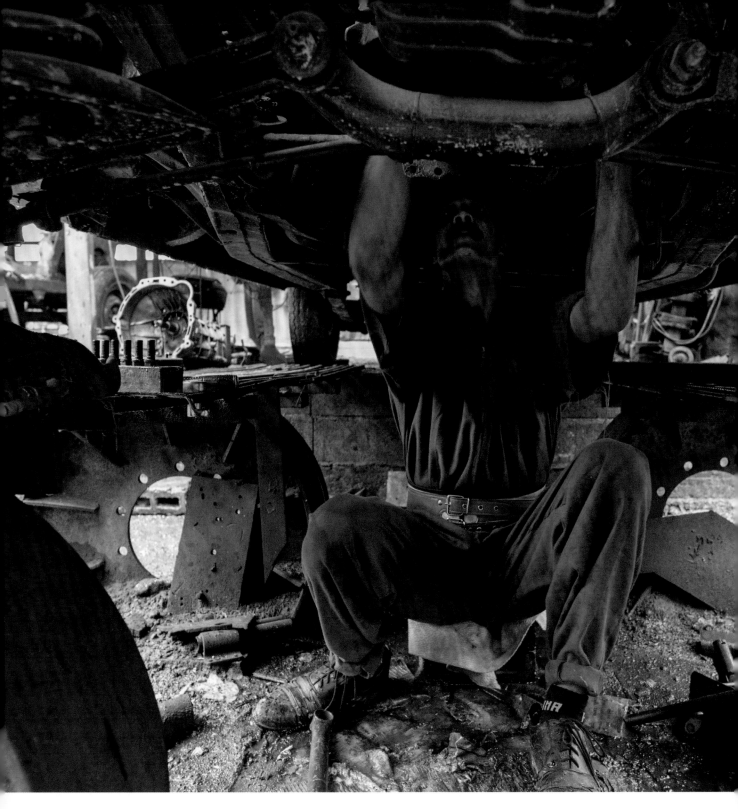

Ford, 1956, La Habana

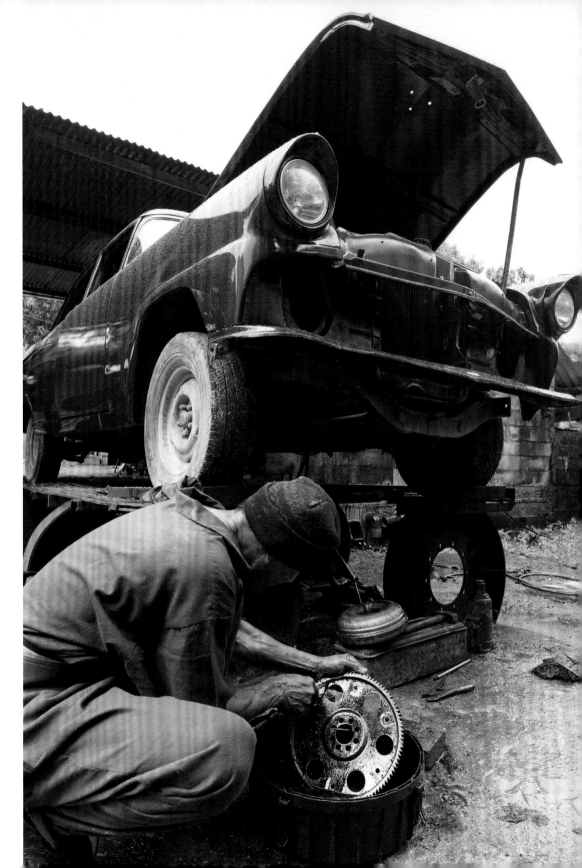

Ford, 1956, La Habana

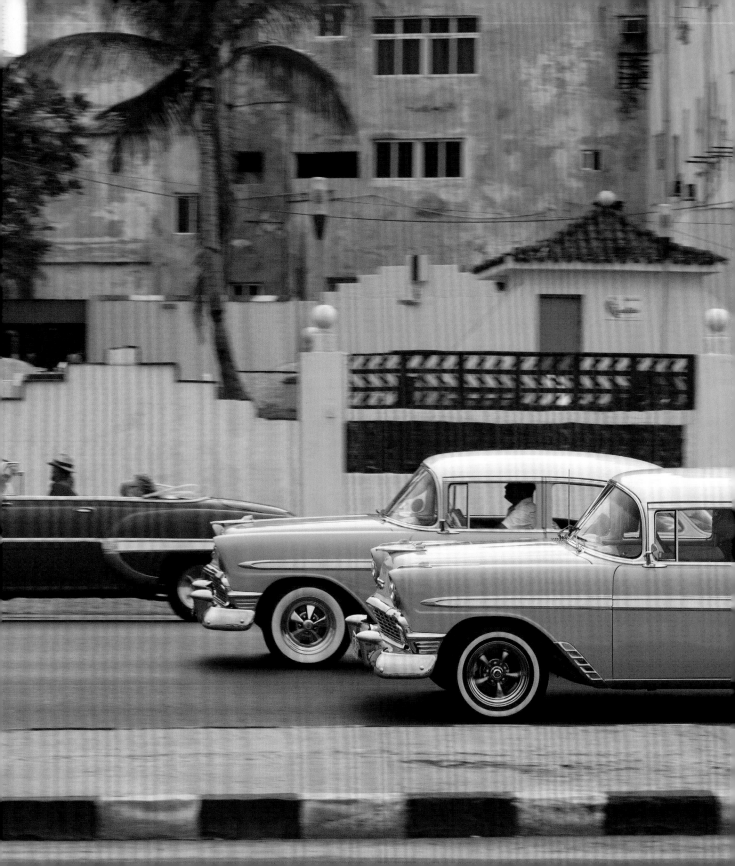

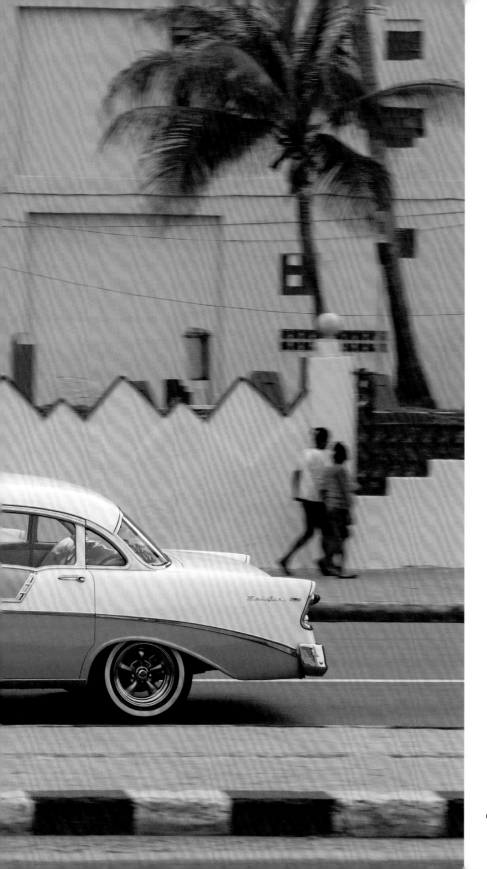

Chevrolet Bel Air, 1956, Malecón, La Habana

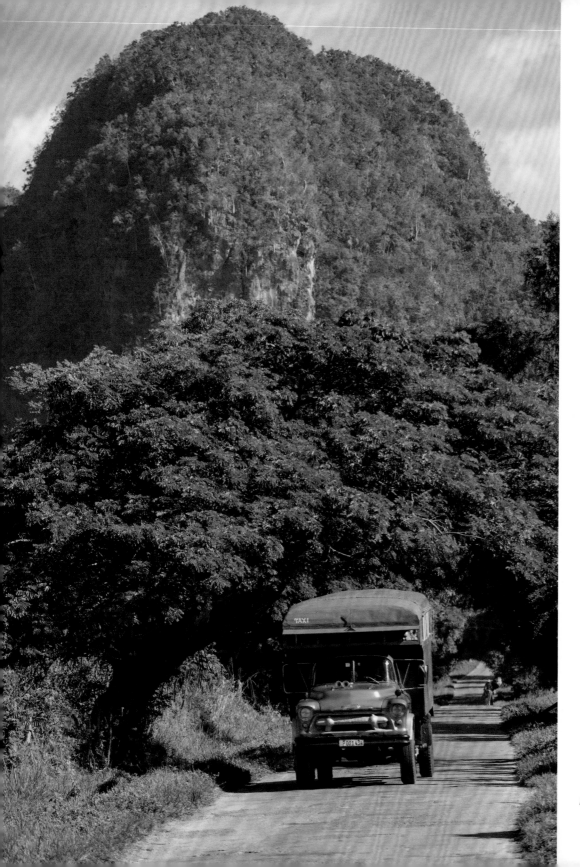

Fabricación casera / Chevrolet
1952, Viñales

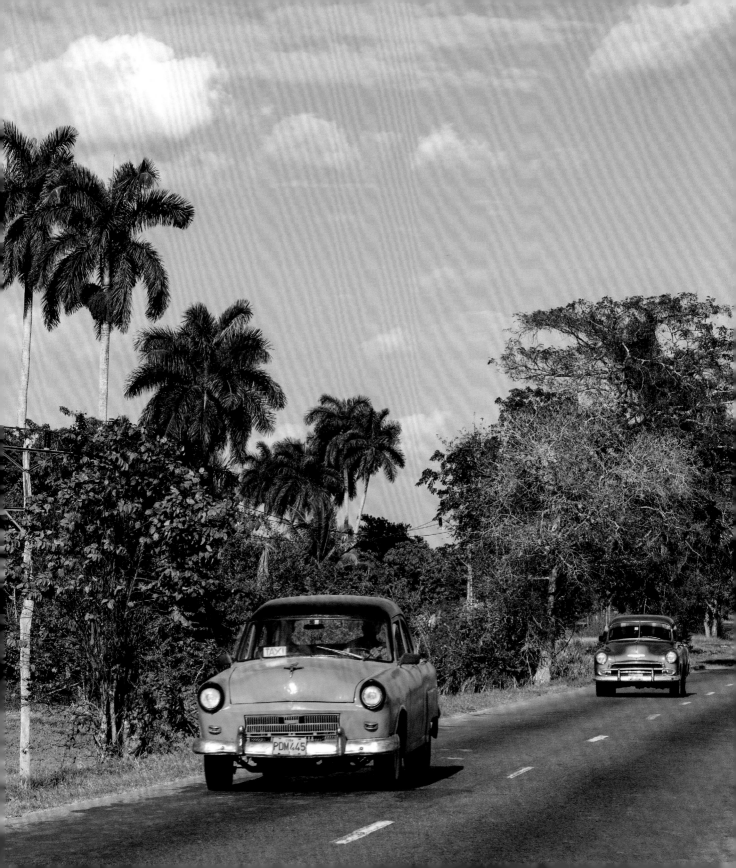

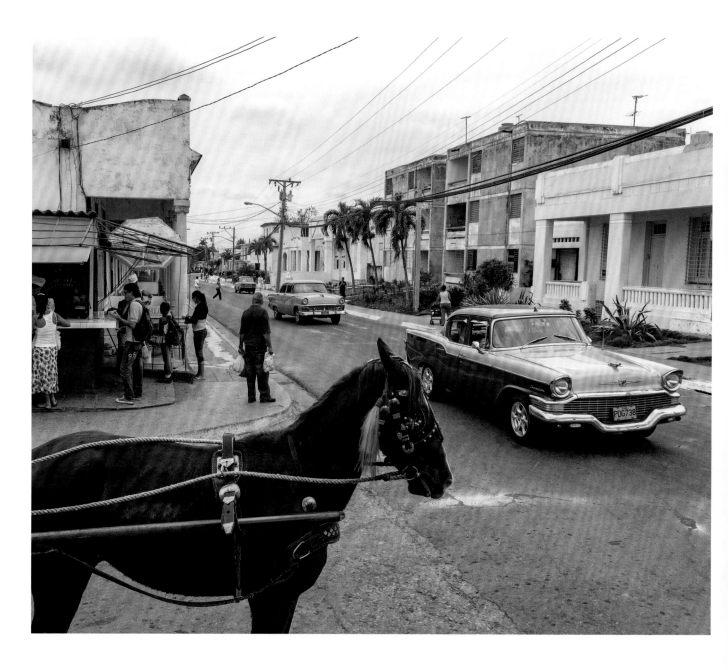

Cubans without currency who want to move from A to B require enormous ingenuity, because transport is an almost insolvable problem on the island. In the countryside in particular people like to rely on natural horsepower. This offers the invaluable advantage of not guzzling petrol.

Les Cubains dépourvus de devises doivent déployer des trésors d'imagination pour se déplacer d'un point A à un point B, car sur l'île les transports représentent un problème quasi insoluble. À la campagne, on a bien volontiers recours aux chevaux, qui présentent l'avantage considérable de ne pas engloutir d'essence.

Kubaner ohne Devisen, die sich von A nach B bewegen wollen, brauchen eine enorme Erfindungsgabe, denn der Transport ist auf der Insel ein schier unlösbares Problem. Vor allem auf dem Land verlässt man sich gern auf natürliche Pferdestärken. Sie bieten den unschätzbaren Vorteil, kein Benzin zu schlucken.

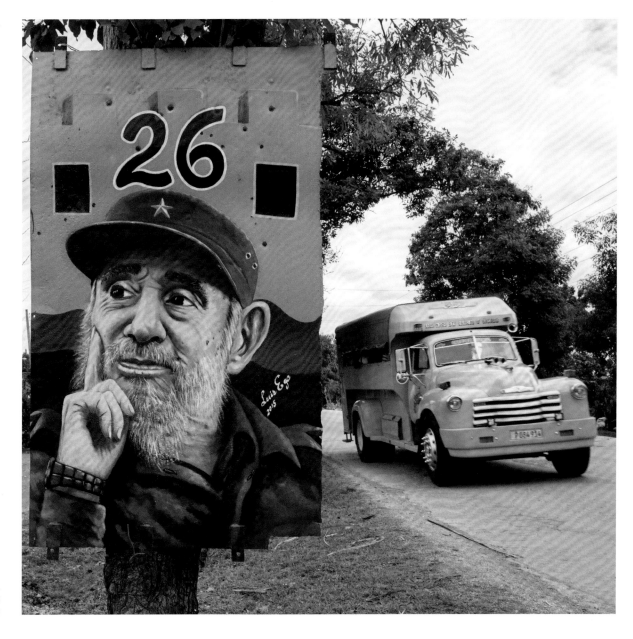

*San Cristóbal,
Provincia
Artemisa*

*Chevrolet,
1952, Sierra
Maestra*

Los cubanos sin divisas que quieren desplazarse de A a B necesitan un gran ingenio, porque el transporte es un problema casi sin solución en la isla. Especialmente en el campo, la gente prefiere recurrir a los caballos de fuerza naturales. Ofrecen la inestimable ventaja de no tragar gasolina.

Os cubanos, não dispondo de divisas, querendo movimentar-se dentro da ilha, precisam de uma enorme capacidade inventiva, porque os transportes são um problema quase insolúvel. Assim, especialmente fora das cidades, confia-se na potência natural de cavalos. Oferecem a vantagem inestimável de não engolir gasolina.

Cubanen zonder deviezen die van A naar B willen reizen, moeten enorm inventief zijn, want transport is een bijna onoplosbaar probleem op het eiland. Vooral op het platteland valt men graag terug op natuurlijke paardenkrachten. Paarden hebben het onschatbare voordeel dat ze geen benzine drinken.

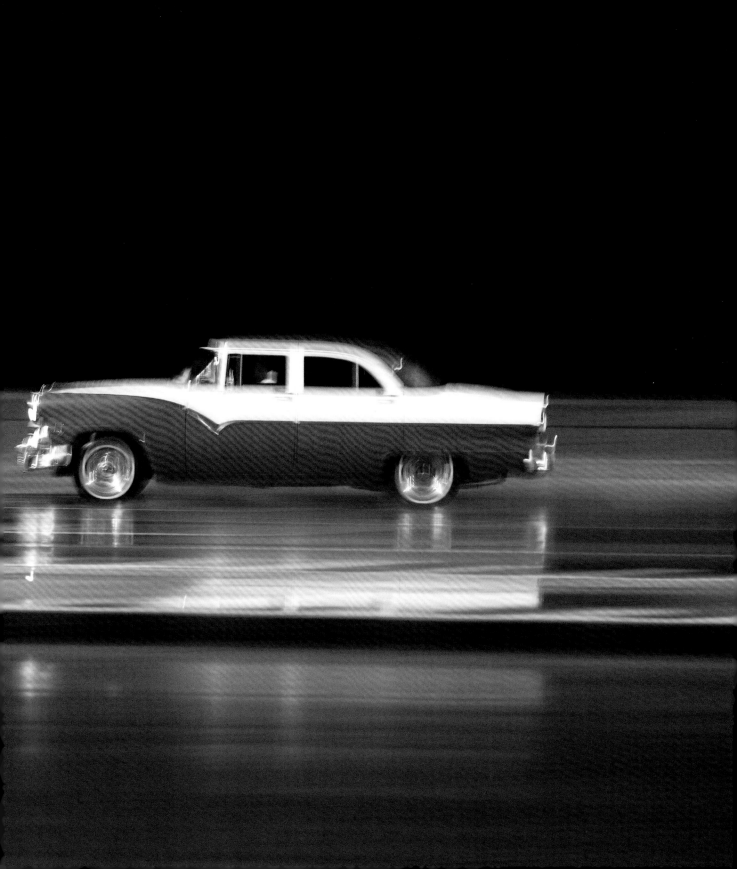

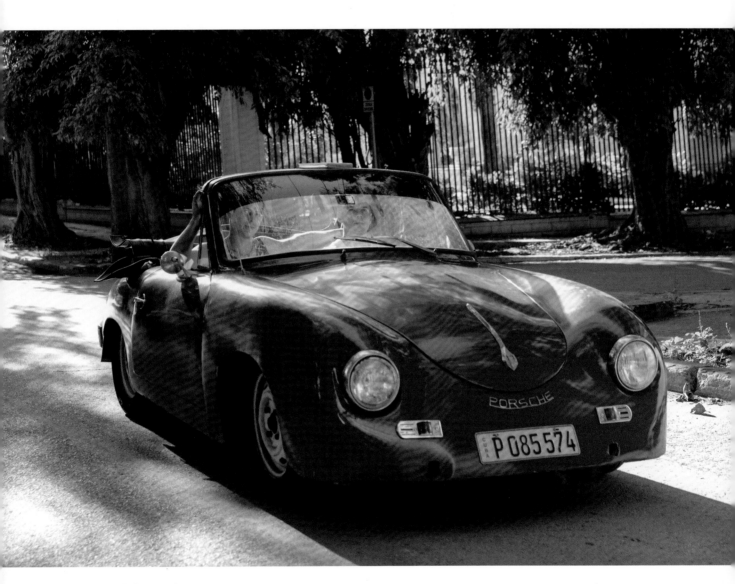

Porsche, 1958, Vedado, La Habana

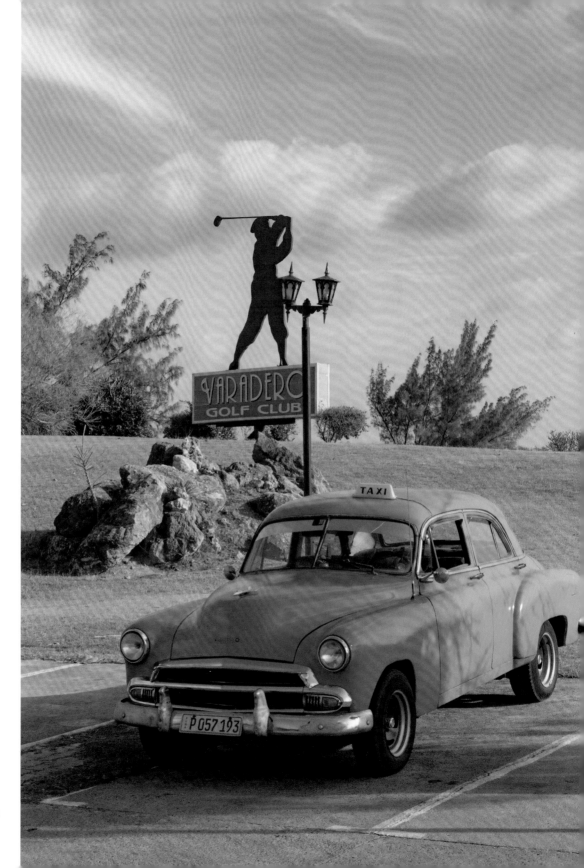

Chevrolet, 1952, Varadero

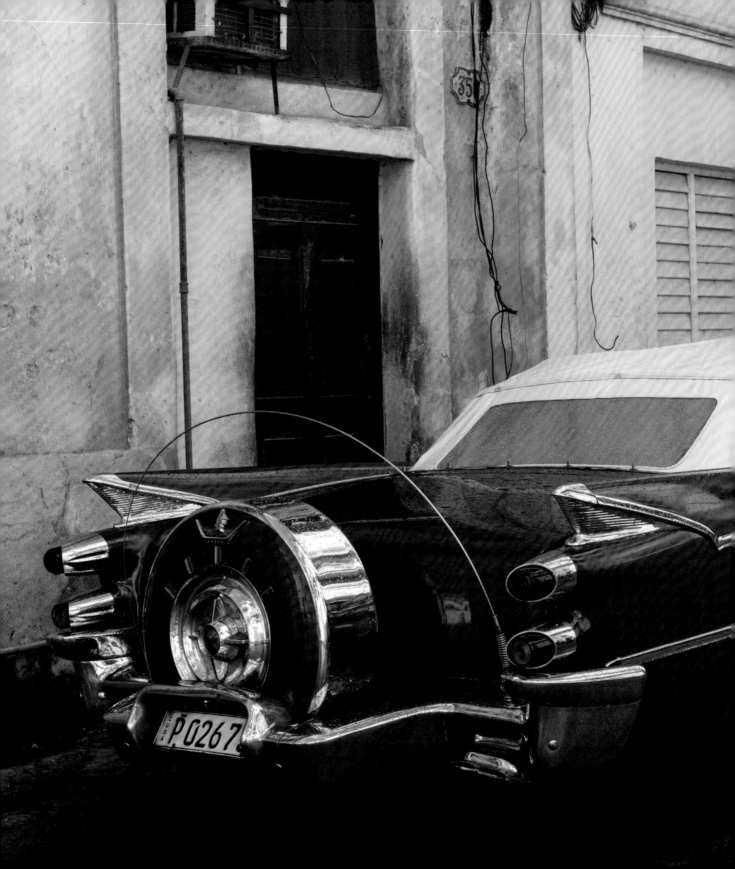

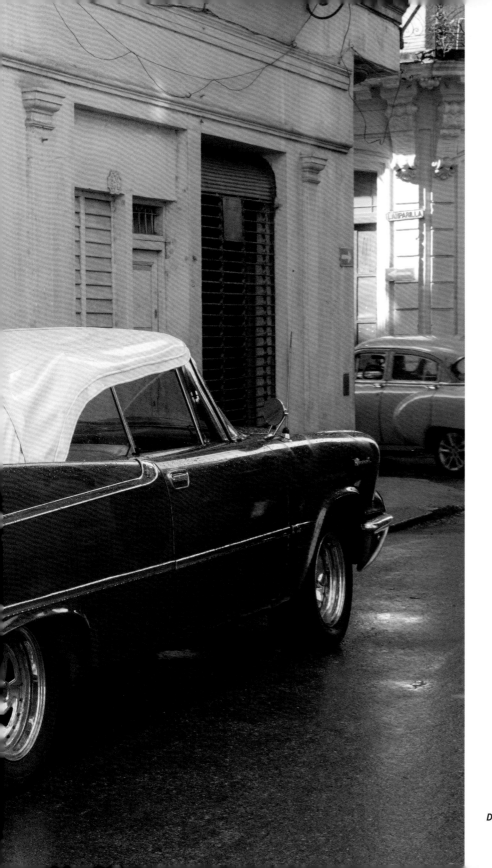

Dodge, Coronet, 1958, La Habana Vieja

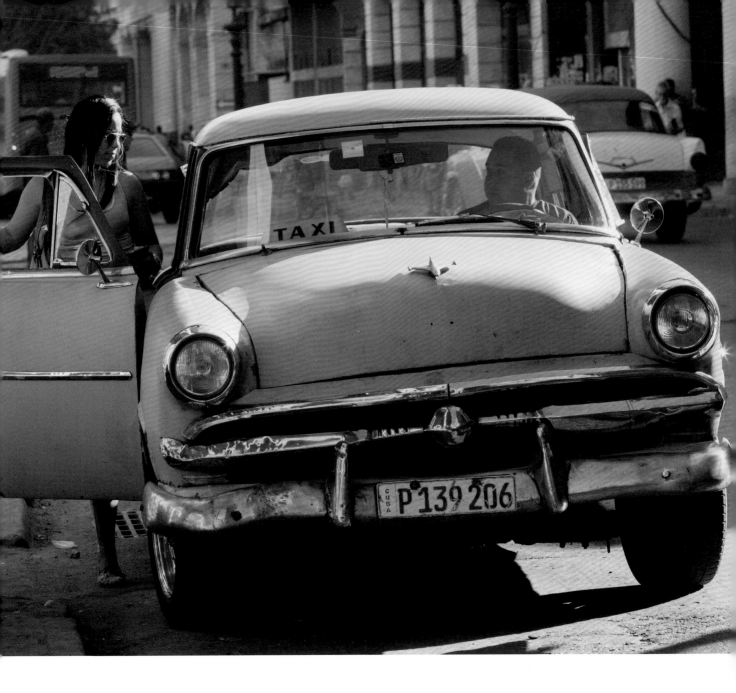

For the transport-stricken Habaneros, the antique gas guzzlers are an affordable solution to make their daily distances using Peso. Many classic cars function as more or less reliable shared taxis (colectivo), which drive on fixed routes.

Pour les habitants de La Havane, qui souffrent du manque de transports, ces antiques gouffres à essence représentent une solution payable en pesos pour les déplacements quotidiens. Beaucoup d'Oldtimers font office de taxis collectifs (*colectivos*) plus ou moins fiables, circulant sur des itinéraires bien précis.

Für die transportgeplagten Habaneros sind die antiken Spritschlucker eine in Peso bezahlbare Lösung, um ihre täglichen Wege zurückzulegen. Viele Oldtimer funktionieren als mehr oder weniger zuverlässige Sammeltaxis (colectivo), die auf festgelegten Routen fahren.

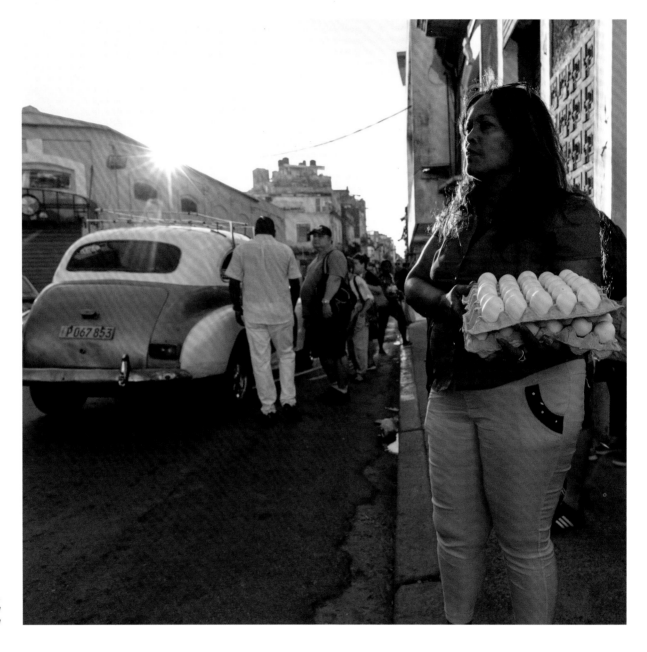

*Collectivo,
Centro, La
Habana*

Para los habaneros en problemas de transporte, los antiguos devoradores de gasolina son una solución que se puede pagar con pesos para cubrir sus distancias diarias. Muchos coches clásicos funcionan como taxis colectivos más o menos fiables que circulan por rutas fijas.

Para o transporte problemático dos Habaneros, os antigos guzzlers a gás são uma solução acessível em pesos cubanos para cobrir as suas distâncias diárias. Muitos carros clássicos (Oldtimer) funcionam como táxis compartilhados mais ou menos confiáveis (coletivos), que têm trajetos fixos.

Voor de Habaneros met hun transportproblemen vormen de antieke benzineslurpers een met peso's betaalbare oplossing om hun dagelijkse routes af te leggen. Veel oldtimers functioneren als min of meer betrouwbare gedeelde taxi's (*colectivo*), die vaste routes afleggen.

Chevrolet, 1952, Paseo de Martí, La Habana

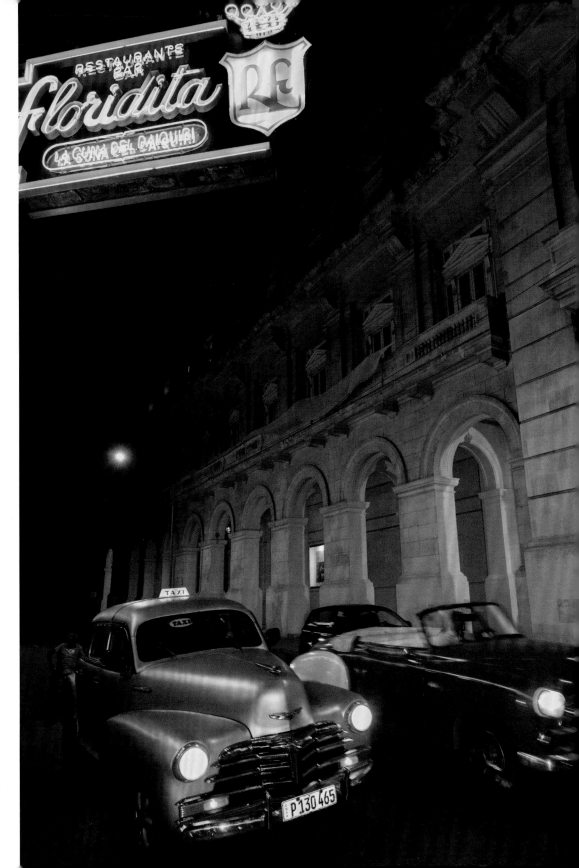

Chevrolet 1948/
Chevrolet 1952, Avenida
Bélgica, La Habana

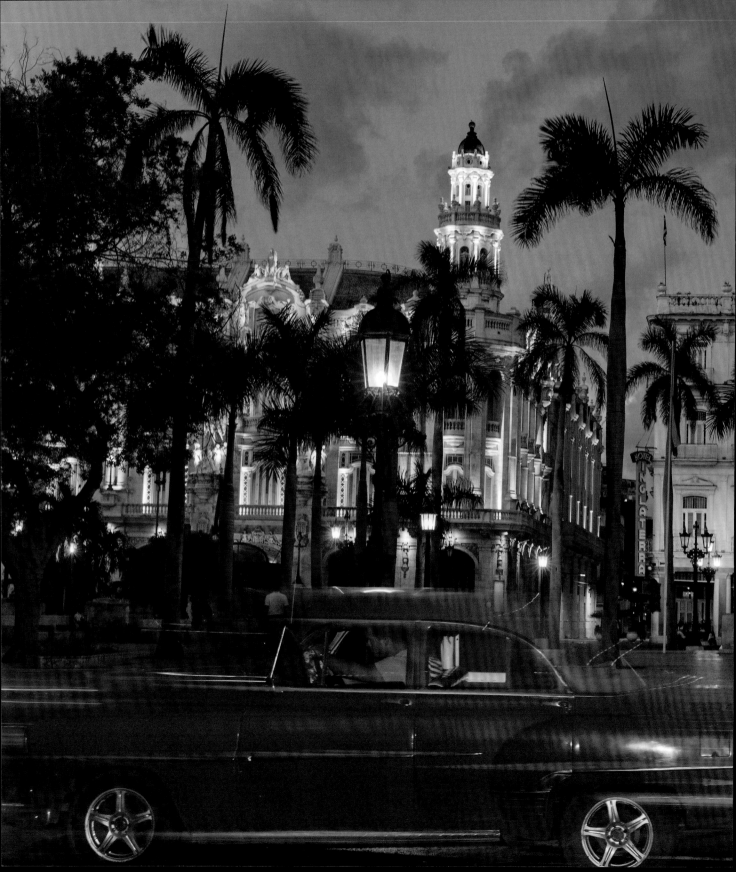

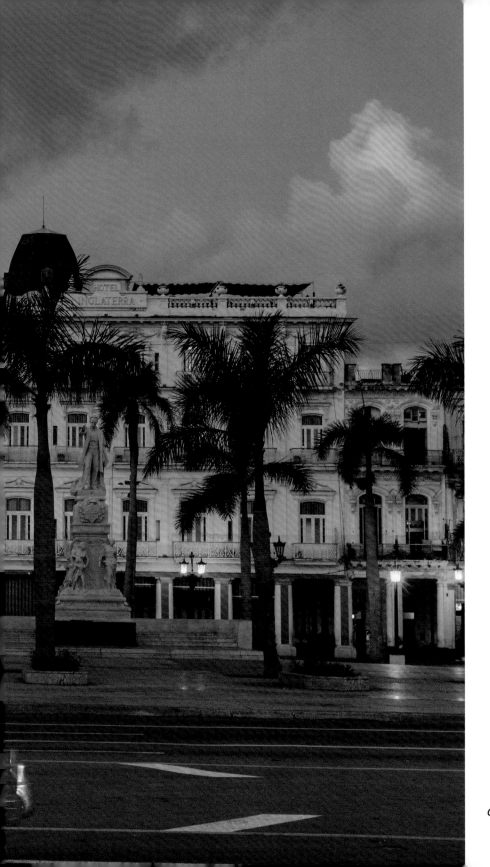

Chevrolet, 1952, Parque Central, La Habana

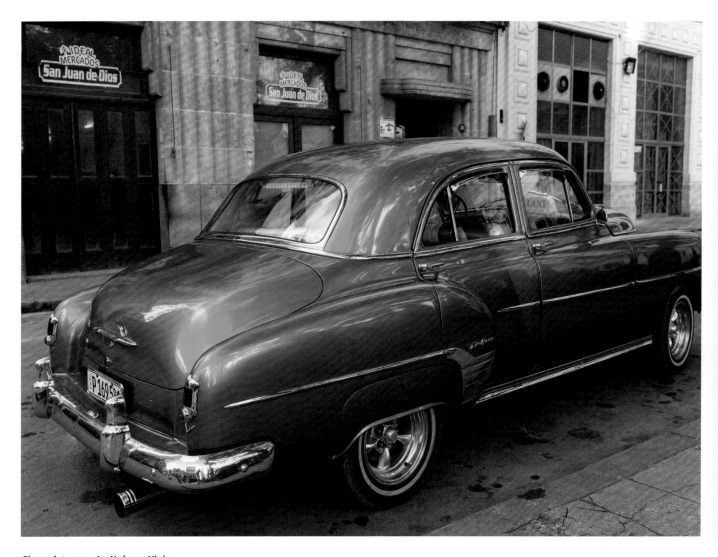

Chevrolet, 1952, La Habana Vieja

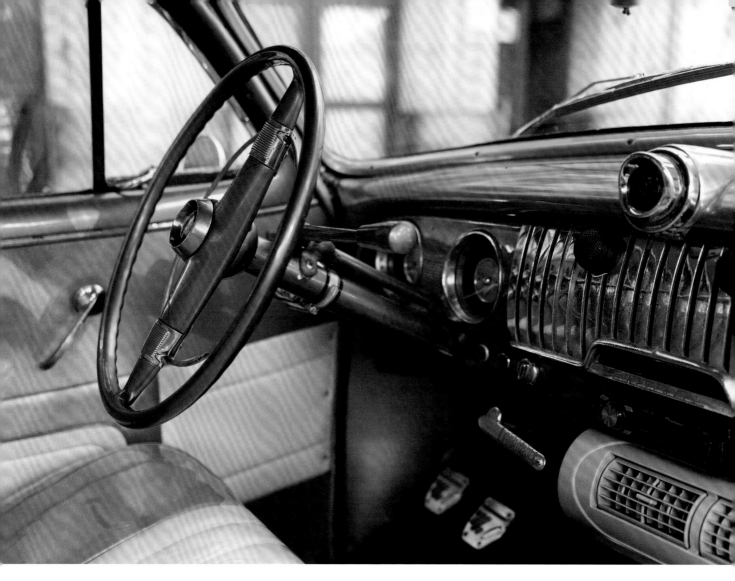

Chevrolet, 1952, La Habana Vieja

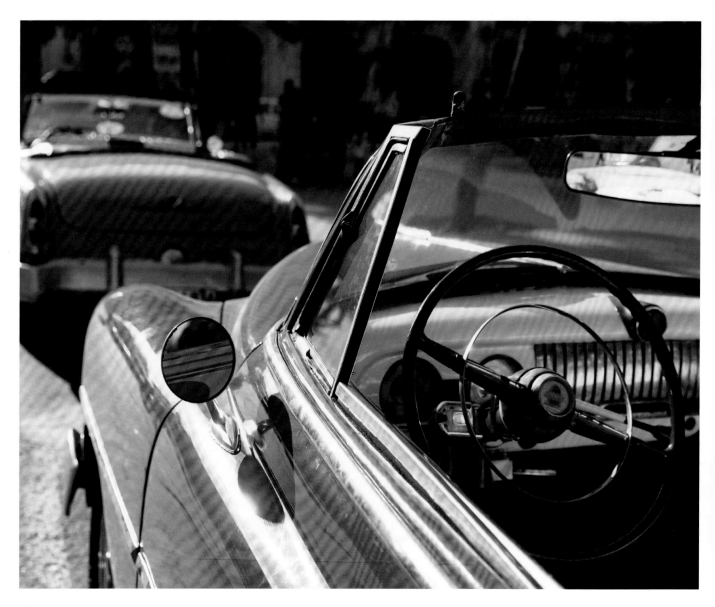

Chevrolet, 1950, La Habana Vieja

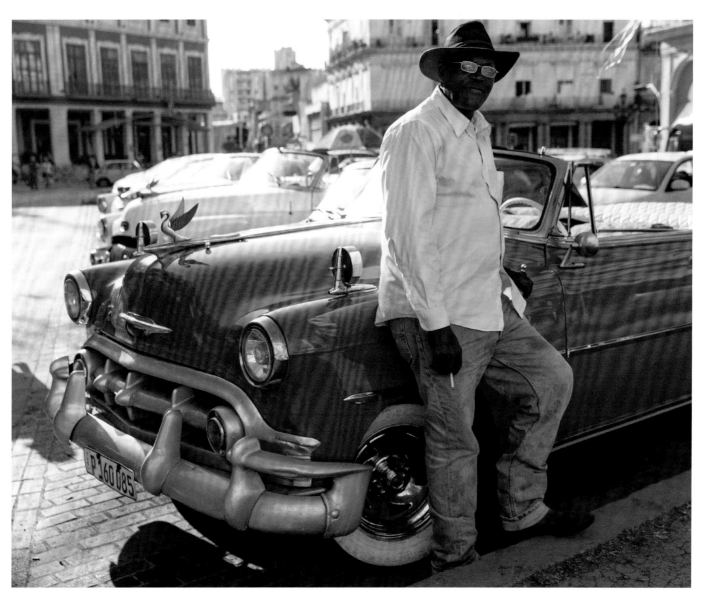

Chevrolet, 1953, La Habana Vieja

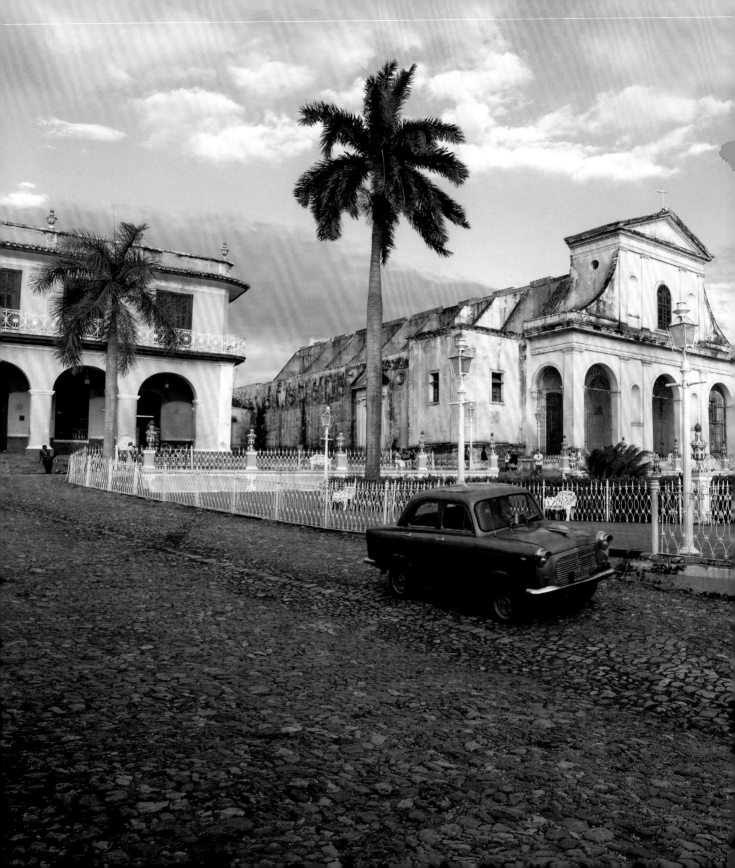

Plaza Mayor, Trinidad

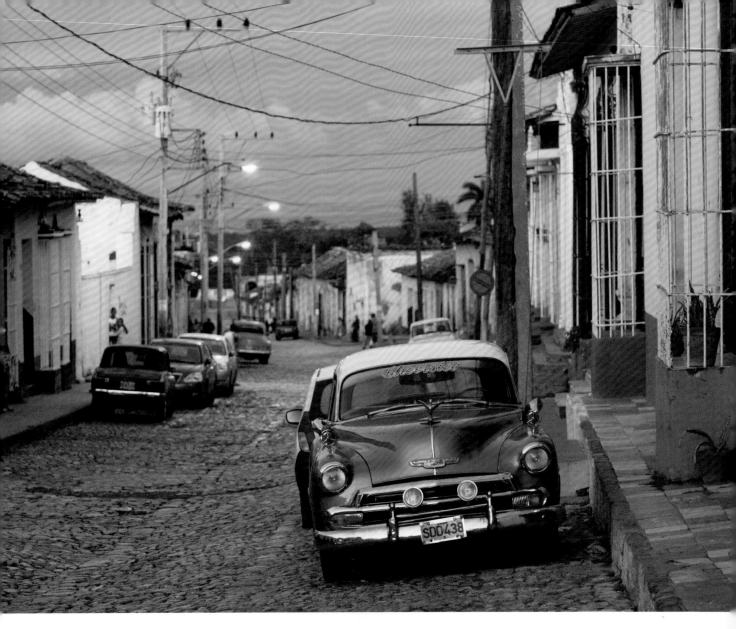

Chevrolet, 1952, Trinidad

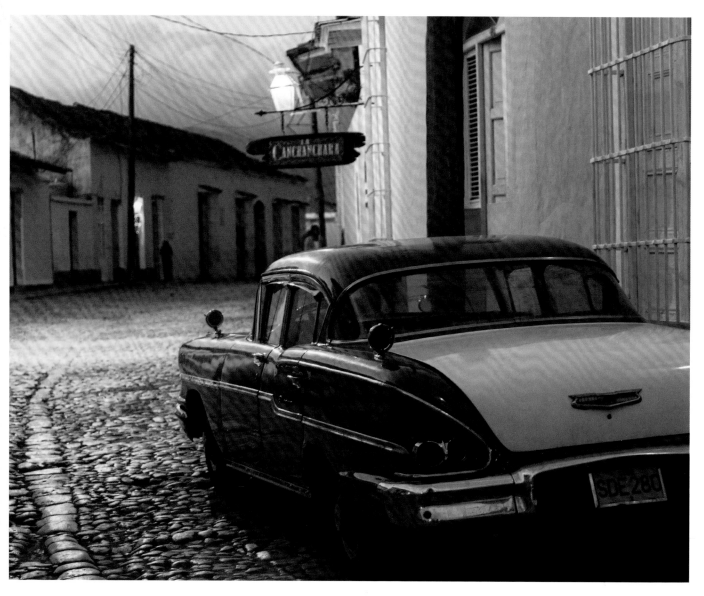

Chevrolet, 1958, Trinidad

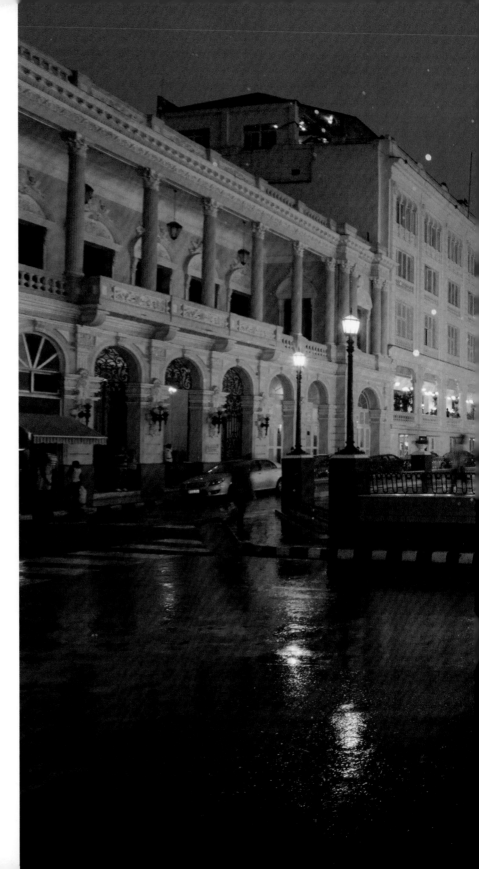

*Dodge, 1957, Parque Céspedes,
Santiago de Cuba*

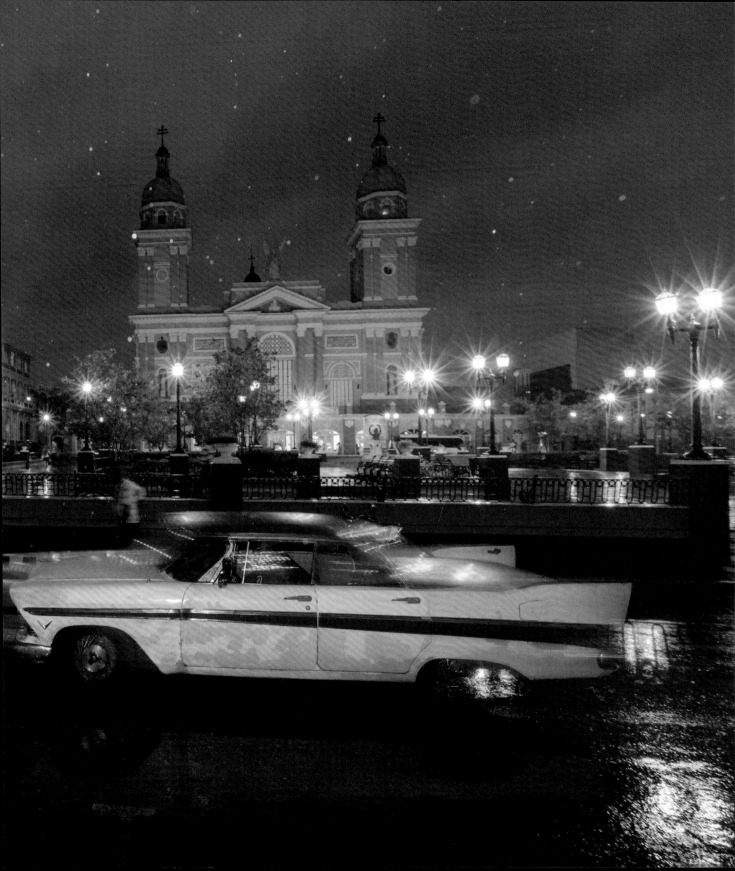

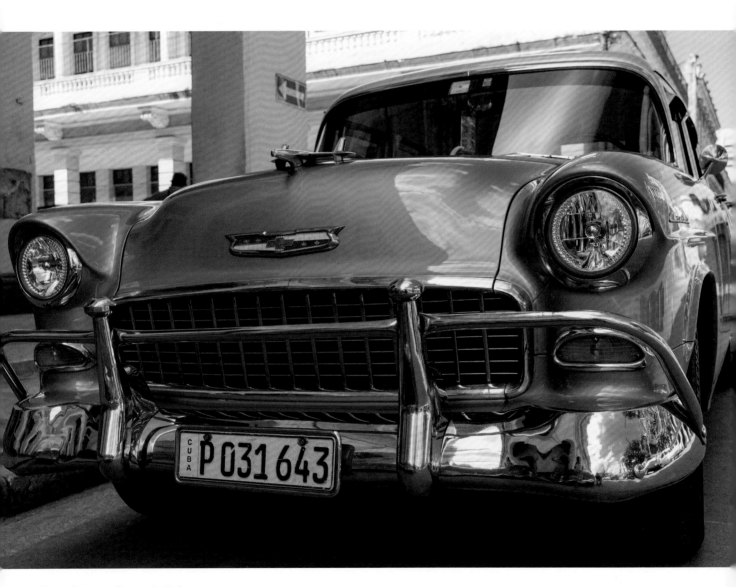

Chevrolet, 1955, Centro, La Habana

Chevrolet, 1956, Centro, La Habana

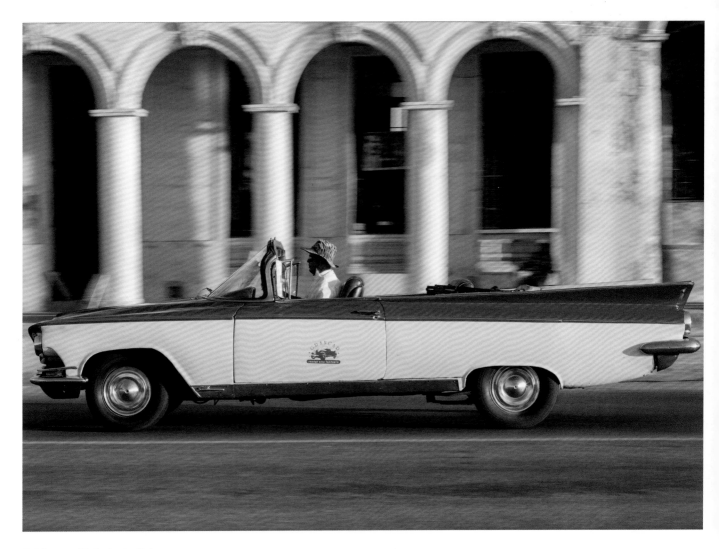

Buick, 1959, Malecón, La Habana

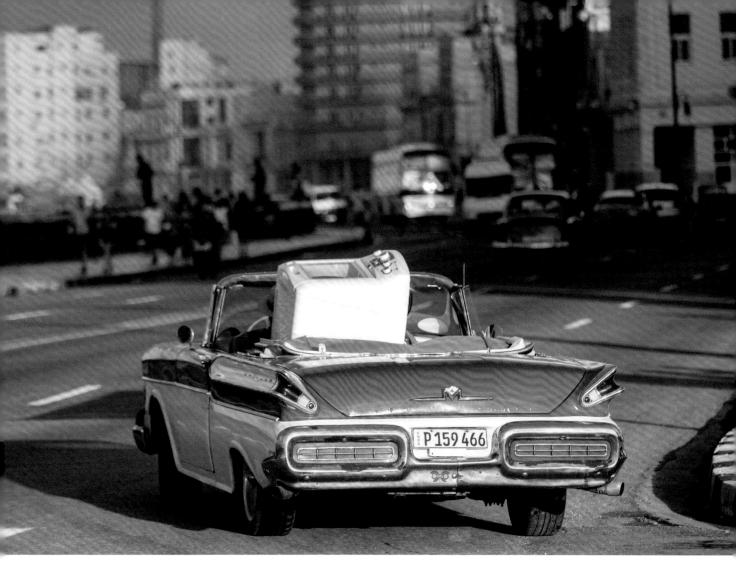

Mercury, 1957, Malecón, La Habana

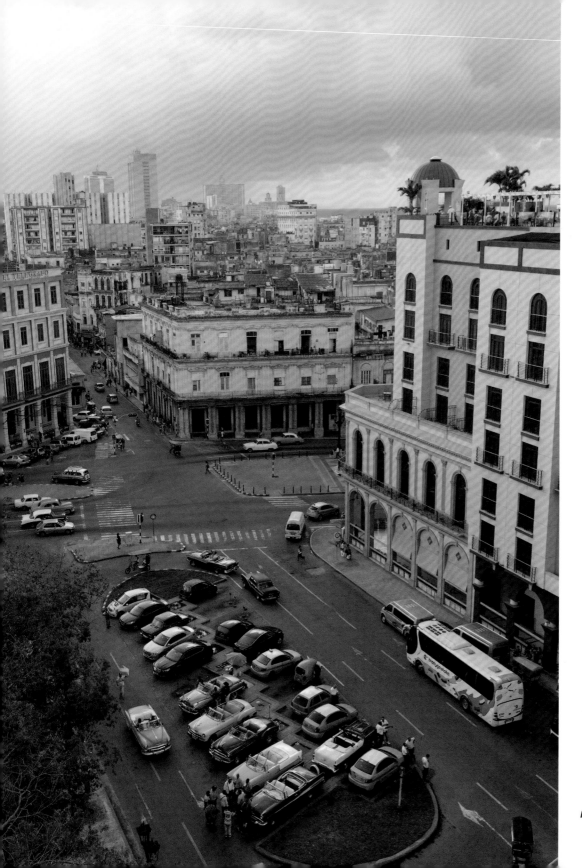

Parque Central, La Habana

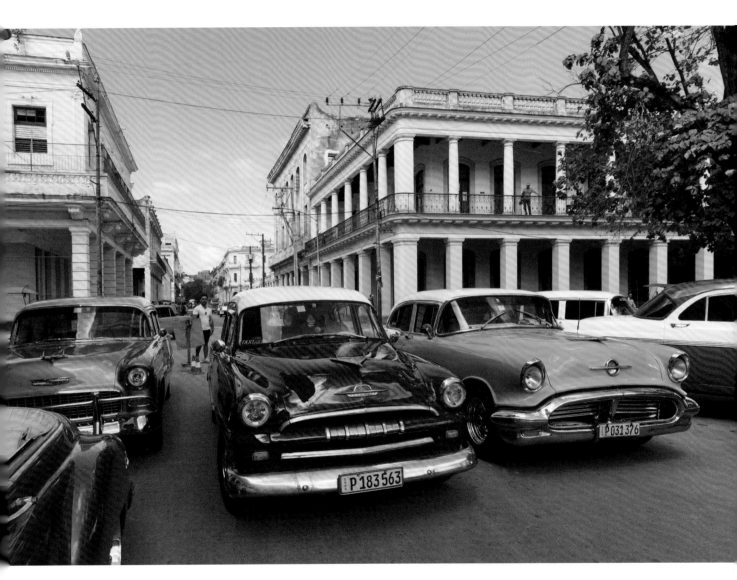

Dodge 1954/Oldsmobile 1957, Centro, La Habana

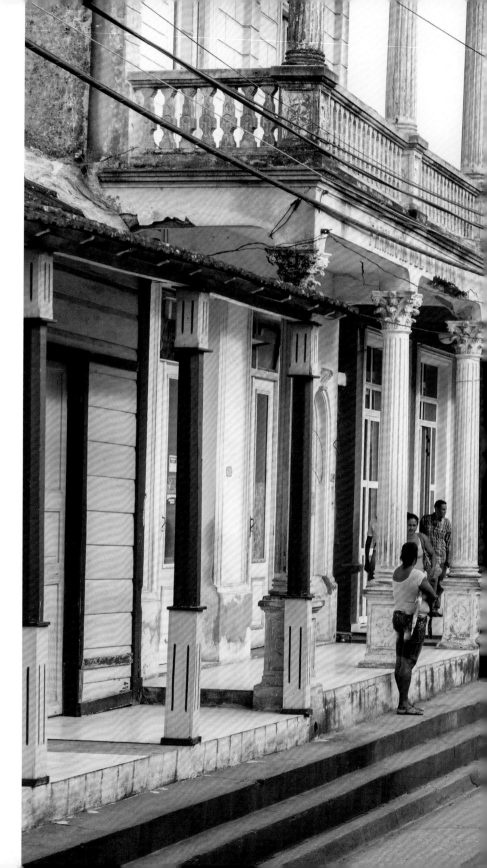

Chevrolet, 1948, Baracoa,
Provincia de Guantánamo

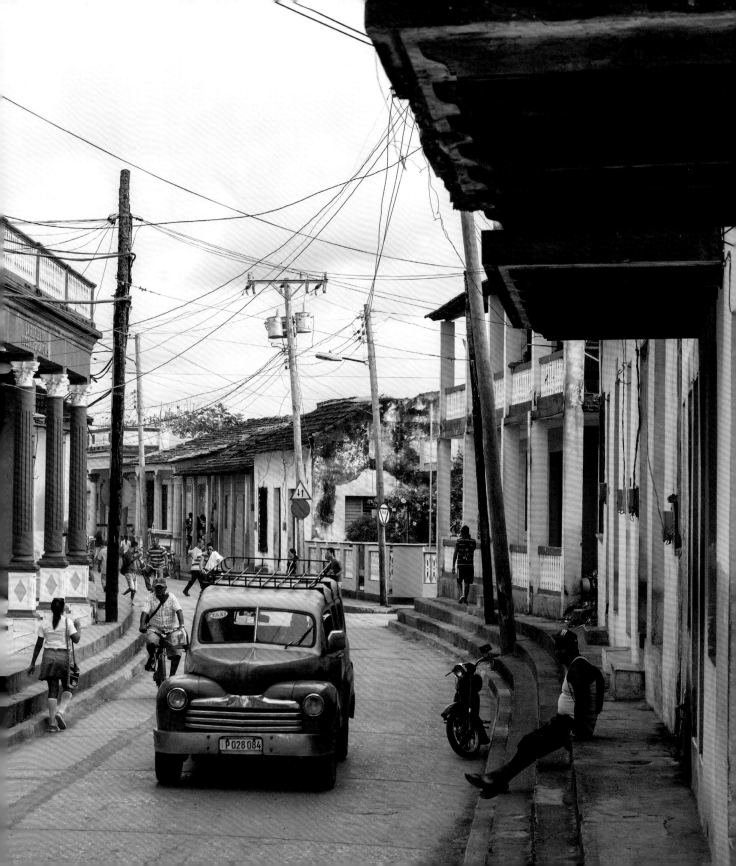

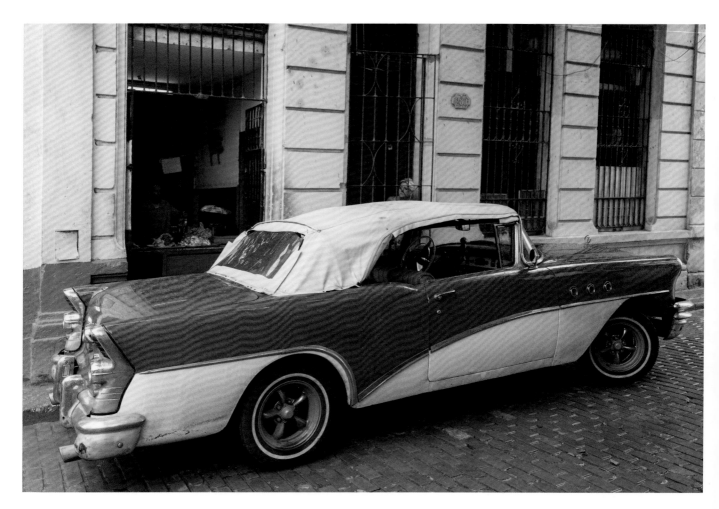

Buick, 1955, La Habana Vieja

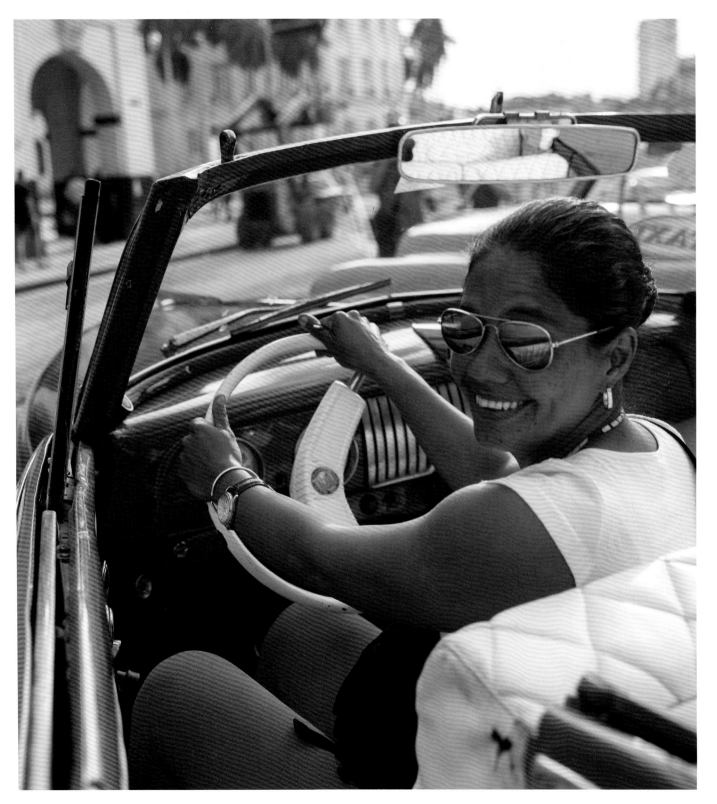

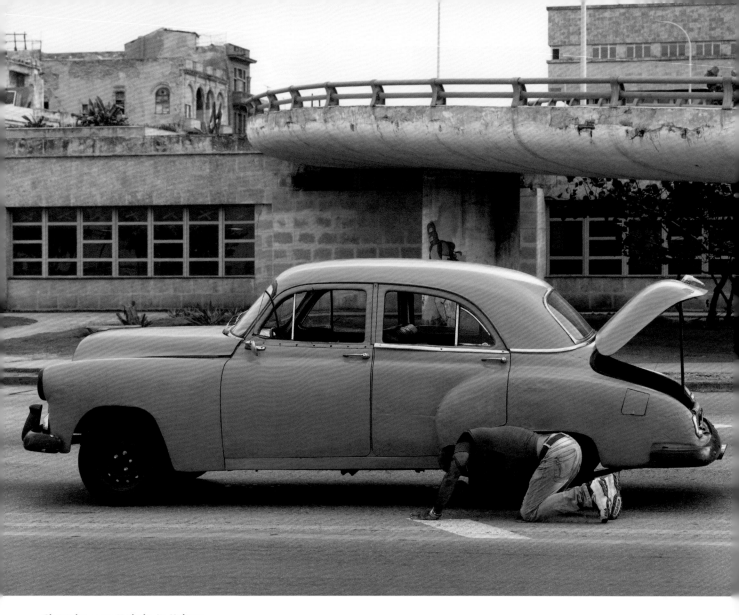

Chevrolet, 1951, Vedado, La Habana

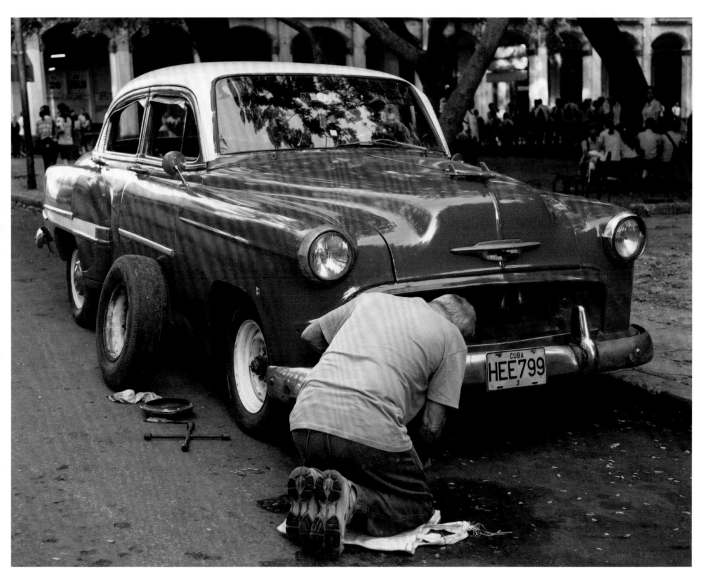

Chevrolet, 1953, La Habana Vieja

*Ford Fairlane, 1956, Palacio de
los Matrimonios, La Habana*

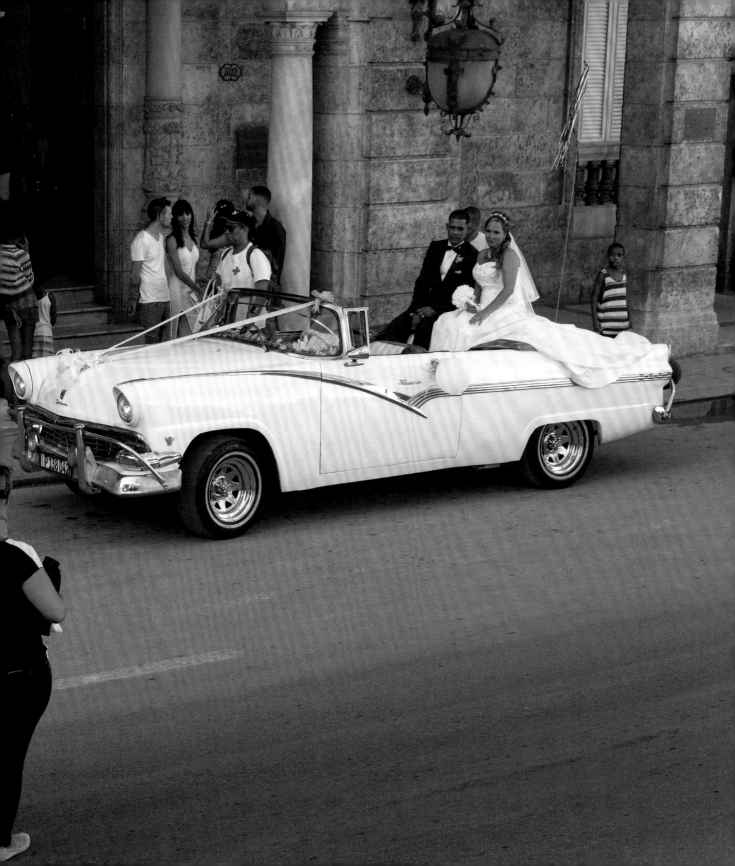

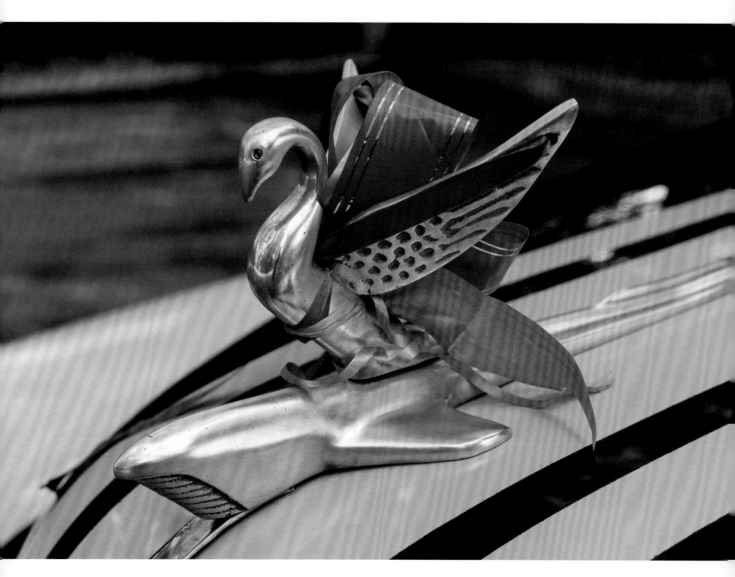

Mascota del radiador, La Habana

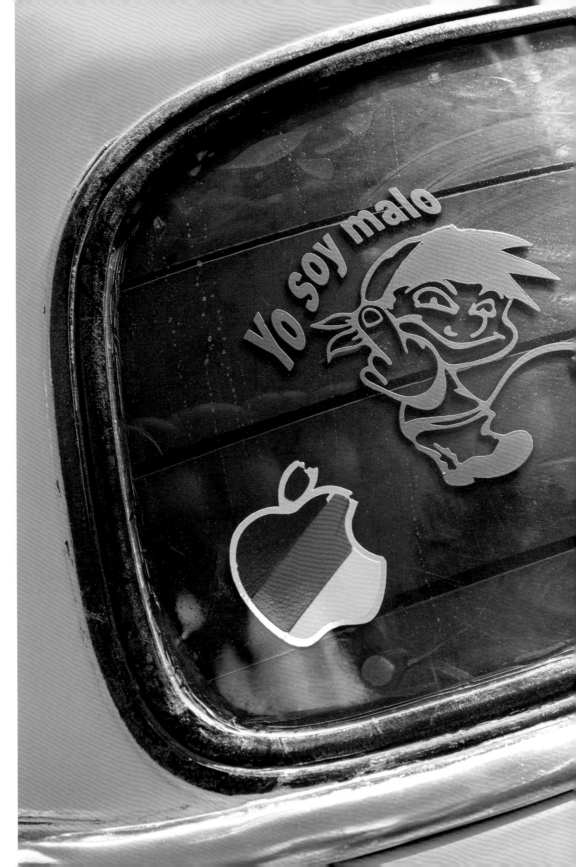

Pegatina, La Habana

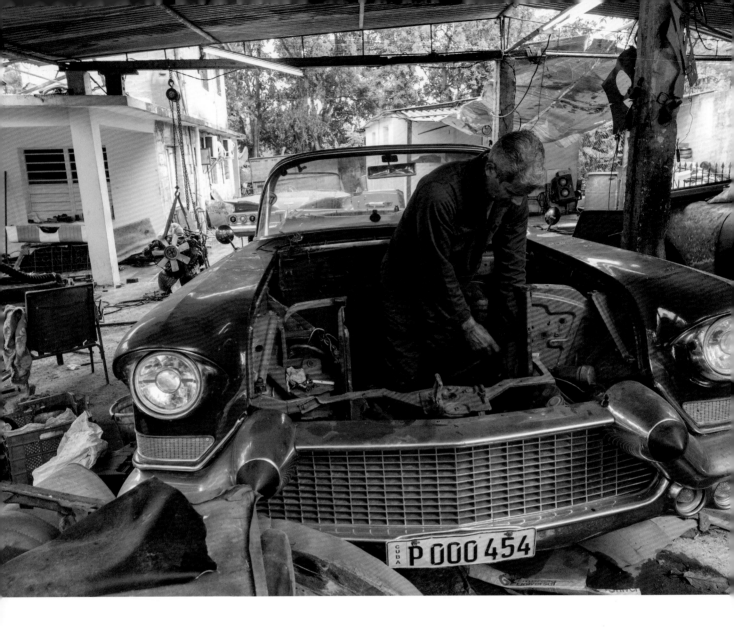

Cuban car mechanics are the best in the world, because they must develop magical skills to keep their cars alive. They work with what's at hand—maybe a Soviet tractor engine (or parts from one), maybe a refrigerator engine or spare parts from an old boat, or they build or weld the spare parts themselves.

Les mécanos cubains sont les meilleurs du monde, car pour maintenir ces voitures en état de marche ils doivent développer des talents dignes d'un magicien. Ils travaillent avec ce qu'ils ont sous la main : cela peut être tantôt un moteur de tracteur soviétique, tantôt un moteur de frigo, ou bien encore les pièces de rechange d'un vieux bateau… à moins qu'ils ne fabriquent et soudent tout simplement eux-mêmes les pièces dont ils ont besoin.

Die kubanischen Automechaniker sind die besten der Welt, denn sie müssen geradezu magische Fähigkeiten entwickeln, um ihre Autos am Leben zu erhalten. Dabei arbeiten sie mit dem, was gerade zur Hand ist – vielleicht ein sowjetischer Traktormotor (oder Teile davon), vielleicht ein Kühlschrankmotor oder Ersatzteile aus einem alten Boot, oder man baut oder schweißt sich die Ersatzteile selbst.

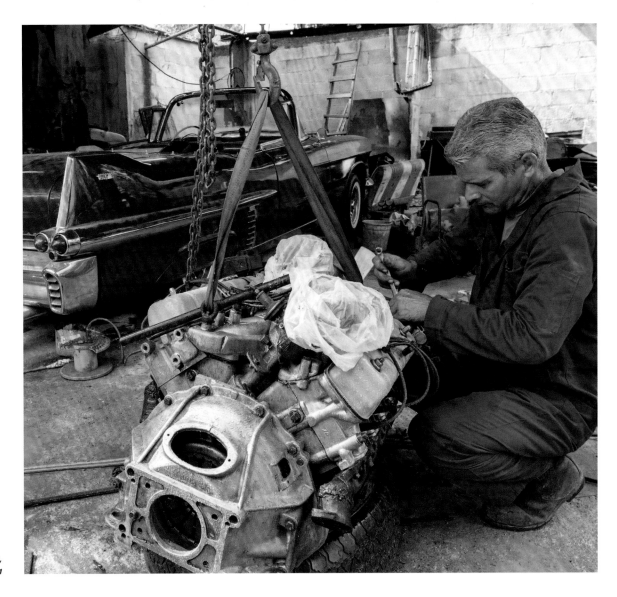

Cadillac, 1957,
La Habana

Cadillac, 1957,
La Habana

Los mecánicos de coches cubanos son los mejores del mundo, porque tienen que desarrollar habilidades mágicas para mantener vivos sus coches. Trabajan con lo que tienen a mano en cada momento: tal vez un motor de un tractor soviético (o partes de él), tal vez un motor de un refrigerador o piezas de repuesto de un barco viejo, o ellos mismos construyen o sueldan las piezas de repuesto.

Os mecânicos cubanos são os melhores do mundo, pois têm que desenvolver talentos verdadeiramente mágicos para manter os seus carros vivos e em condições de condução. Trabalham com tudo aquilo que está, de momento, à mão – talvez um motor de trator soviético (ou partes dele), um motor de frigorífico, peças sobresselentes de um barco velho, ou constroem ou soldam as peças sobresselentes.

Cubaanse automonteurs zijn de beste ter wereld, omdat ze magische vaardigheden moeten ontwikkelen om hun auto's in leven te houden. Ze werken met wat er voorhanden is – een motor (of onderdelen daarvan) uit een Sovjet-tractor, een koelkastmotor of onderdelen uit een oude boot – of ze maken de onderdelen zelf.

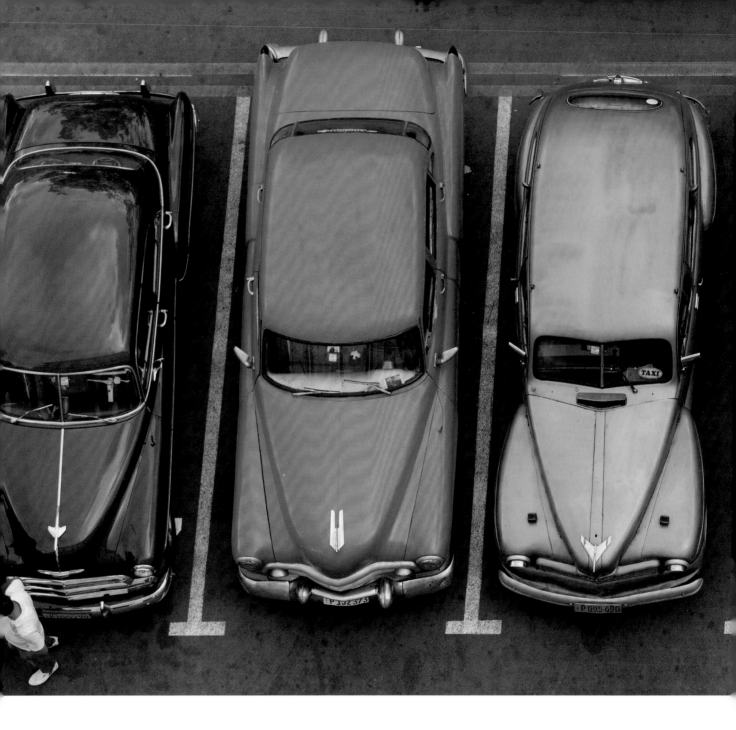

Turning a wrecked vintage car into a pastel-colored icon, such as those waiting here for tourists at Parque Central in Havana, costs between 6000 and 10000 Euros and often takes half a year to a whole year.

Pour transformer une vieille épave en un carrosse pastel comme ceux que l'on voit ici attendant les touristes à Parque Central, à La Havane, il faut compter entre 6 000 et 10 000 euros et en général six mois à un an.

Ein Oldtimer-Wrack in eine pastellfarbene Ikone zu verwandeln, wie sie hier am Parque Central in Havanna auf Touristen warten, kostet zwischen 6000 und 10000 Euro und dauert häufig ein halbes bis ein ganzes Jahr.

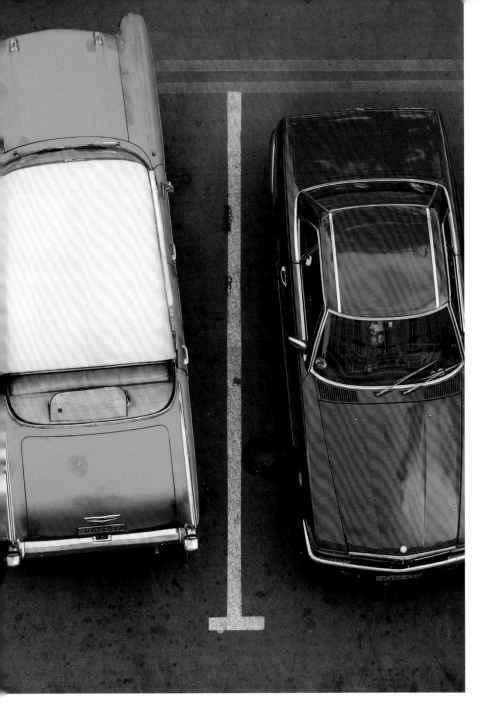

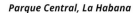

Convertir un coche antiguo destrozado en un icono de color pastel, como los que esperan a los turistas aquí, en el Parque Central de La Habana, cuesta entre 6000 y 10 000 euros y a menudo lleva de medio año a un año entero.

Transformar os destroços de um carro antigo num ícone de cor pastel, enquanto esperam pelos turistas aqui no Parque Central em Havana, custa entre 6000 e 10.000 euros e muitas vezes demora meio ano a um ano inteiro.

Een oldtimerwrak veranderen in een pastelkleurig icoon, zoals dat hier in het Parque Central in Havana op toeristen wacht, kost tussen de 6000 en 10.000 euro en vergt vaak een halfjaar tot een jaar werk.

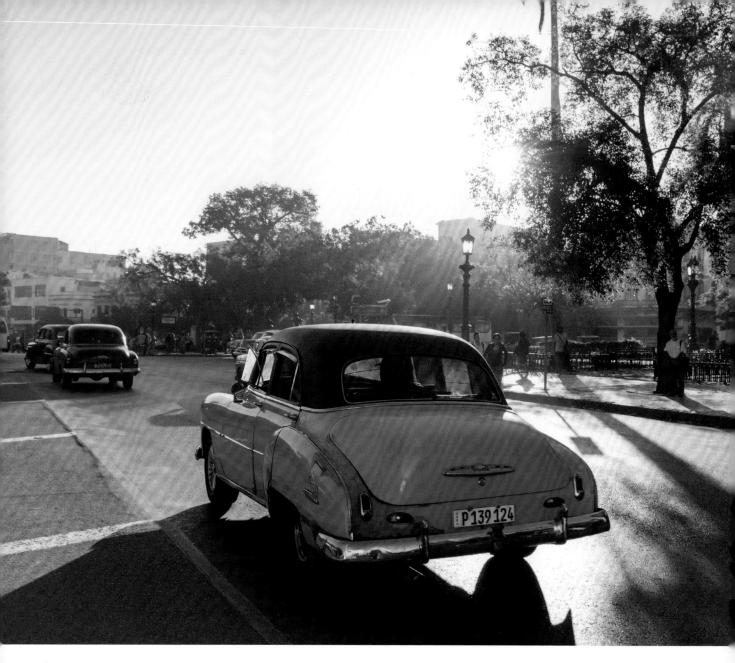

Chevrolet, 1949, Avenida Dragones, La Habana

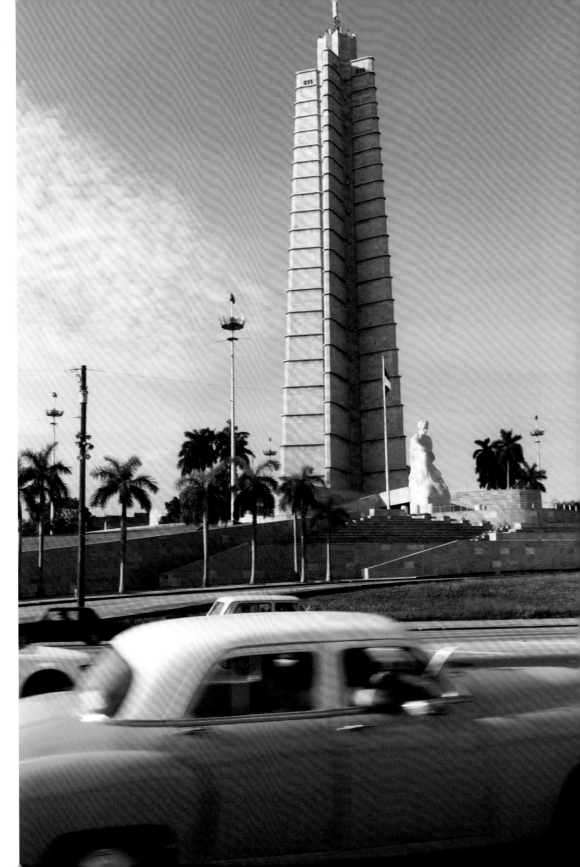

Plaza de la Revolución,
La Habana

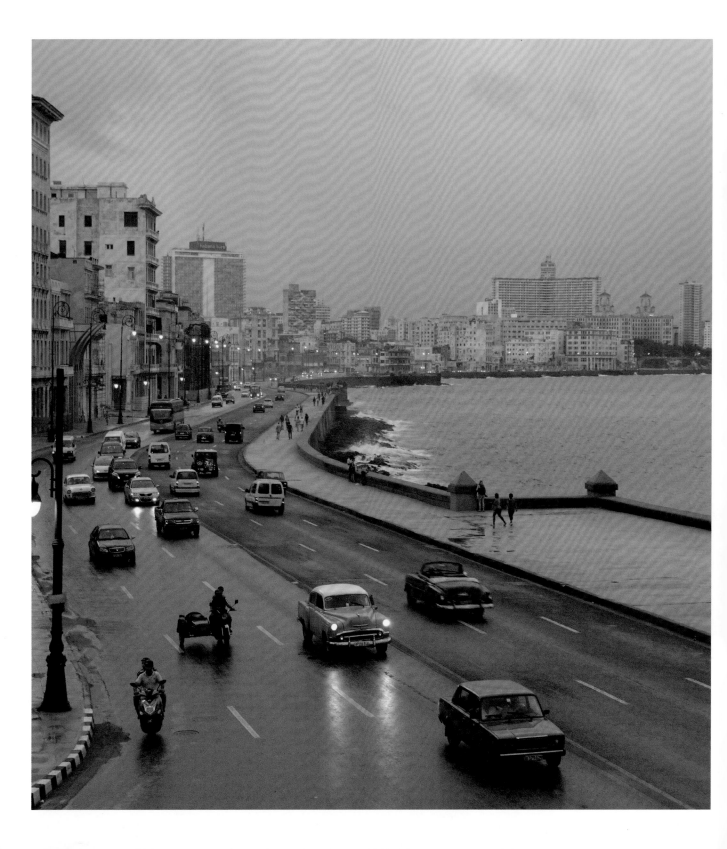

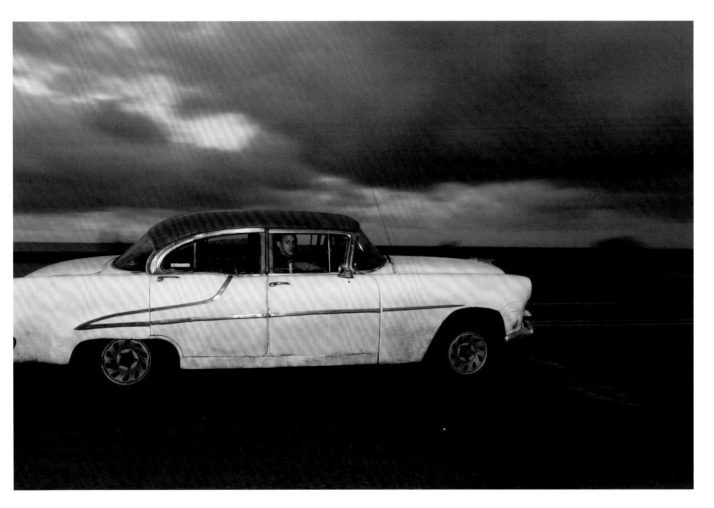

Oldsmobile, 1953, Malecón, La Habana

Malecón,La Habana

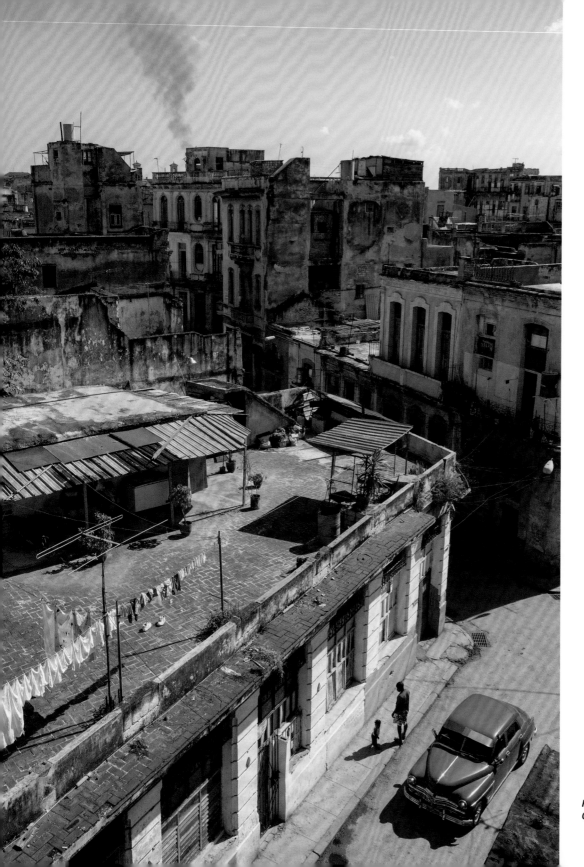

Plymouth, 1950,
Centro, La Habana

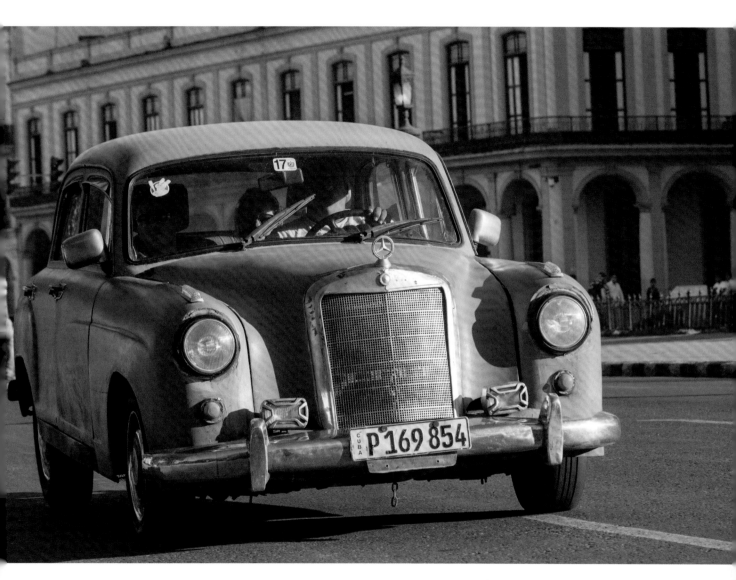

Mercedes Benz 180, 1959, Paseo de Martí, La Habana

Chevrolet, 1952, Avenida del Puerto, La Habana Vieja

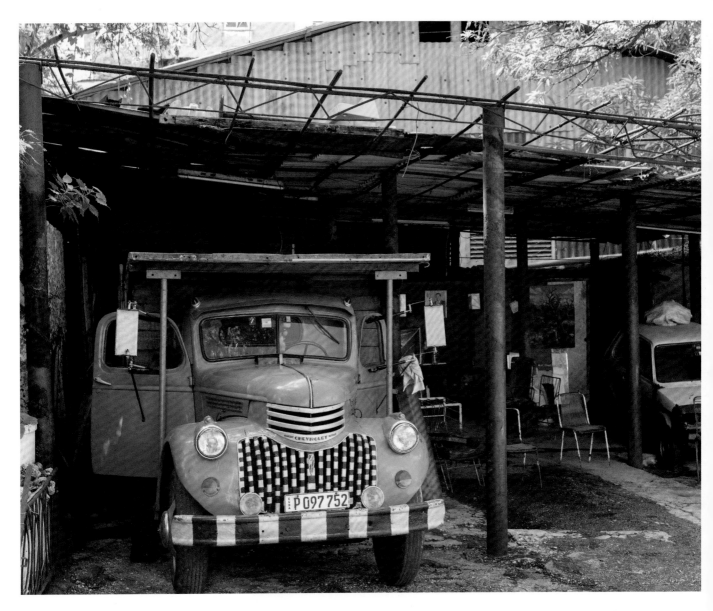

Chevrolet, 1947, Vedado, La Habana

Chevrolet Impala, 1959, La Habana Vieja

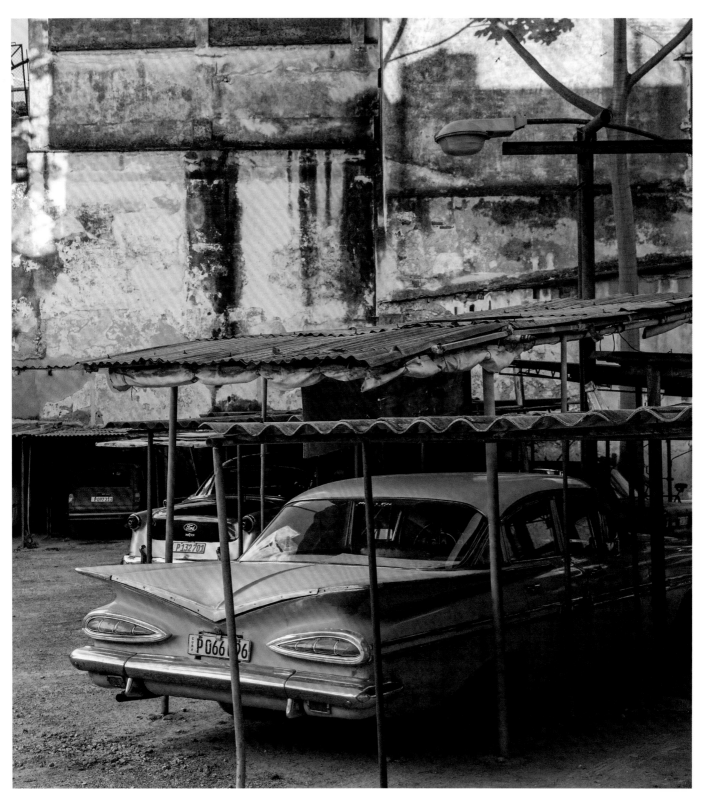

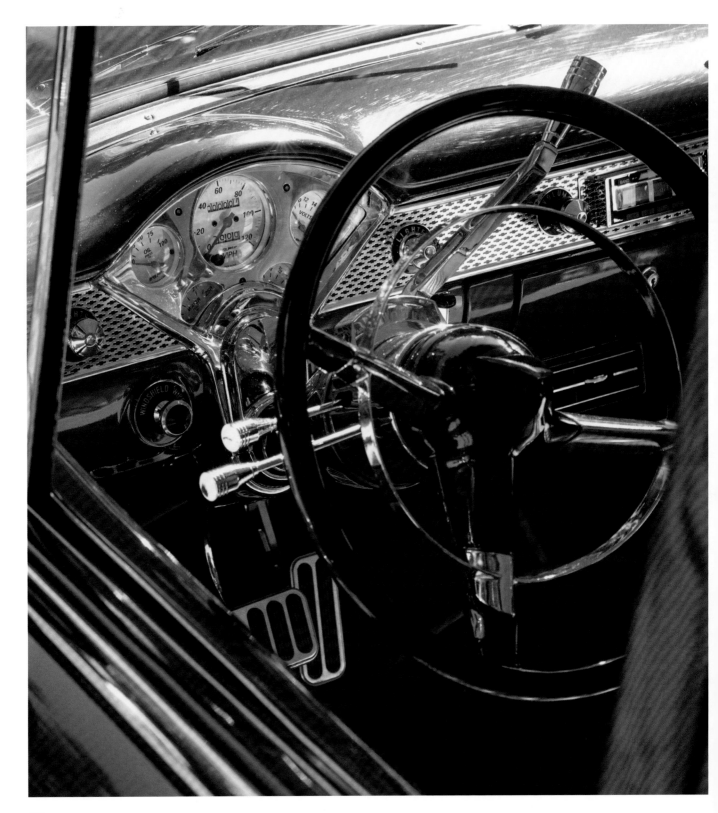

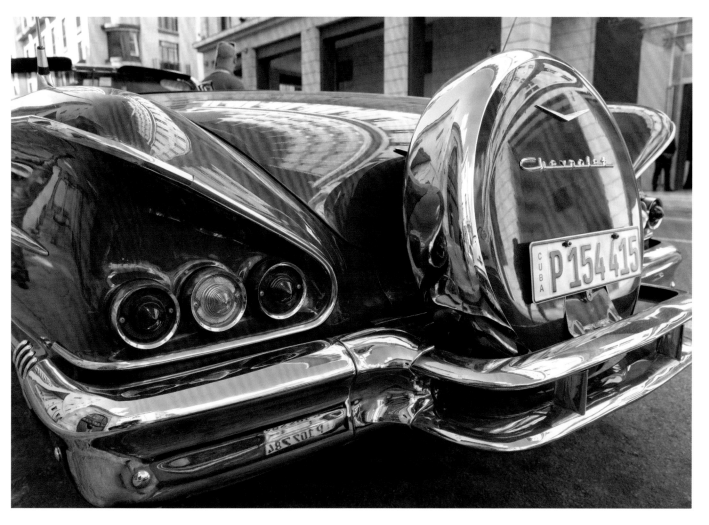

Chevrolet, 1959, Agramonte, La Habana

Chevrolet, 1956, La Habana

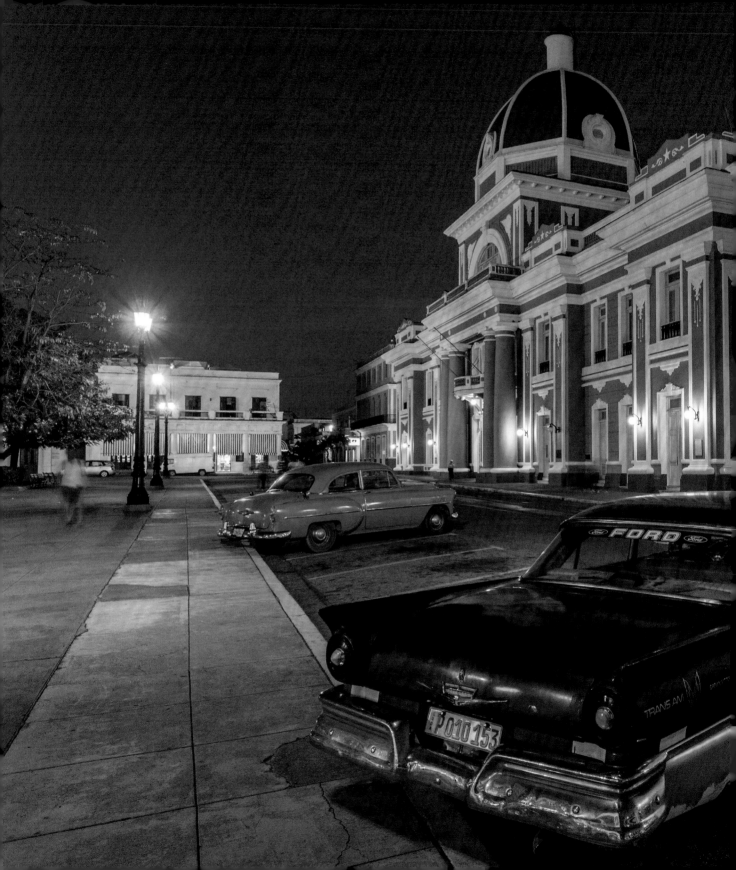

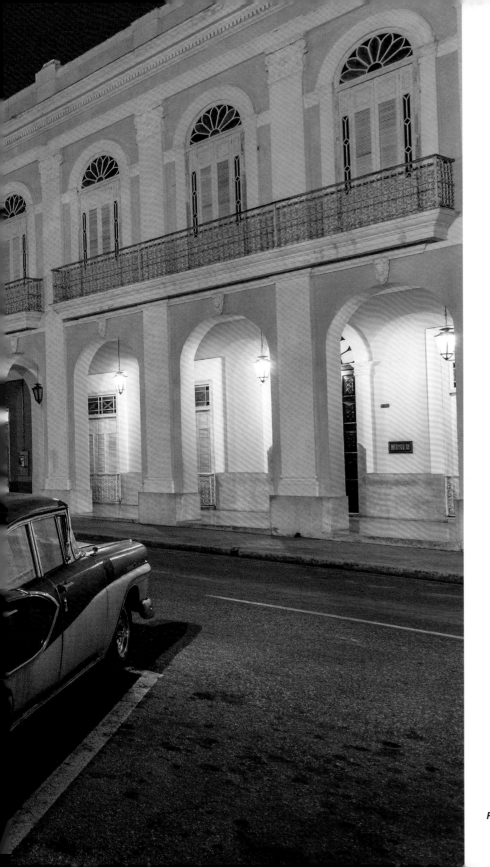

Ford, 1956, Cienfuegos

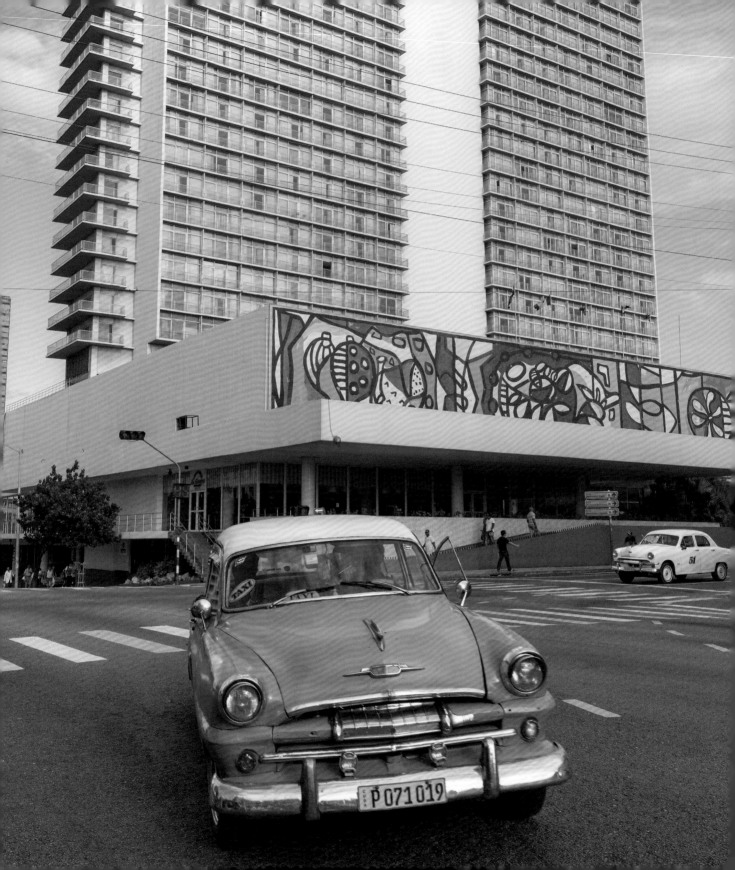

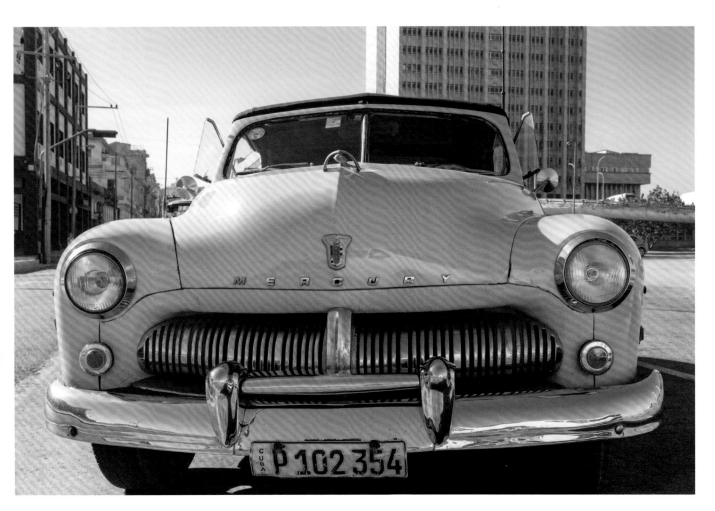

Mercury, 1950, Vedado, La Habana

Plymouth, 1954, Vedado, La Habana

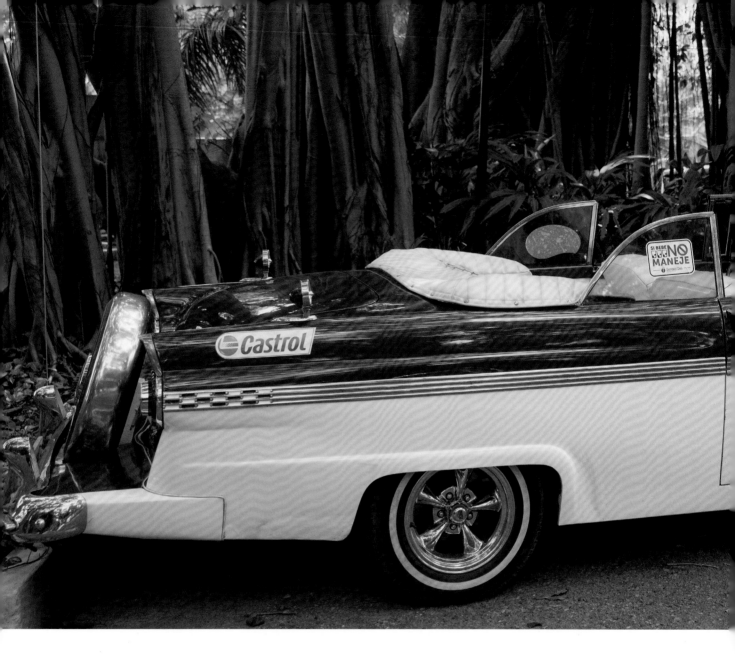

Whoever can call such a convertible his own has the best ticket in the classic car parade, because Cuban passengers love to be driven in convertibles. However, the owners must also pay astronomically high taxes for their pastel-colored cream slice when they chauffeur tourists with it.

Quand on est l'heureux détenteur d'un cabriolet comme celui-ci, on a une carte maîtresse en poche, car les touristes visitant Cuba adorent se faire conduire en décapotable. Les propriétaires doivent toutefois s'acquitter de taxes colossales pour avoir le droit de balader des touristes à bord de leur joyau aux tons pastel.

Wer ein solches Cabrio sein Eigen nennen kann, hat die beste Karte im Oldtimer-Defilee, denn Kuba-Reisende lieben es, sich in Cabrios spazieren fahren zu lassen. Allerdings müssen die Besitzer für ihre pastellfarbenen Sahneschnittchen auch astronomisch hohe Steuern zahlen, wenn sie damit Touristen chauffieren.

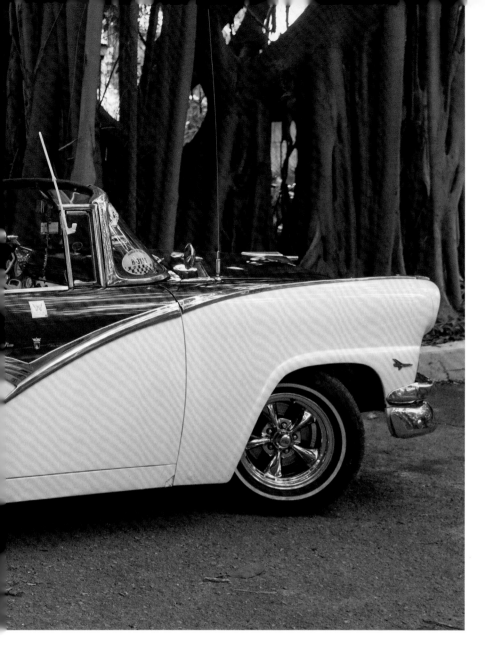

Ford Sunliner, 1956, Miramar, La Habana

Los que pueden presumir de tener descapotable de este tipo, tiene el mejor pase para el desfile de coches clásicos, porque a los viajeros cubanos les encanta que les lleven en descapotables. Sin embargo, los propietarios también tienen que pagar impuestos exageradamente altos por su trozo de crema de color pastel cuando transportan a los turistas con él.

Quem puder considerar seu um destes descapotáveis, terá as melhores condições no Oldtimer Defilee, pois tanto os cubanos como os viajantes a Cuba adoram ser conduzidos em descapotáveis. No entanto, ao transportarem turistas, os proprietários passam a ter também de pagar impostos, astronomicamente elevados, pela suas maravilhosas „carroçarias" de cor pastel.

Wie zo'n cabriolet de zijne kan noemen, heeft de beste kaarten in het oldtimer-defilé, want bezoekers van Cuba laten zich graag rondrijden in cabrio's. De bezitters moeten echter ook astronomisch hoge belastingen betalen voor hun pastelkleurige slagroomtaarten als ze er toeristen in vervoeren.

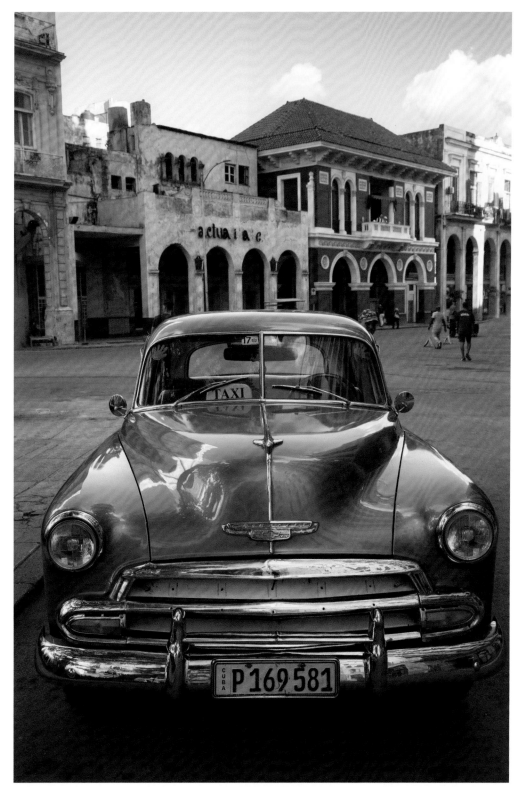

Chevrolet, 1957, La Habana

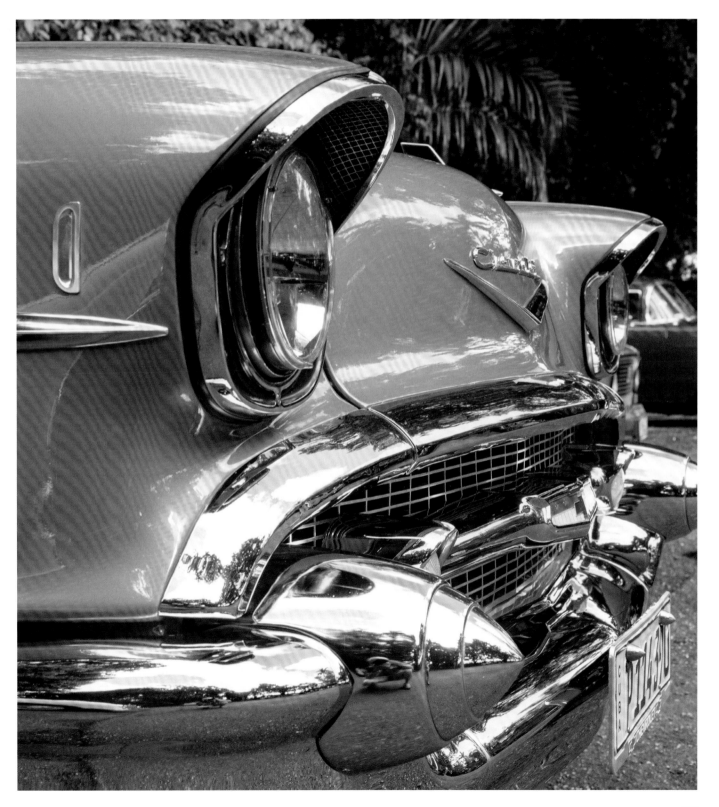

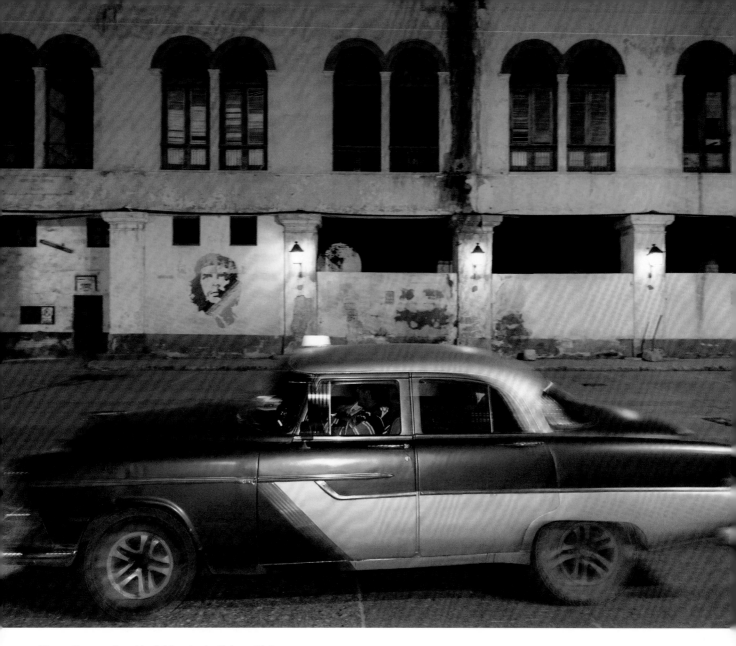

Plymouth, 1955, Avenida del Puerto, La Habana Vieja

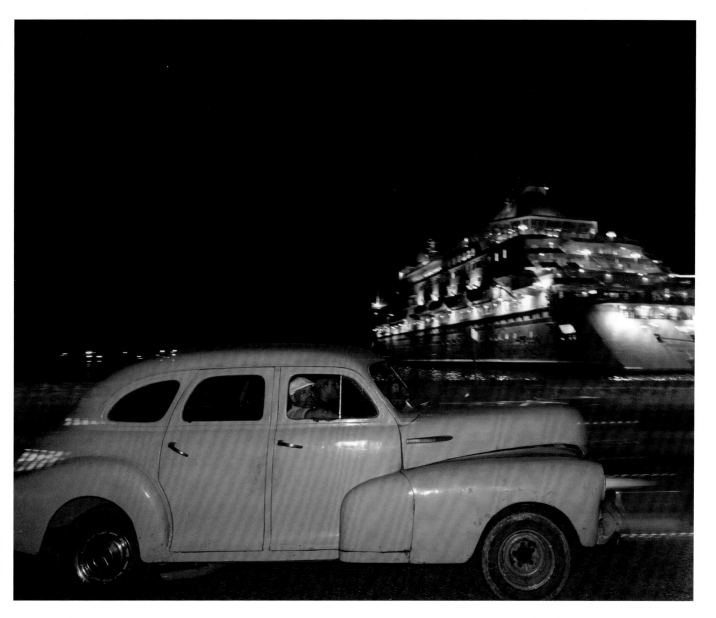

Chevrolet, 1948, Malecón, La Habana

Paseo del Prado, La Habana

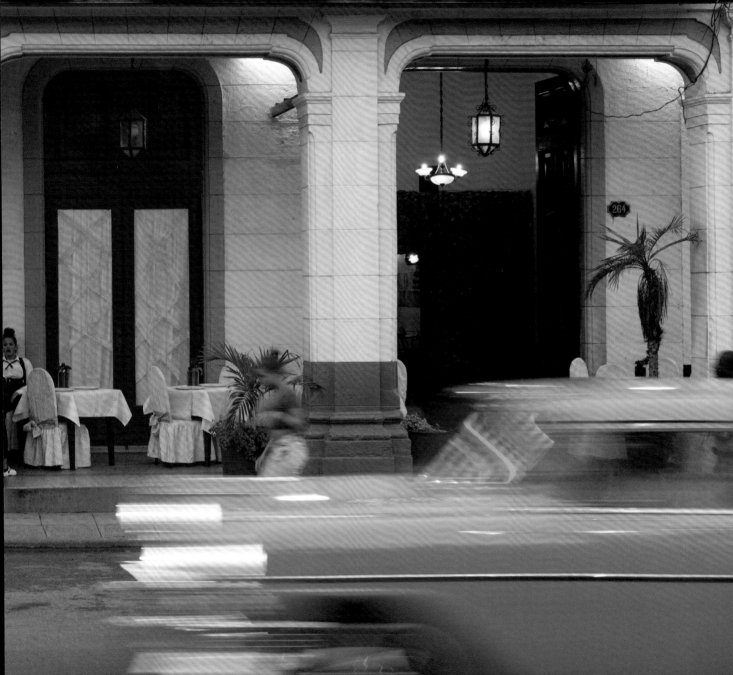

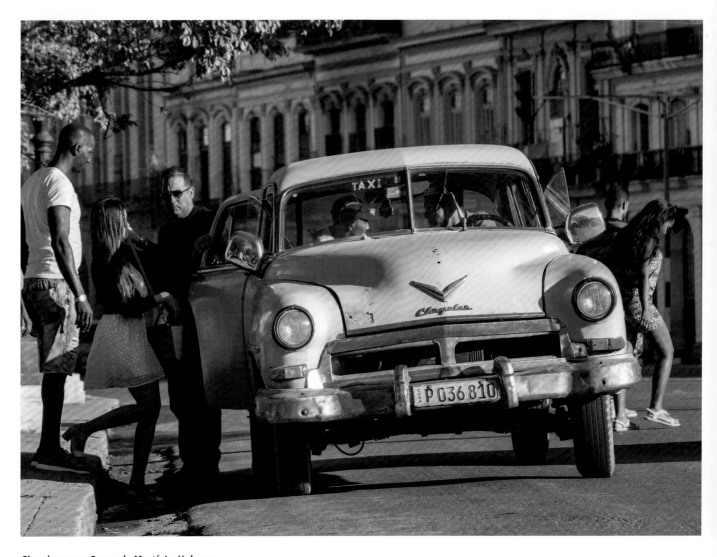

Chrysler, 1949, Paseo de Martí, La Habana

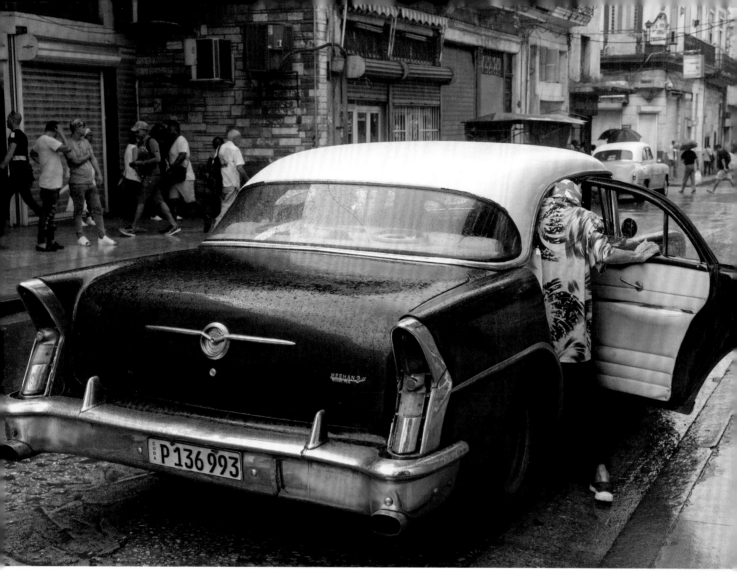

Oldsmobile, Centro, La Habana

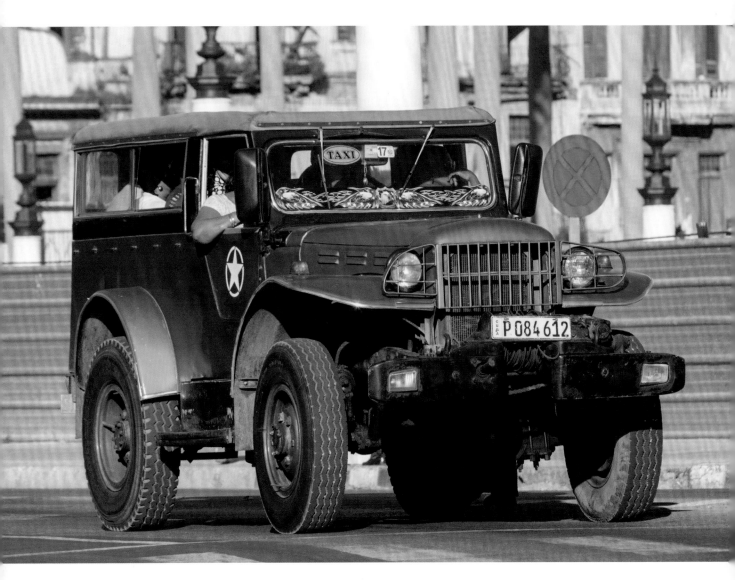

Colectivo, Paseo de Martí, La Habana

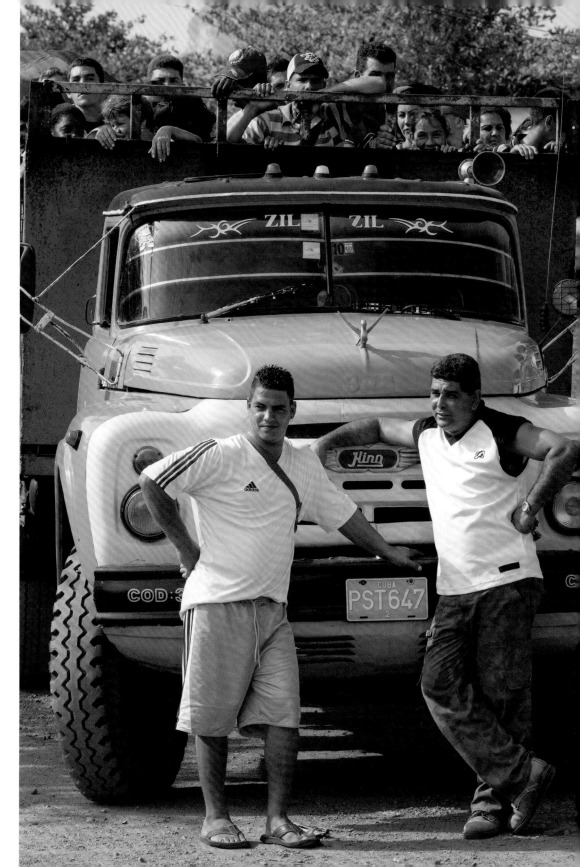

*Camión ruso Zil 130,
1975, Soroa*

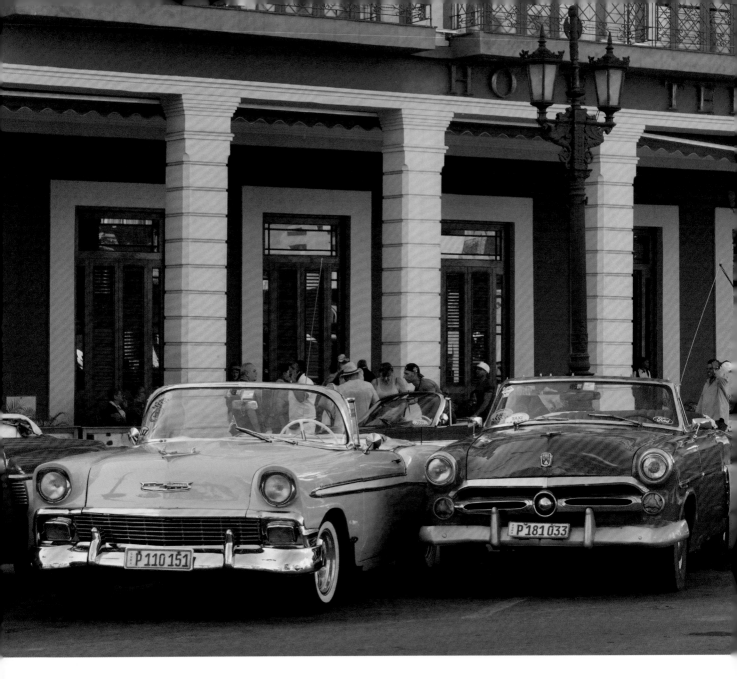

In Cuba, the vintage cars are called either máquina or almendrones ("big almonds", derived from almendra, almond), perhaps because the shape of these 50s sledges is reminiscent of a gigantic almond. At Havana's most sought-after taxi rank, Parque Central, you will find extremely elegant specimens of its type.

À Cuba, les Oldtimers sont surnommées *máquinas* ou *almendrones*, littéralement « grosses amandes » (du mot *almendra*, amande), peut-être parce que la forme des bagnoles des années 1950 rappelle celle d'une énorme amande. À la station de taxis la plus prisée de La Havane, Parque Central, on trouve des spécimens particulièrement élégants.

In Kuba heißen die Oldtimer entweder máquina oder almendrones, „Große Mandeln", abgeleitet von almendra, Mandel – vielleicht, weil die Form der 50er-Jahre-Schlitten an eine gigantische Mandel erinnert. Am begehrtesten Taxistand Havannas, am Parque Central, findet man äußerst elegante Exemplare ihrer Gattung.

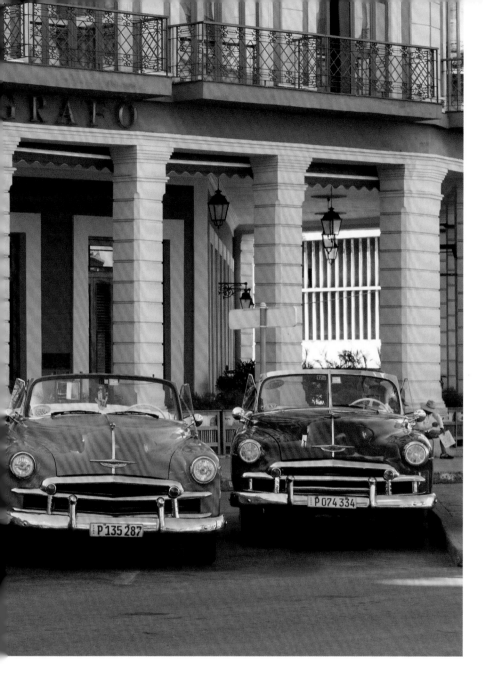

En Cuba, a los veteranos se les llama *máquina* o *almendrones*, quizás porque la forma del trineo de los años 50 recuerda a una almendra gigantesca. En la parada de taxis más solicitada de La Habana, Parque Central, se pueden encontrar especímenes extremadamente elegantes de este género.

Em Cuba, os Oldtimer chamam-se máquina ou almendrones "amêndoas grandes", de almendra, amêndoa - talvez porque a forma das „carroçarias" dos anos 50 lembra uma amêndoa gigantesca. Na praça de táxis mais procurada de Havana, o Parque Central, encontram-se espécimes extremamente elegantes.

In Cuba worden de oldtimers *máquina* of almendrones genoemd, 'grote amandelen', van *almendra*, amandel – misschien omdat de vorm van de sleeën uit de jaren vijftig doet denken aan een gigantische amandel. Op de meest gewilde taxistandplaats van Havana, Parque Central, staan uiterst elegante exemplaren.

Chevrolet, 1952, Centro, La Habana

Chevrolet, 1955, La Habana

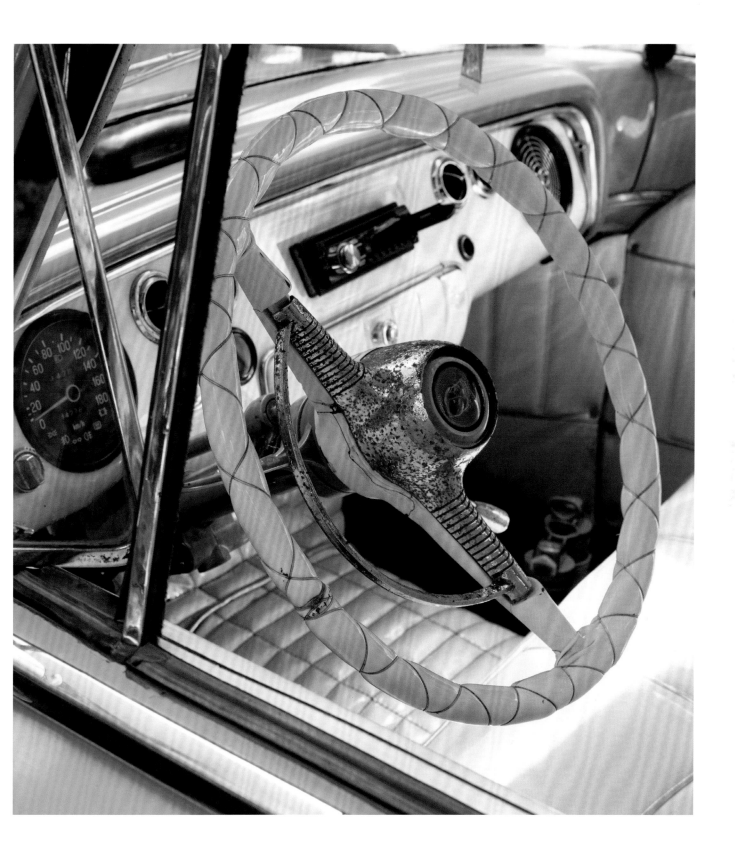

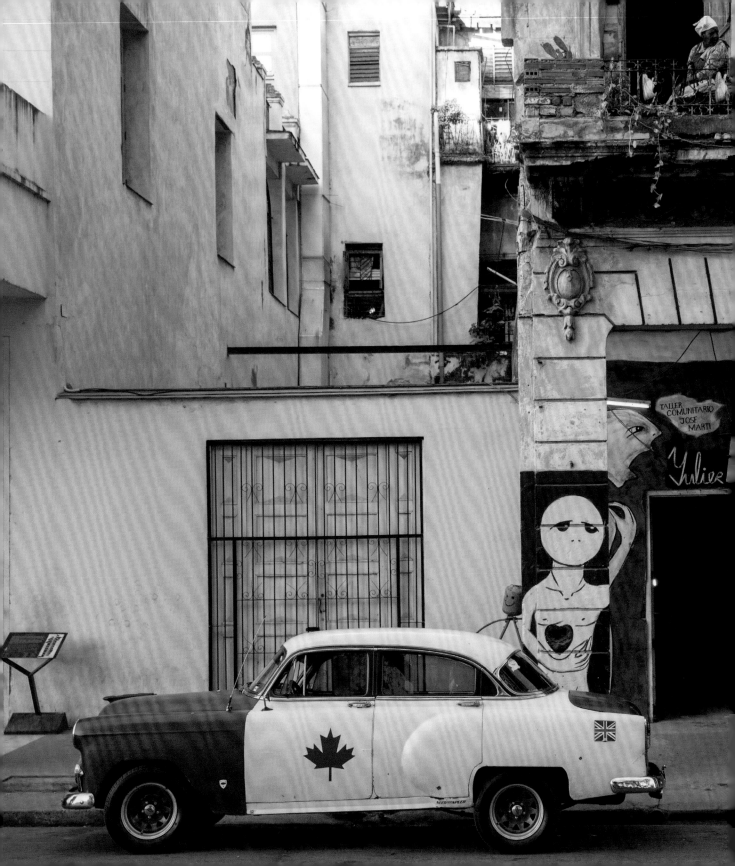

Chevrolet, 1953, Paseo del Prado, La Habana

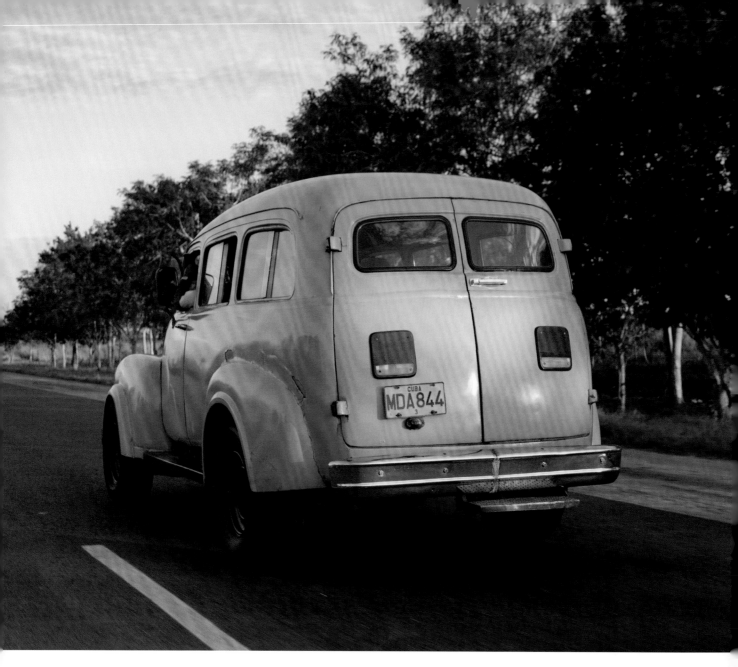

Carretera Central

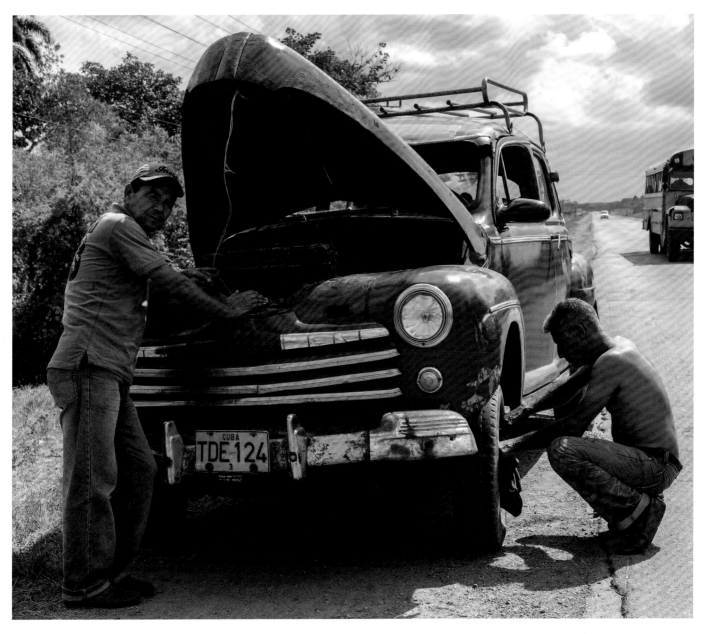

Carretera Central

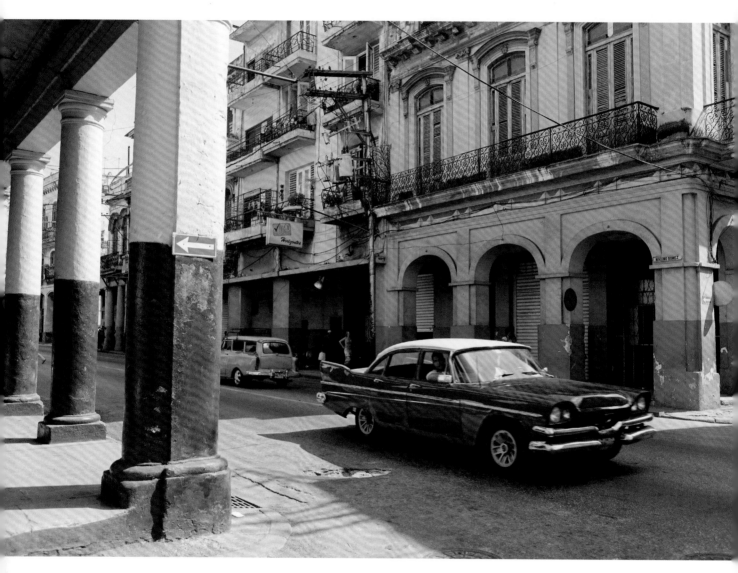

Dodge, 1957, Centro, La Habana

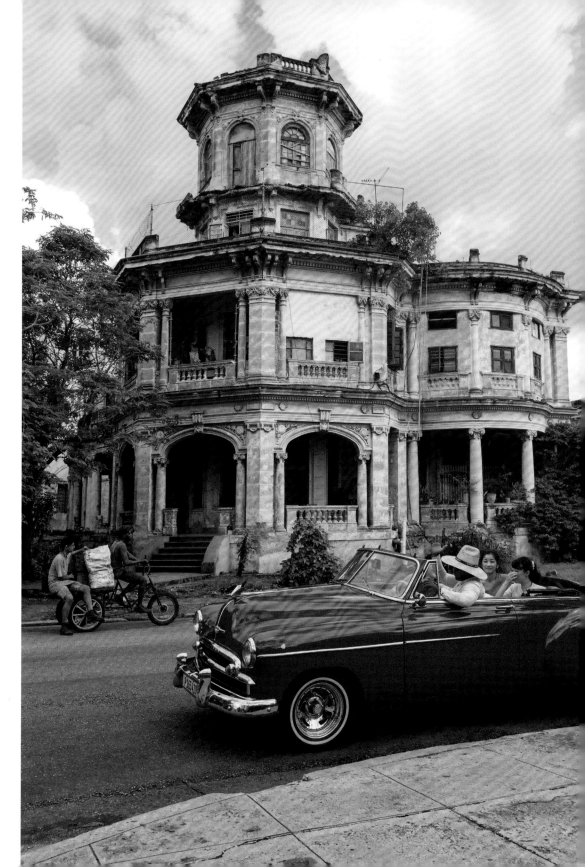

Chevrolet, 1952,
Vedado, La Habana

Ford Fairlane Crown Victoria,
1956, Miramar, La Habana

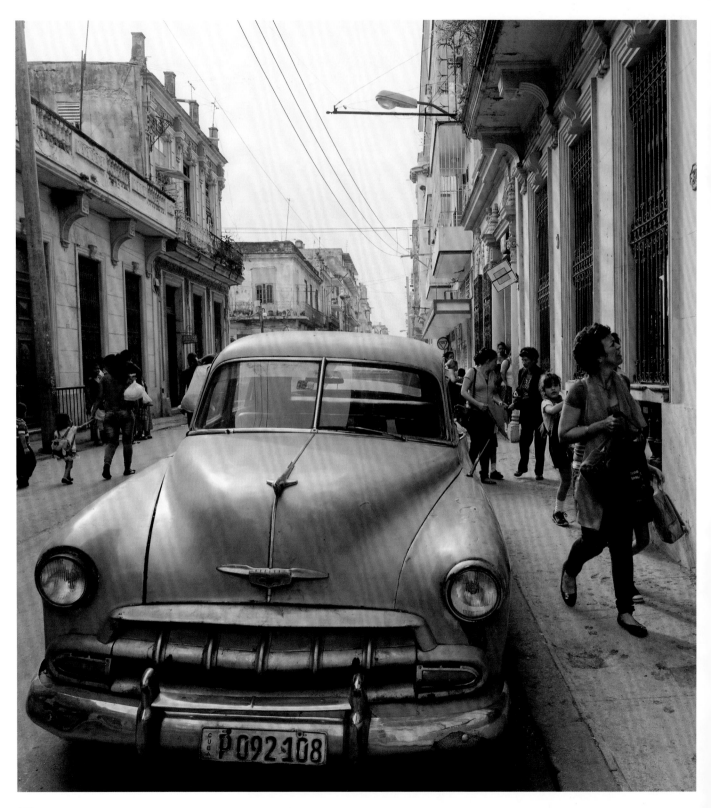

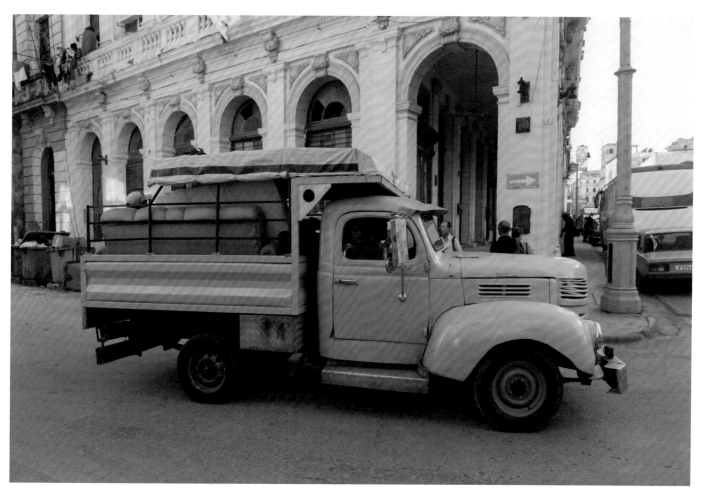

Chevrolet, 1947, Centro, La Habana

Chevrolet, 1952, Centro, La Habana

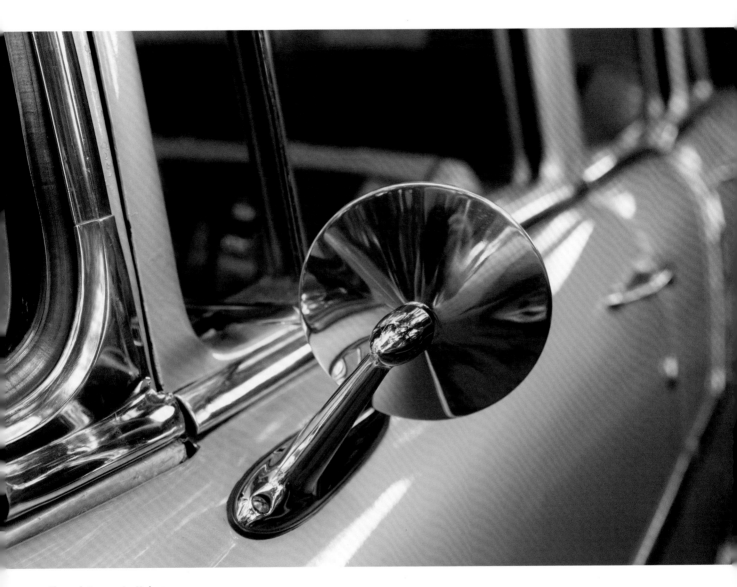

Chevrolet, 1955, La Habana

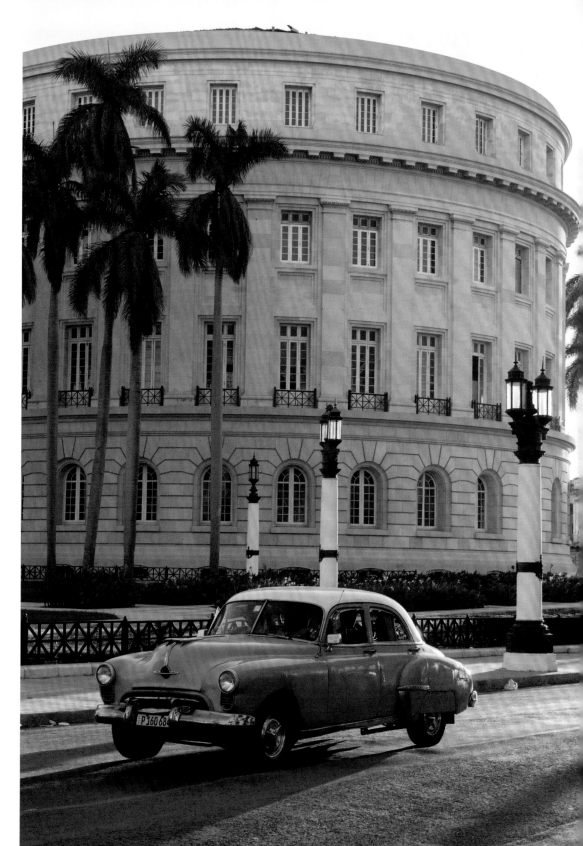

Oldsmobile, 1959,
Capitolio, La Habana

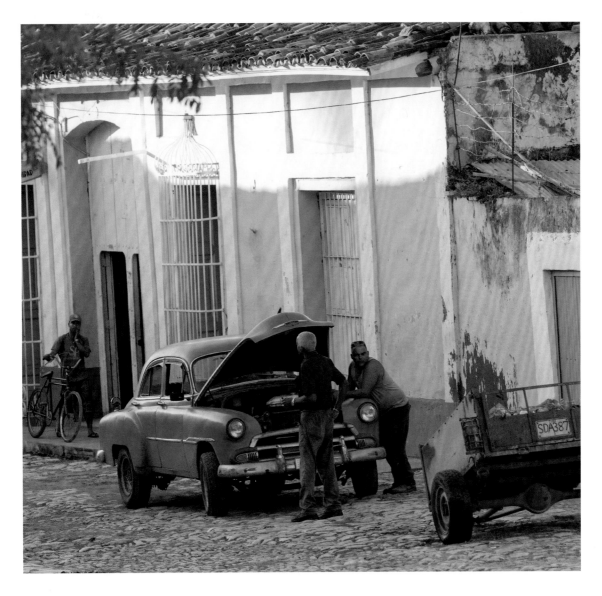

Chevrolet, 1952, Trinidad

Ford Fairlane 500, 1958, Vedado, La Habana

Many an owner would love to exchange his historic vehicle for a reasonably functioning modern car, because breakdowns are commonplace. The countless potholes on the streets of Cuba are a particularly lethal danger for old axles and brittle tires. However, new cars are exorbitantly expensive, and with the average monthly salary of 15 Euros, they are not affordable.

Plus d'un propriétaire troquerait bien volontiers son antique pétoire pour une voiture moderne à peu près en état de marche, car les pannes sont quasiment quotidiennes. Les innombrables nids-de-poule des rues de Cuba sont particulièrement dangereux pour les vieux essieux et les pneus usés. Mais les prix exorbitants des voitures neuves les rendent inaccessibles pour des gens qui gagnent en moyenne 15 euros par mois.

Nur zu gern würde manch ein Besitzer sein historisches Gefährt gegen einen halbwegs funktionierenden modernen Wagen tauschen, denn Pannen sind alltäglich. Vor allem die unzähligen Schlaglöcher auf den Straßen Kubas sind eine tödliche Gefahr für alte Achsen und mürbe Reifen. Neuwagen sind jedoch exorbitant teuer und mit einem monatlichen Durchschnittsgehalt von 15 Euro nicht zu bezahlen.

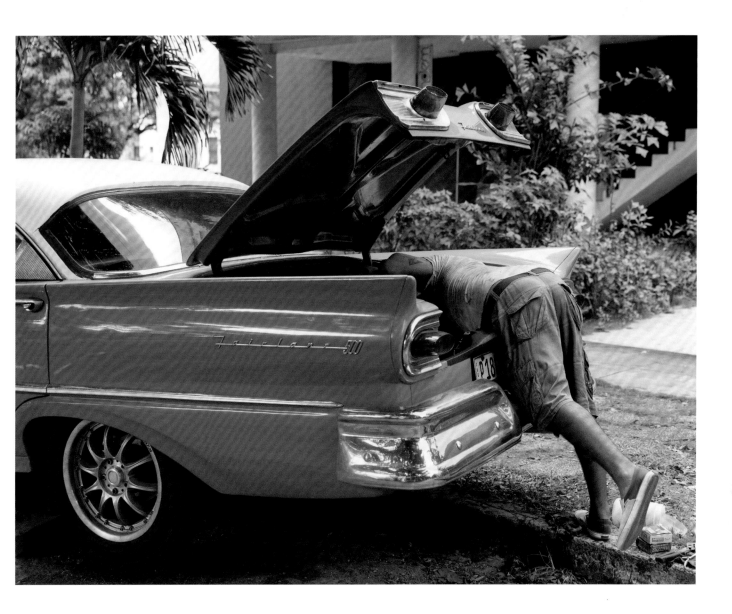

A muchos propietarios les encantaría cambiar su vehículo histórico por un coche moderno que funcione razonablemente, porque las averías son comunes. Especialmente los innumerables baches en las calles de Cuba son un peligro mortal para los ejes viejos y los neumáticos frágiles. Sin embargo, los coches nuevos son exorbitantemente caros y no se pueden pagar con un salario medio mensual de 15 euros.

Muitos proprietários gostariam de trocar o seu veículo histórico por um carro moderno que funcionasse razoavelmente, pois as avarias são diárias. Especialmente, a grande quantidade de buracos nas estradas de Cuba são um perigo mortal para eixos velhos e pneus ressequidos. No entanto, os automóveis novos são exorbitantemente caros e, com um salário médio mensal de 15 euros, são impossíveis de adquirir.

Menig bezitter zou zijn historische voertuig graag willen inruilen voor een redelijk functionerende moderne auto, want defecten zijn aan de orde van de dag. Vooral de ontelbare kuilen in de straten van Cuba vormen een dodelijk gevaar voor oude assen en broze banden. Nieuwe auto's zijn echter exorbitant duur en niet te betalen van een gemiddeld maandsalaris van 15 euro.

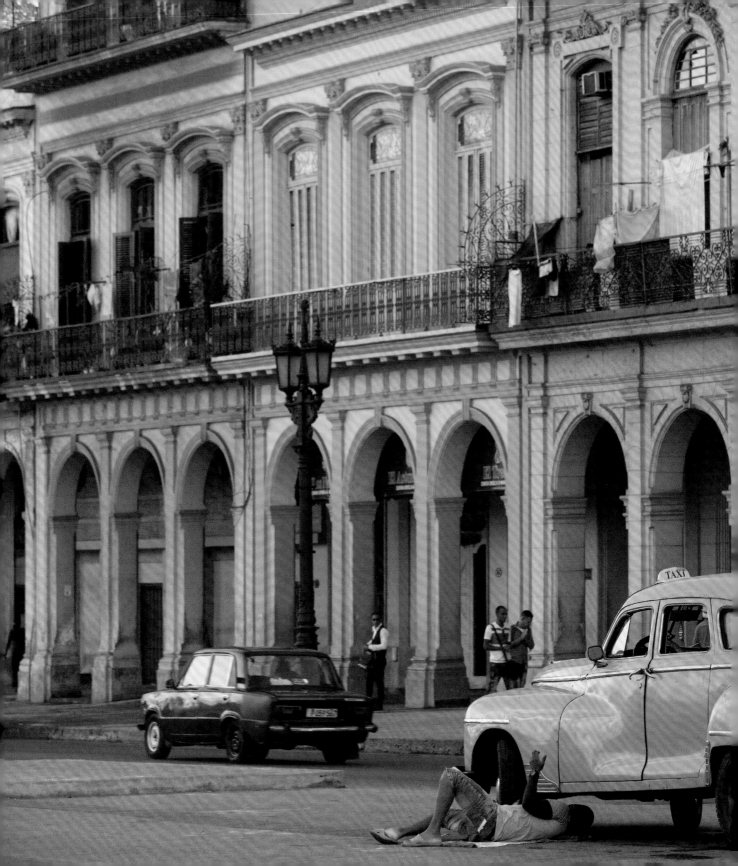

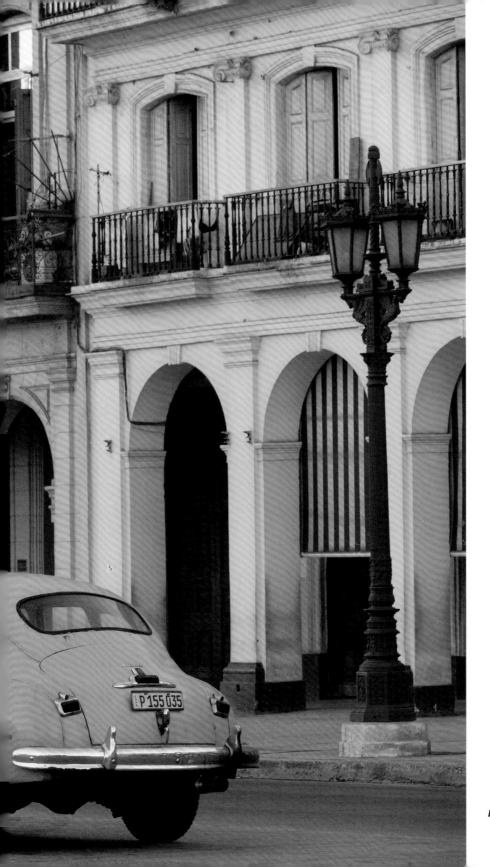

Dodge, 1948, Paseo de Martí, La Habana

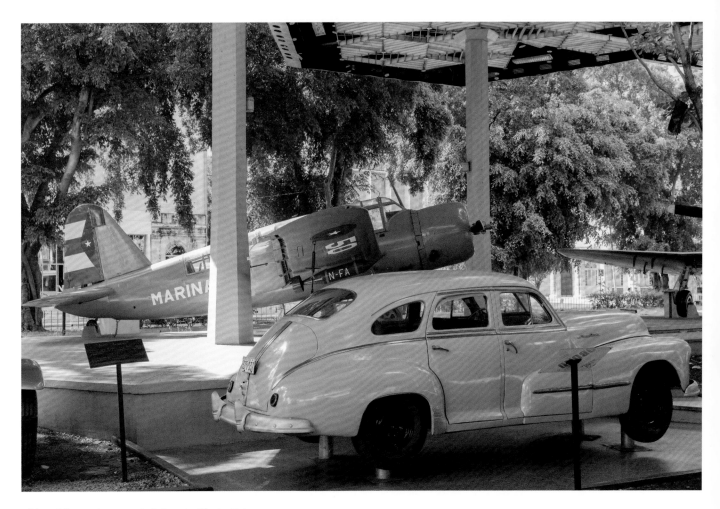

Oldsmobile, 1946, Museo de la Revolución, La Habana

Buick, 1946, Paseo del Prado, La Habana

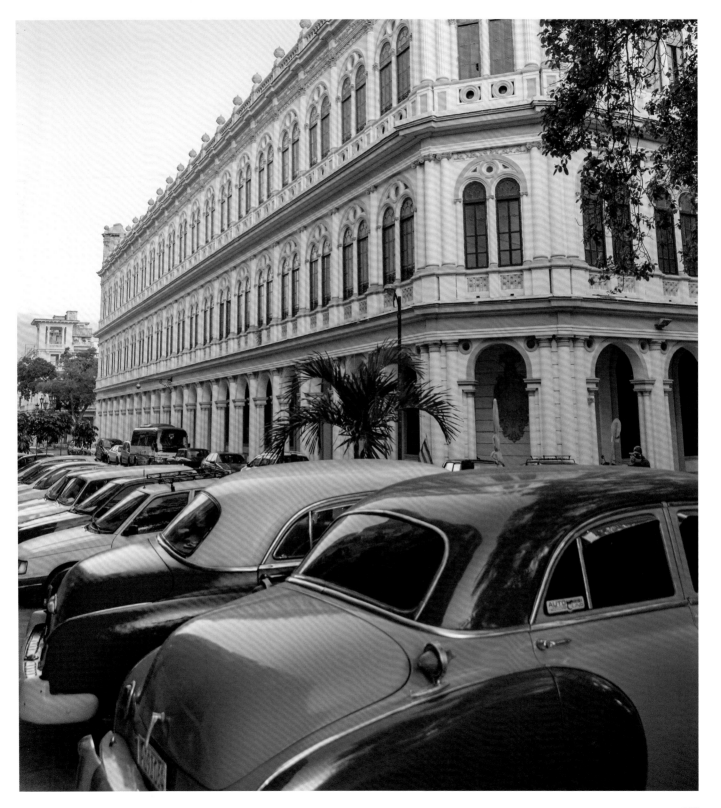

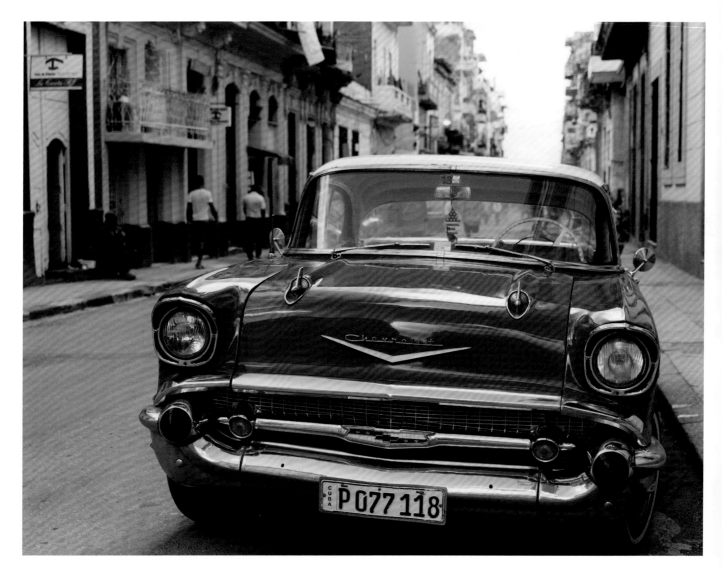

Chevrolet, 1957, Centro, La Habana

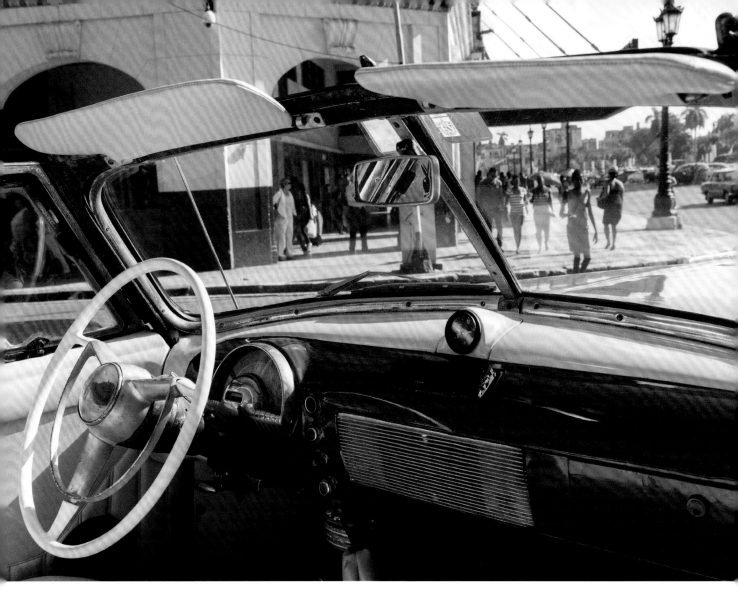

Oldsmobile 1952, Parque Central, La Habana

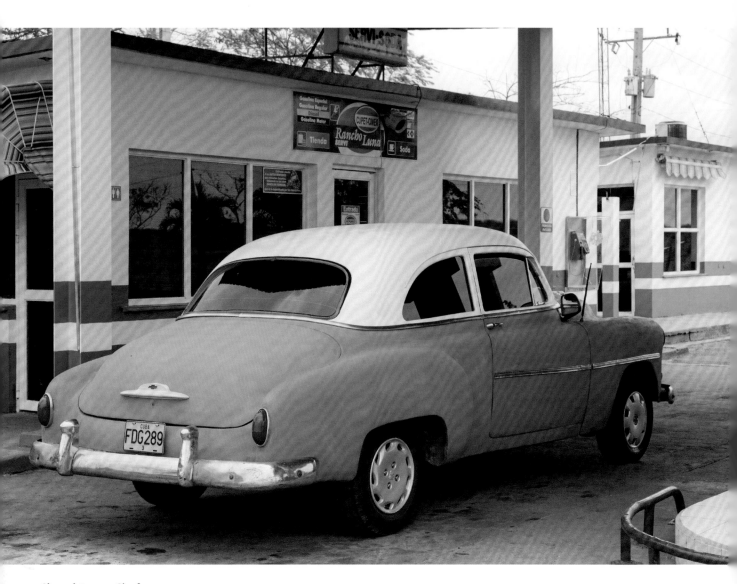

Chevrolet, 1952, Cienfuegos

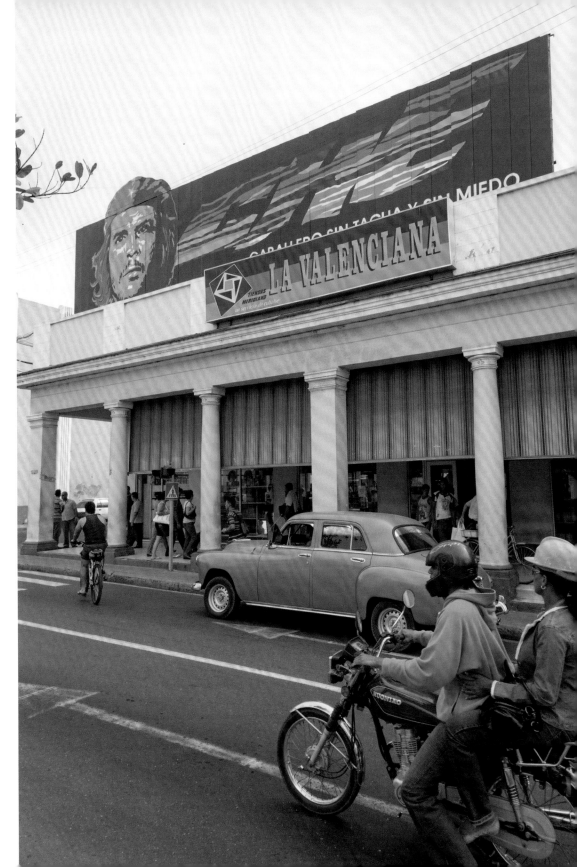

Plymouth, 1950, Cienfuegos

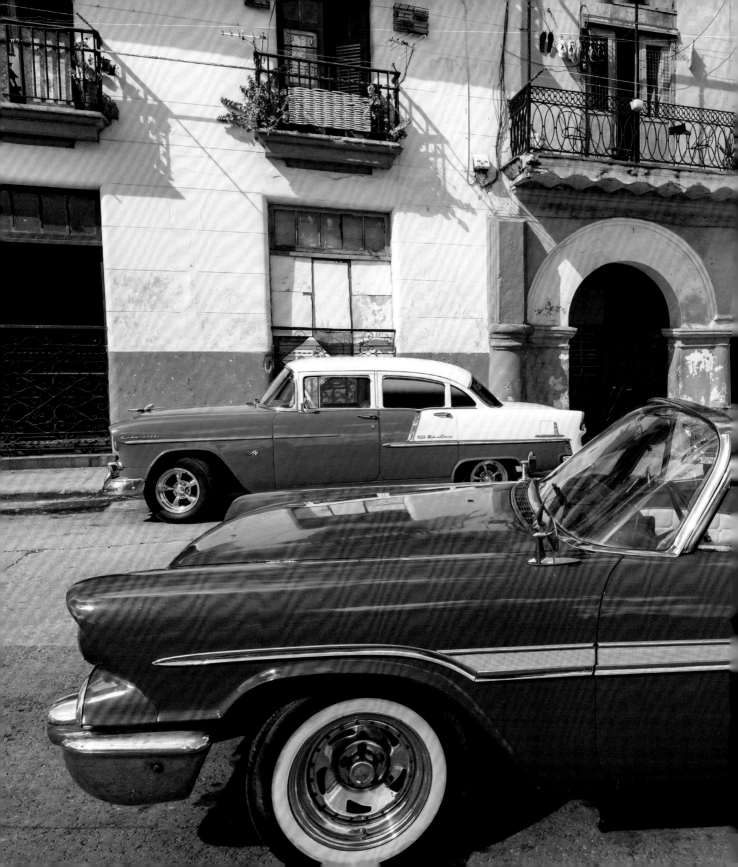

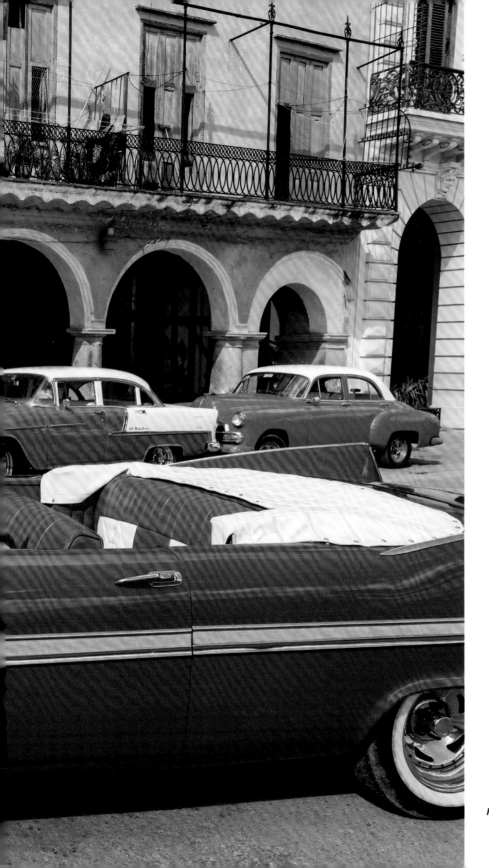

Ford Fairlane, 1958, La Habana Vieja

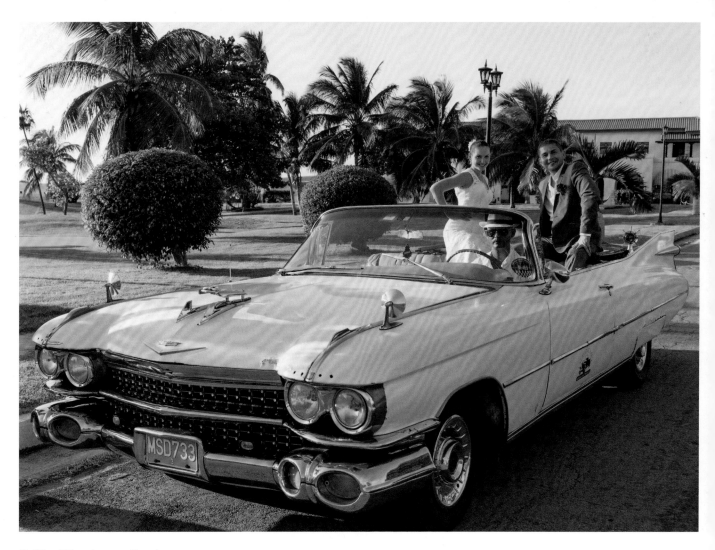

Cadillac Eldorado, 1959, Varadero

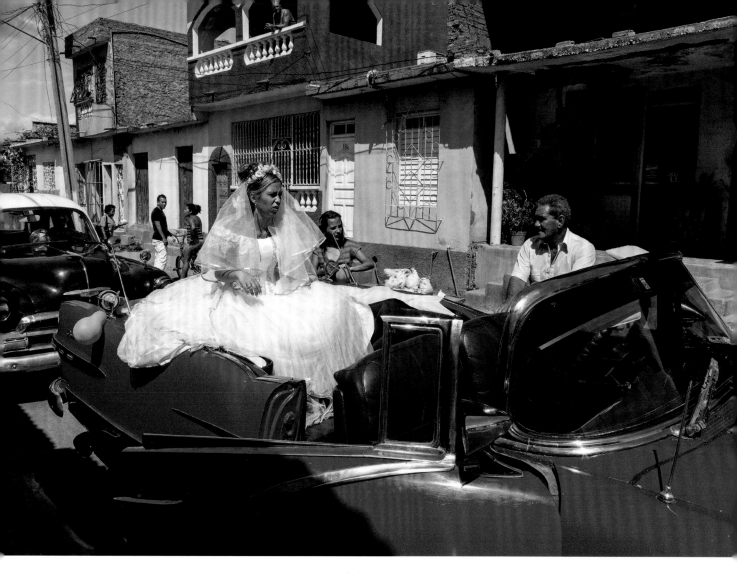

Pontiac, 1956, Trinidad

Chevrolet, 1947, Centro, La Habana

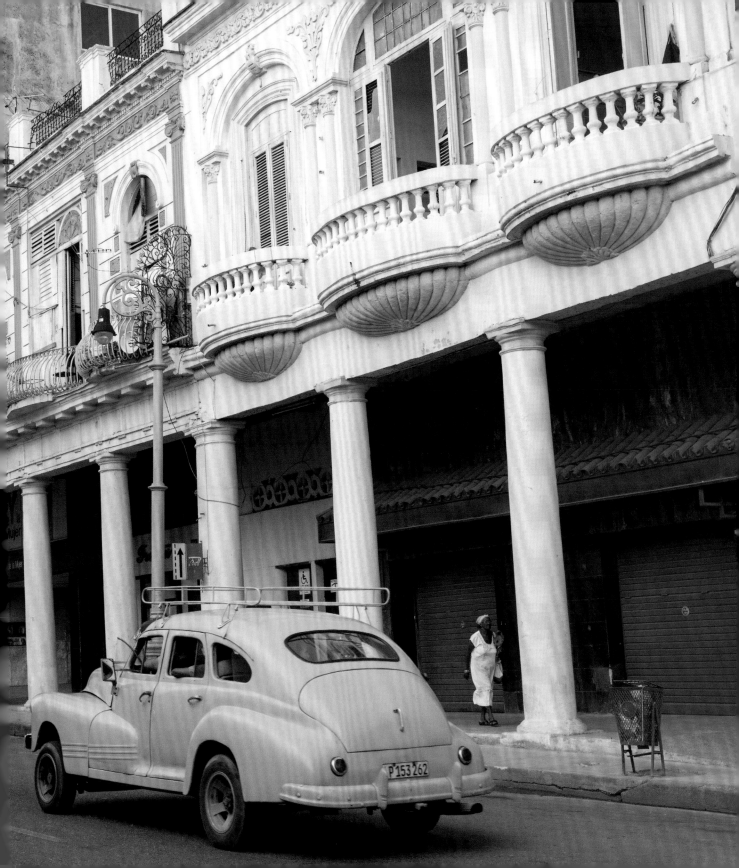

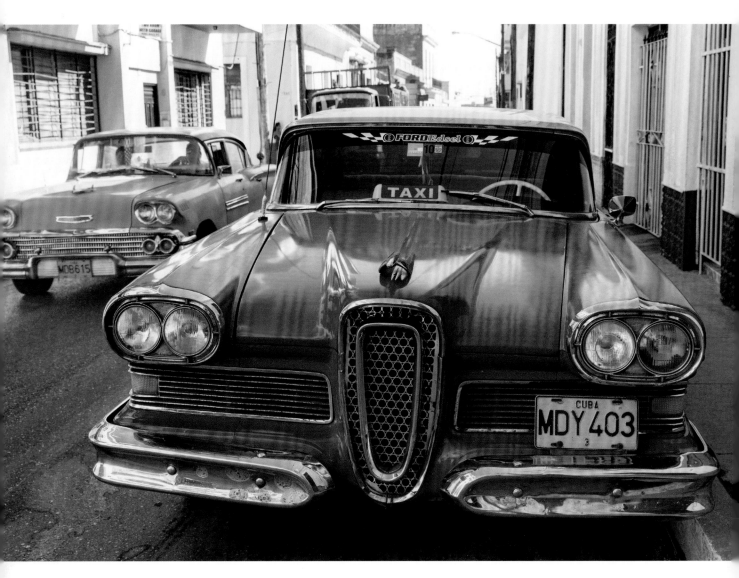

Ford Edsel, 1956, Matanzas

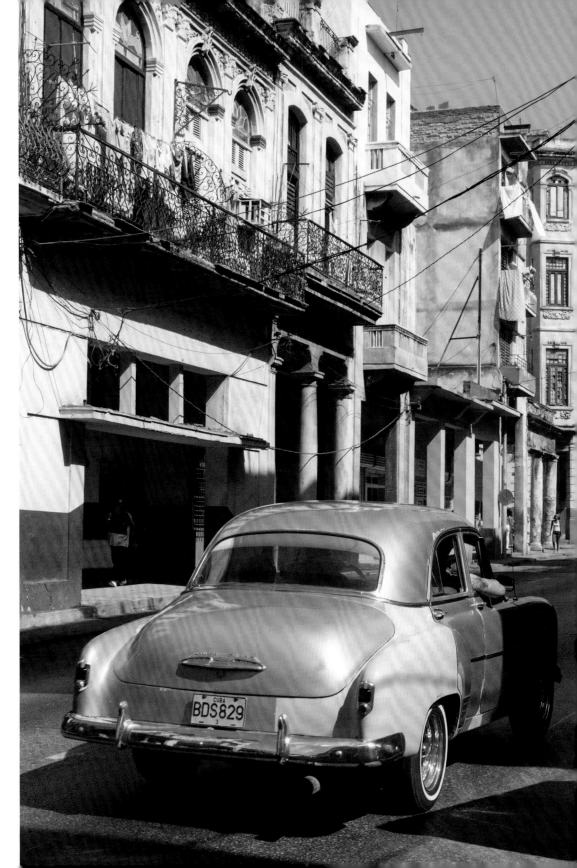

Chevrolet, 1952,
Centro, La Habana

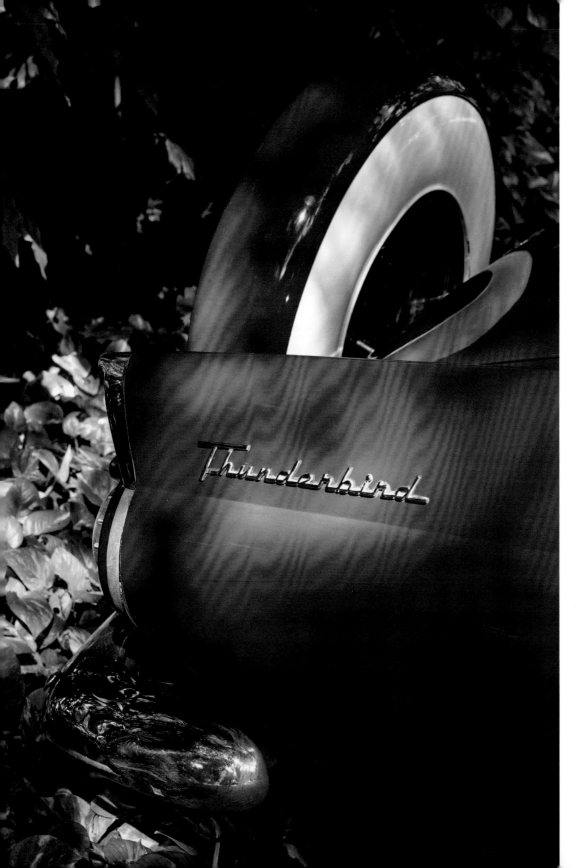

Ford Thunderbird,
1956, La Habana

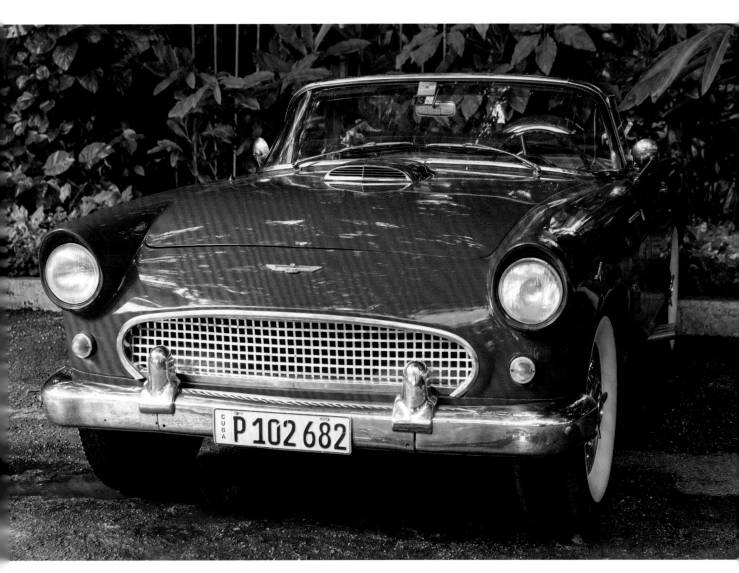

Ford Thunderbird, 1956, La Habana

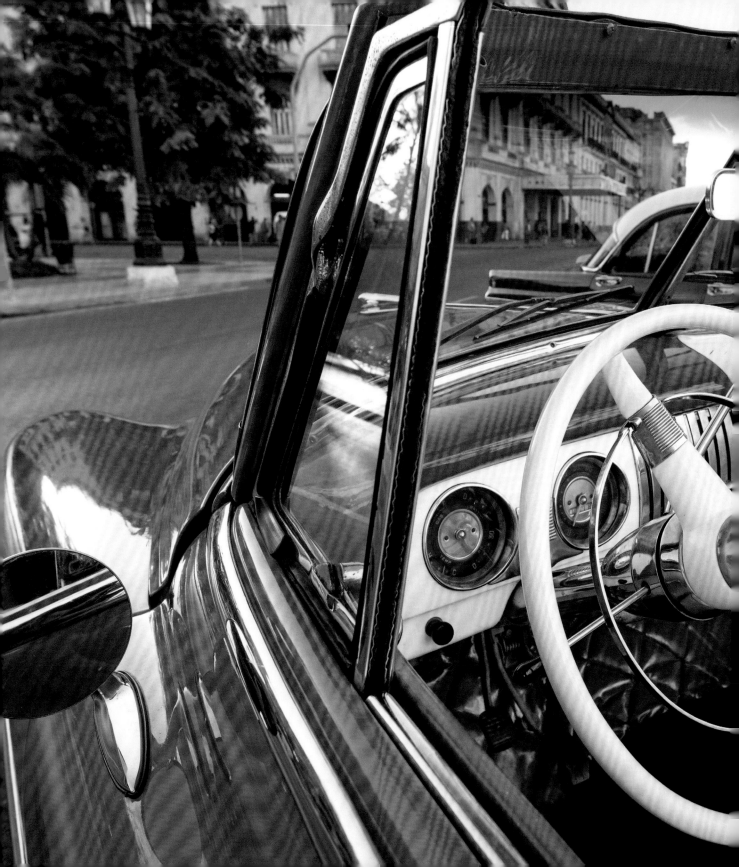

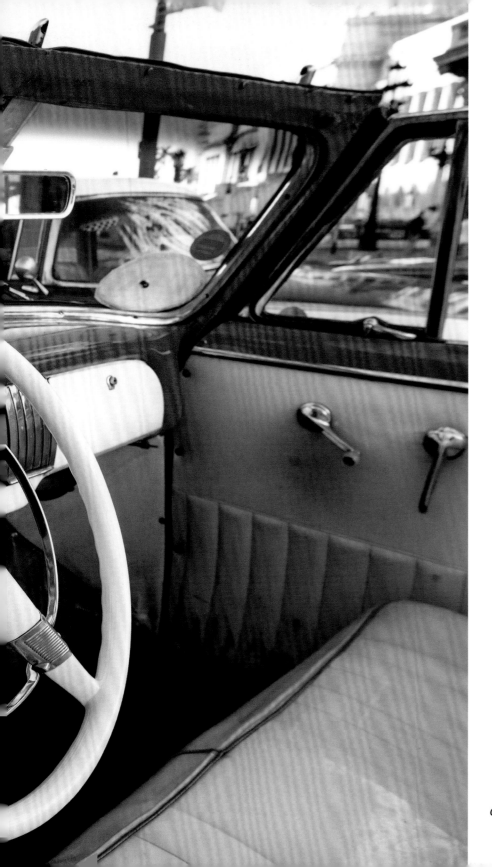

Chevrolet 1952, Parque Central, La Habana

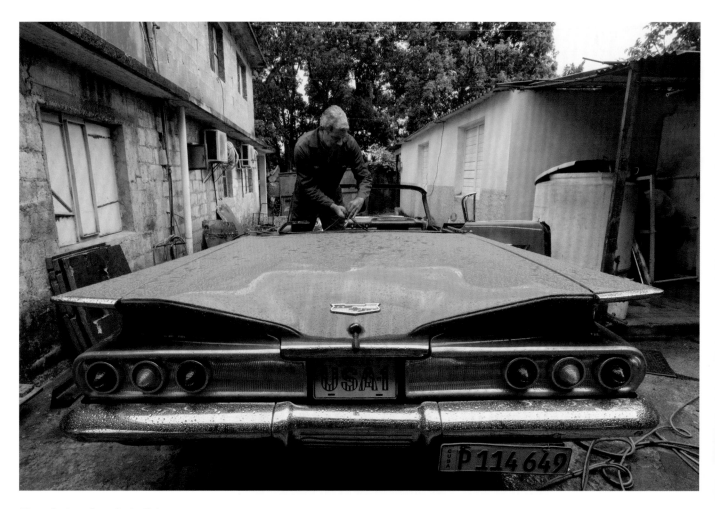

Chevrolet Impala, 1960, La Habana

Ford, 1957, La Habana

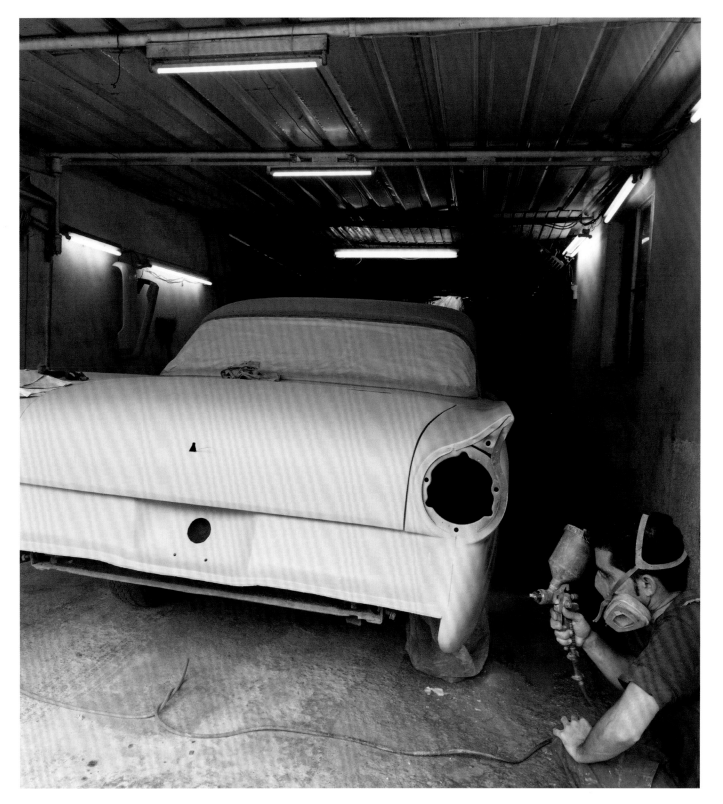

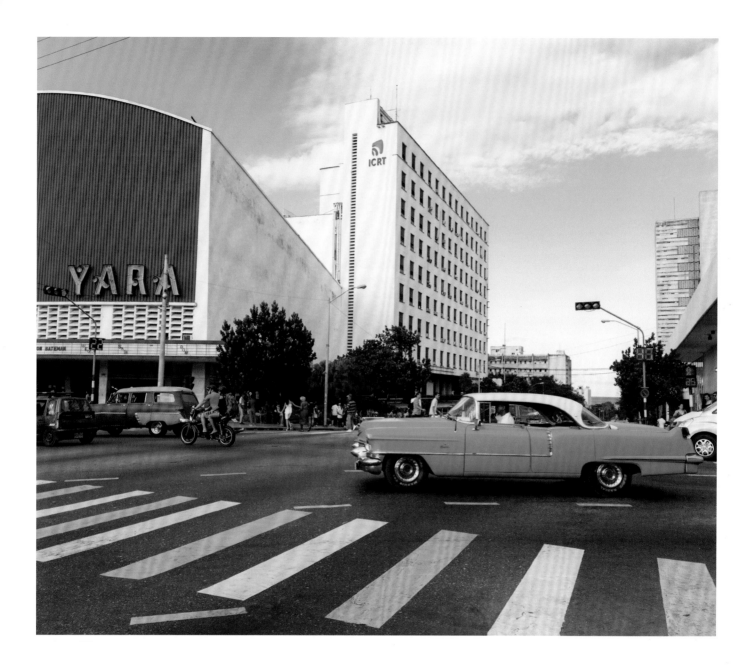

In Cuba, a car is considered to be quite safe if it can take a bend, and the brakes and horn work. In fact, some cars are mainly held together by paint, and some mirrors may be attached with Cuban chewing gum.

À Cuba, on considère qu'une voiture est assez sûre quand elle est en mesure de prendre un virage et que les freins et le klaxon fonctionnent. Après tout, sur certains exemplaires, les pièces ne tiennent plus guère ensemble que grâce à la peinture, et il n'est pas rare qu'un rétroviseur soit fixé avec du chewing-gum.

In Kuba gilt ein Auto bereits als ziemlich sicher, wenn es eine Kurve fahren kann und Bremse sowie Hupe funktionieren. Tatsächlich werden einige Exemplare vor allem vom Lack zusammengehalten, und der eine oder andere Spiegel ist vielleicht mit kubanischem Kaugummi festgeklebt.

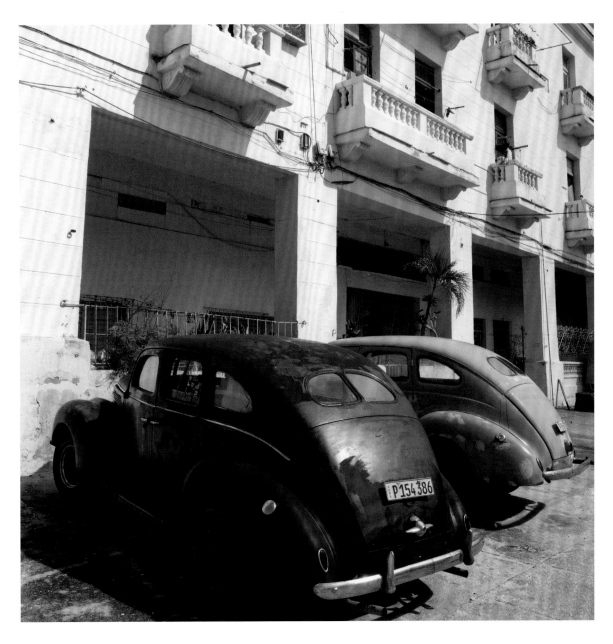

*Cadillac,
1956, Vedado,
LaHabana*

*Chevrolet,
1947, Vedado,
La Habana*

En Cuba, un coche se considera bastante seguro si puede tomar una curva y el freno y la bocina funcionan. De hecho, algunos ejemplares se mantienen unidos principalmente por el barniz, y algunos espejos pueden estar pegados con goma de mascar cubana.

Em Cuba, um carro é já considerado bastante seguro se puder virar numa curva e travar, assim como buzinar. Na verdade, alguns espécimes são sobretudo conservados devido à pintura, sendo que até alguns espelhos chegam a ser colados com a ajuda de pastilha elástica cubana.

In Cuba wordt een auto als tamelijk veilig beschouwd als hij een bocht kan nemen en de remmen en claxon werken. Sommige exemplaren worden daadwerkelijk vooral door de lak bij elkaar gehouden, en spiegels zijn soms met Cubaanse kauwgom vastgeplakt.

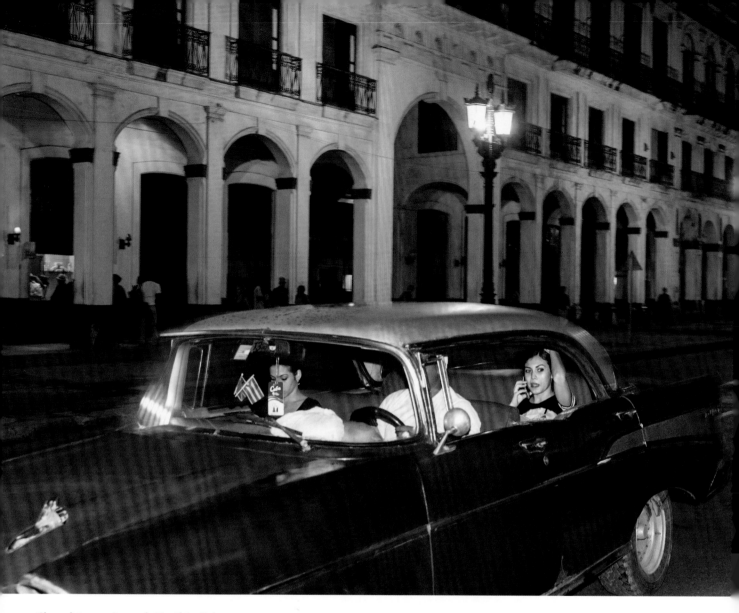

Chevrolet, 1957, Paseo de Martí, La Habana

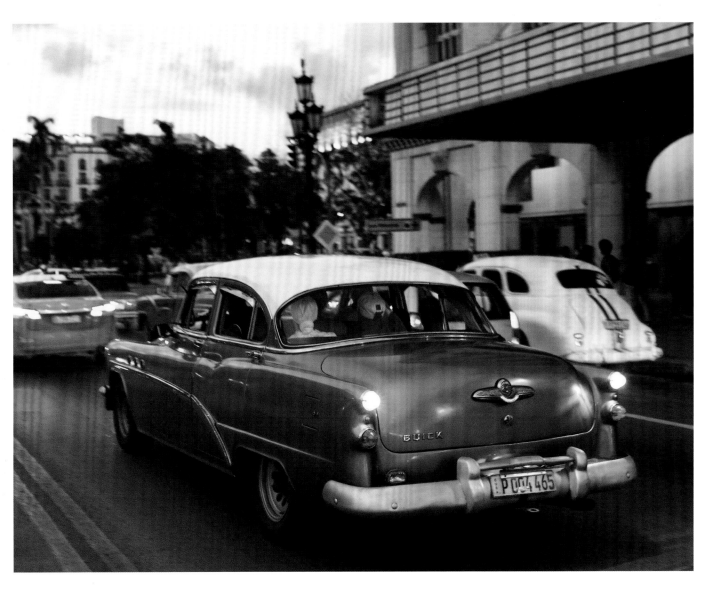

Buick, 1954, Paseo de Martí, La Habana

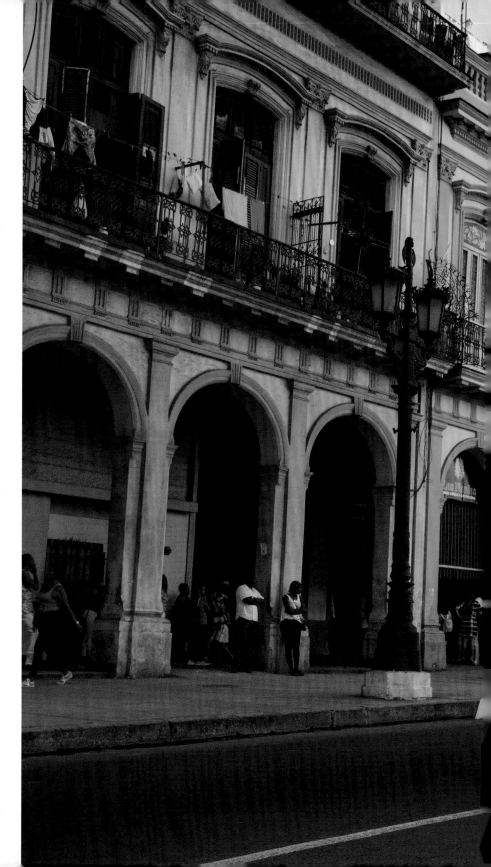

Plymouth, 1952, Paseo de Marti, La Habana

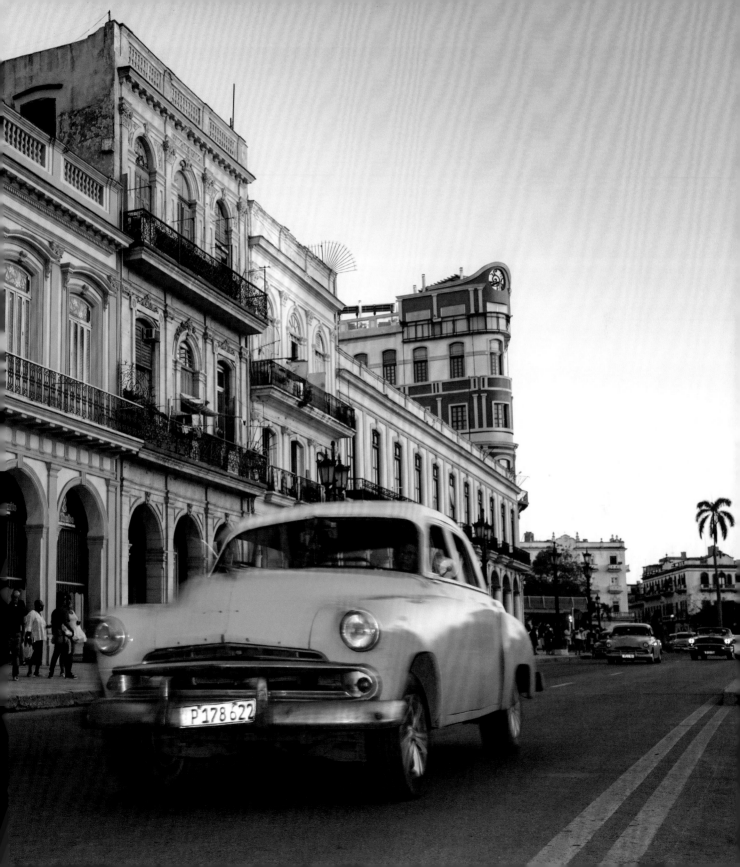

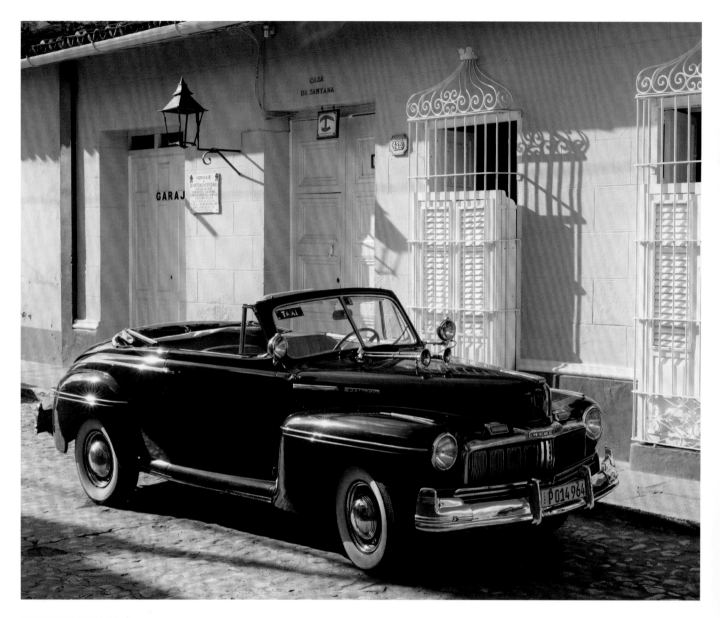

Mercury, 1948, Trinidad

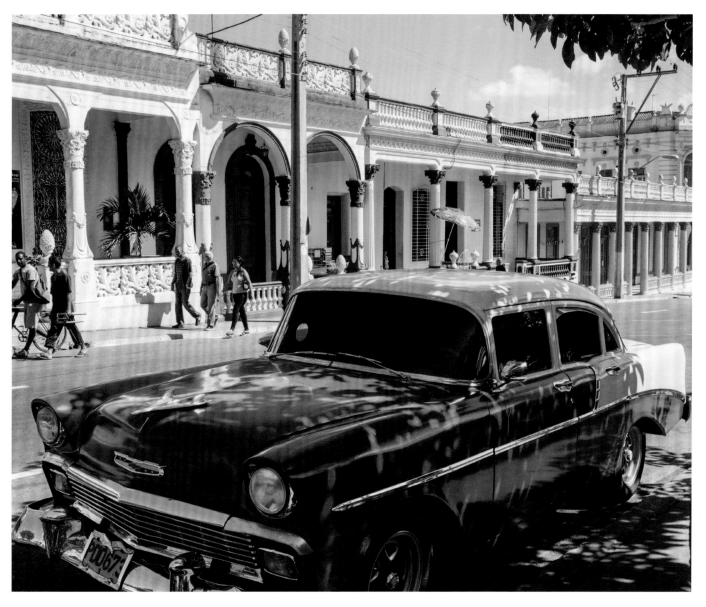

Chevrolet, 1956, Pinar del Rio

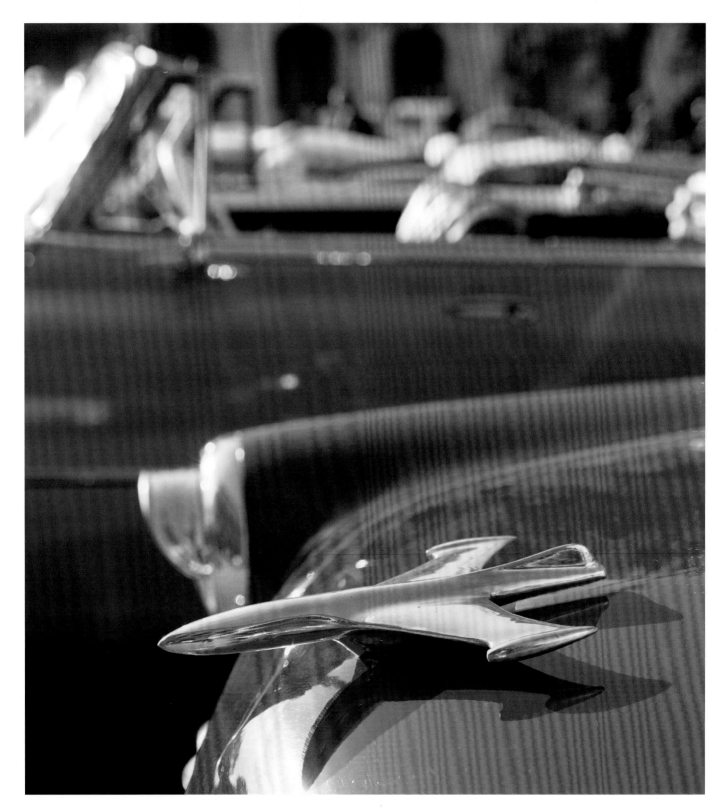

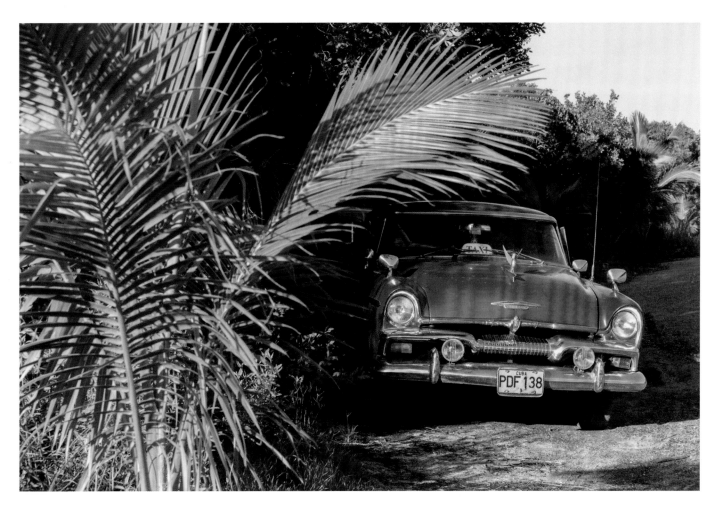

Plymouth, 1955, Santa Luzia, Pinar del Rio

Chevrolet, 1954, Parque Central, La Habana

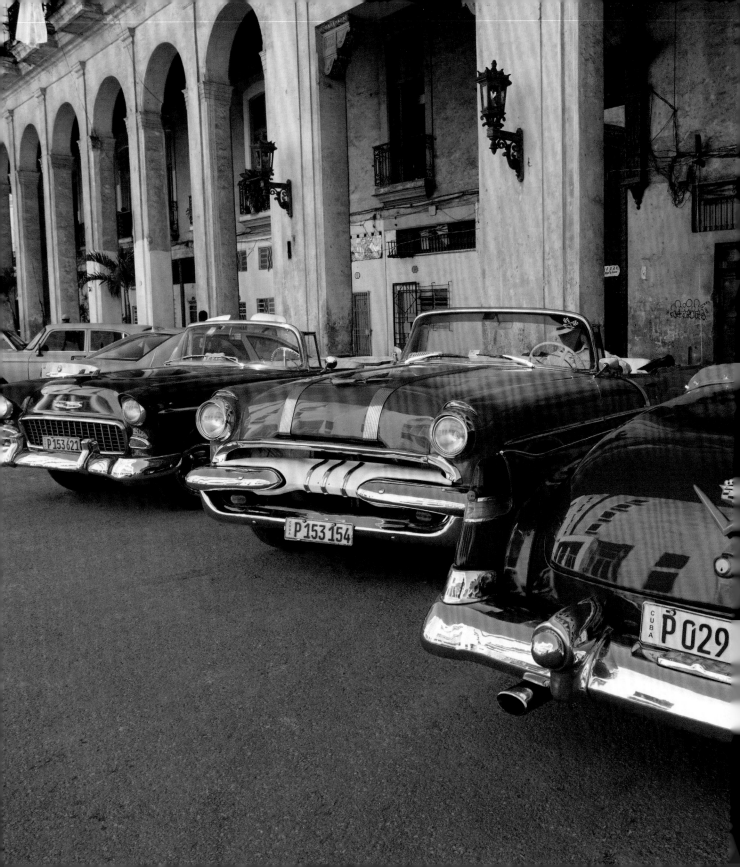

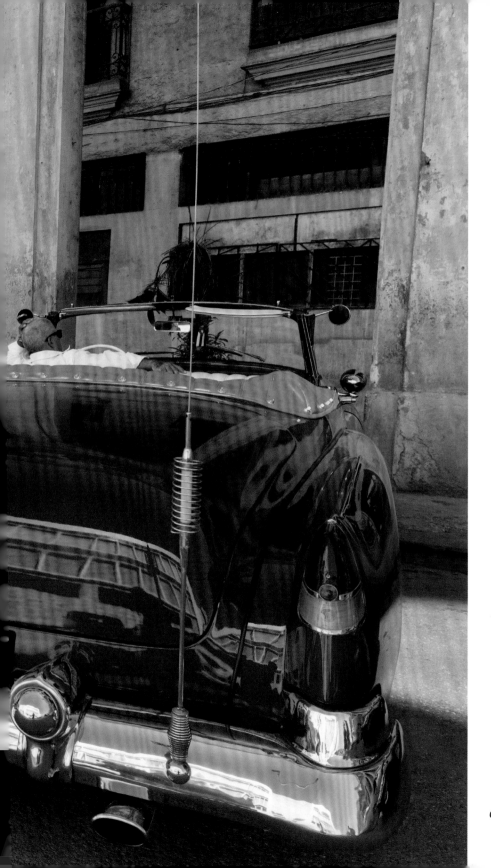

Cadillac, 1955, Trocadero, La Habana

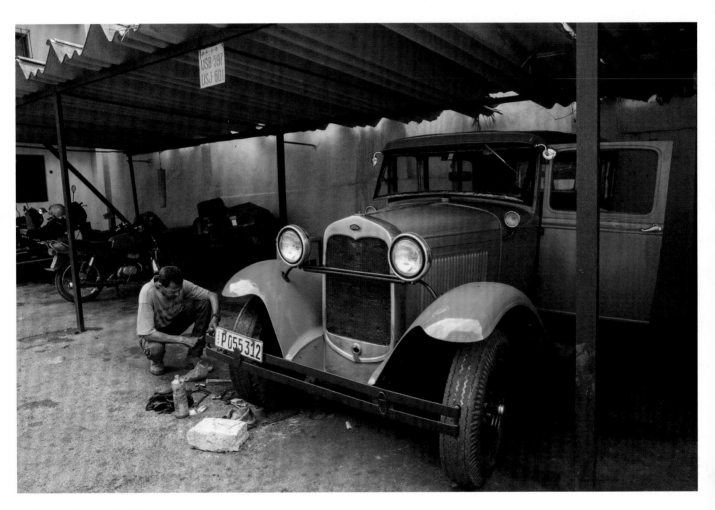

Ford, 1928, Santiago de Cuba

Chevrolet, 1942,Baracoa, Provincia Guantánamo

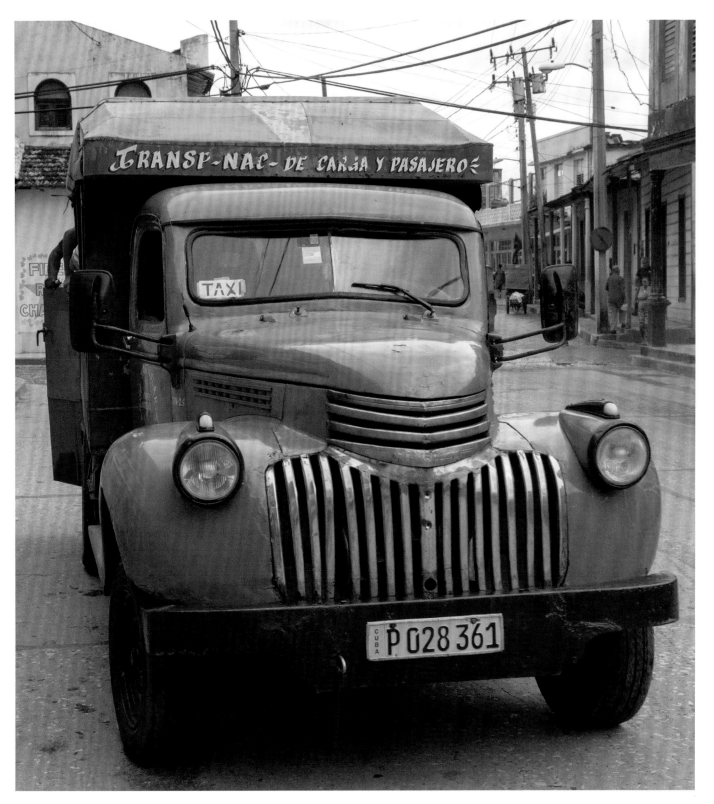

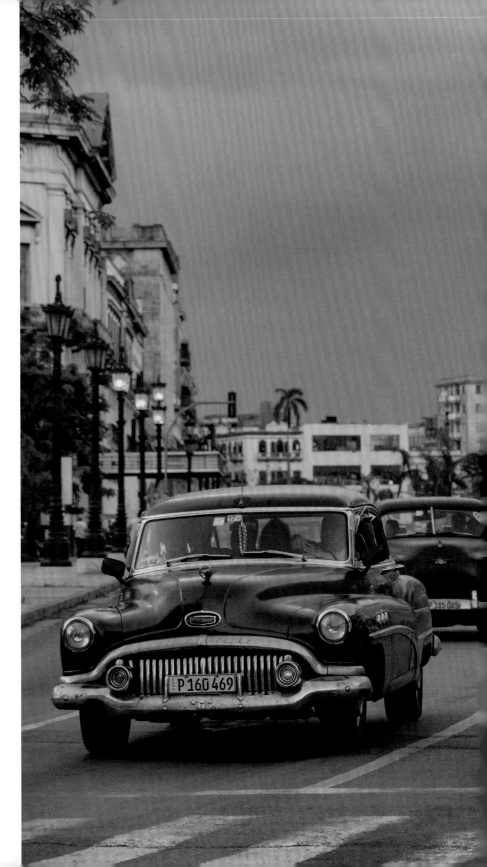

Buick 1954 / Buick 1952 / Pontiac 1958, Paseo de Martí, La Habana

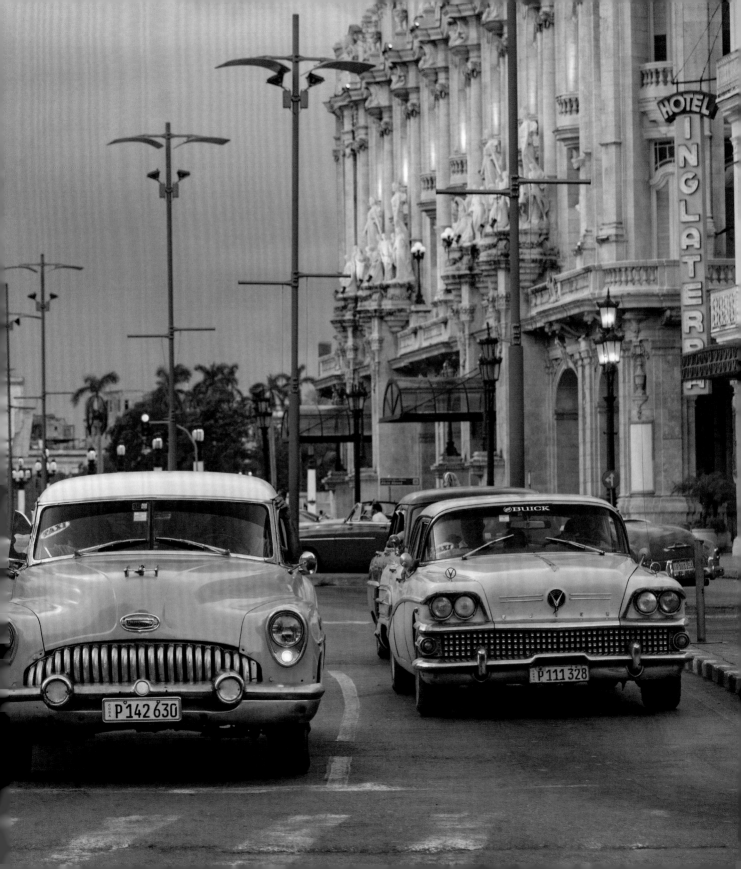

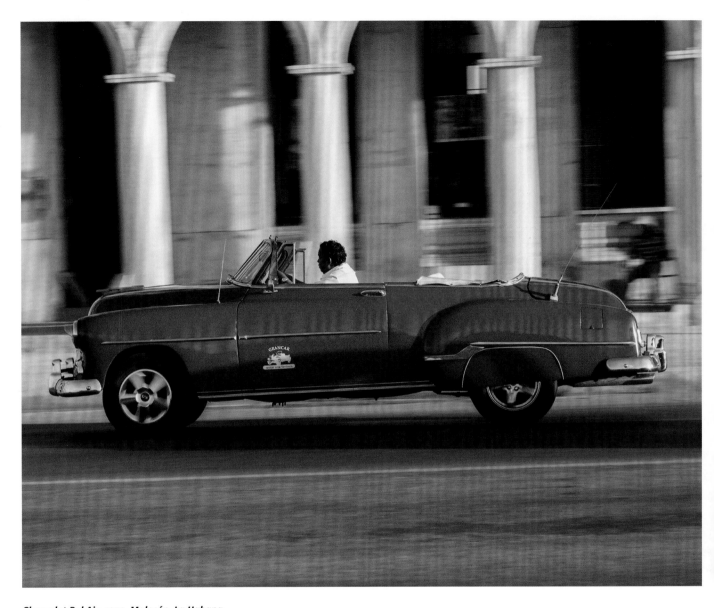

Chevrolet Bel Air, 1952, Malecón, La Habana

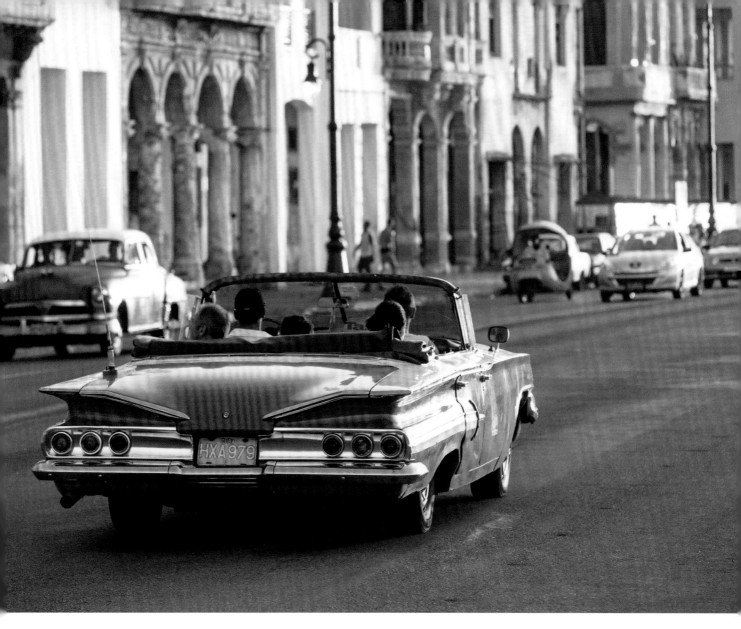

Chevrolet Impala, 1960, Malecón, La Habana

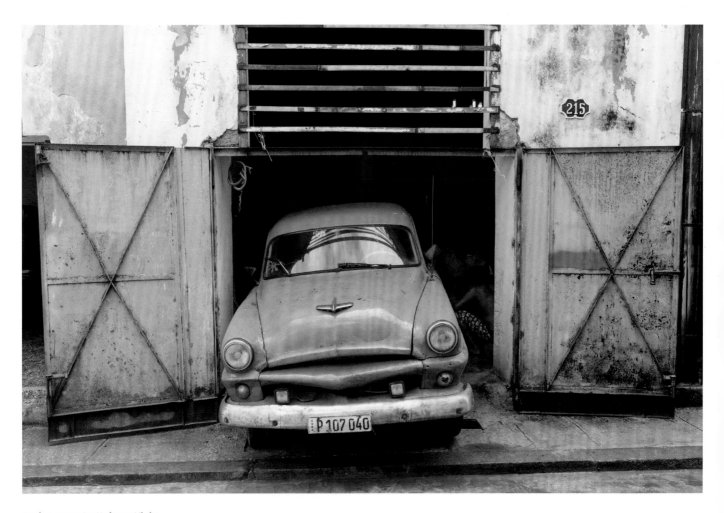

Dodge, 1954, La Habana Vieja

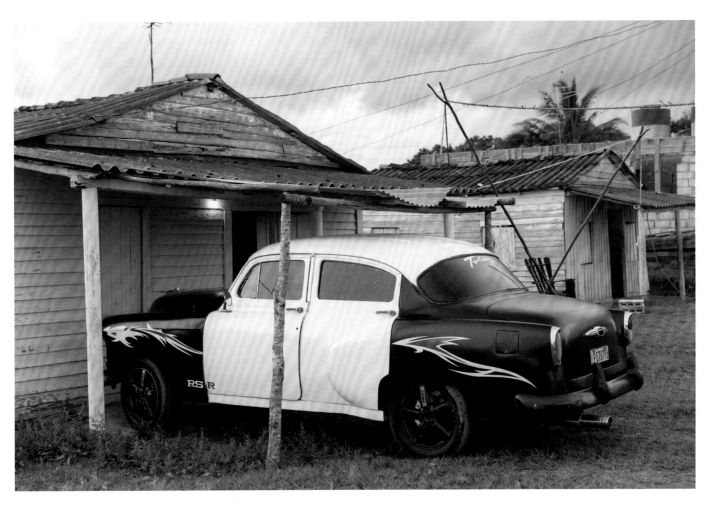

Chevrolet, 1942, Viñales

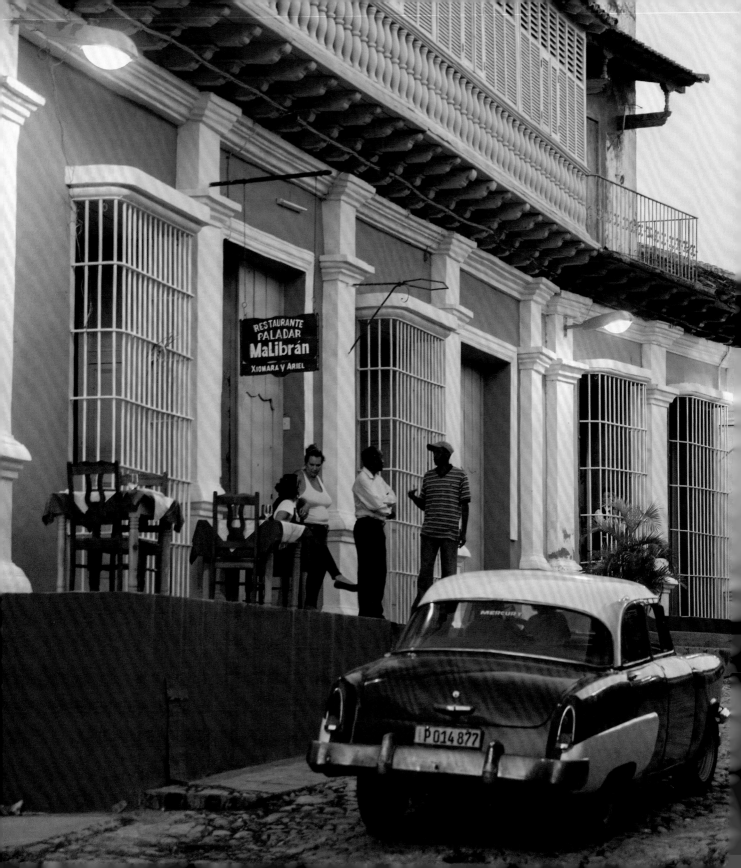

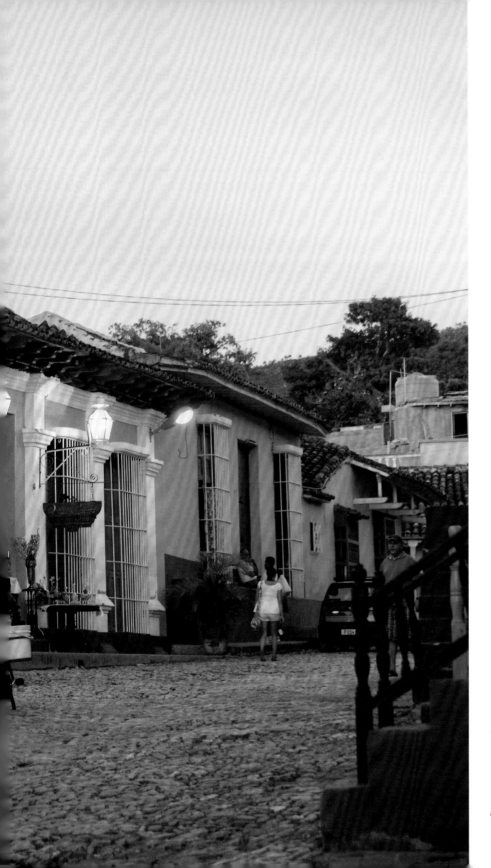

Dodge, 1953, Trinidad

These brave old-timers survived not only Fidel Castro, but also the many decades in which they were regarded as embarrassing symbols of poverty and technological backwardness, and were only sheepishly tolerated by the revolutionary government. Today, Cuban cars are considered to be a globally unique tourist attraction, travelling eyewitnesses and a cultural heritage of an island that has suffered an extremely volatile fate over recent decades.

Ces vaillantes voitures de collection n'ont pas survécu seulement à Fidel Castro, mais aussi aux longues décennies pendant lesquelles elles étaient considérées comme des symboles honteux de pauvreté et de retard technologique, tolérées seulement avec une certaine gêne par le gouvernement révolutionnaire. Aujourd'hui, les « *Cuban Cars* » représentent une attraction touristique connue dans le monde entier, véritables symboles sur roues et en même temps héritage cultuel d'une île qui depuis des dizaines d'années a connu un destin extrêmement mouvementé.

Die tapferen Oldtimer haben nicht nur Fidel Castro überlebt, sondern auch die vielen Jahrzehnte, in denen sie als peinliche Symbole von Armut und technologischer Rückständigkeit galten und von der Revolutionsregierung lediglich verschämt geduldet wurden. Heutzutage gelten die „Cuban Cars" als weltweit einzigartige Touristenattraktion, als fahrende Zeitzeugen und kulturelles Erbe einer Insel, die in den vergangenen Jahrzehnten ein äußerst wechselvolles Schicksal durchlebt hat.

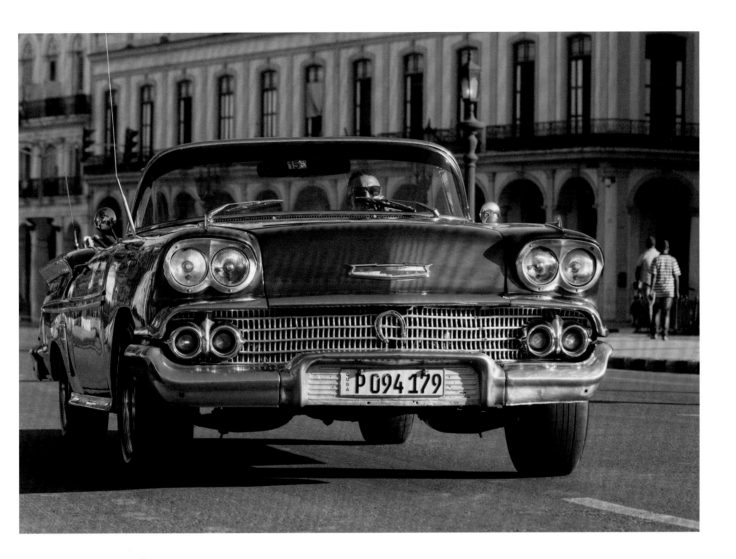

Los valientes veteranos sobrevivieron no solo a Fidel Castro, sino también a las muchas décadas en las que fueron considerados símbolos vergonzosos de pobreza y atraso tecnológico (solo fueron vergonzosamente tolerados por el gobierno revolucionario). Hoy en día, los coches cubanos se consideran una atracción turística única en el mundo, un testigo ocular itinerante y el patrimonio cultural de una isla que ha sufrido un destino muy variado en las últimas décadas.

Os „corajosos veteranos" sobreviveram não só a Fidel Castro, mas também às muitas décadas em que foram vistos como símbolos constrangedores da pobreza e do atraso tecnológico e apenas deploravelmente tolerados pelo governo revolucionário. Hoje em dia, os automóveis cubanos são considerados uma atração turística única no mundo, como vestígio circulante e património cultural de uma ilha que viveu situações extraordinariamente diferentes nas últimas décadas.

De dappere oldtimers hebben niet alleen Fidel Castro overleefd, maar ook de vele decennia waarin ze werden beschouwd als pijnlijke symbolen van armoede en technologische achterstand. Ze werden slechts beschaamd geduld door de revolutionaire regering. Tegenwoordig worden Cubaanse auto's wereldwijd beschouwd als een unieke toeristische attractie, als rijdende ooggetuigen en cultureel erfgoed van een eiland dat in de afgelopen decennia een uiterst wisselvallig lot heeft doorstaan.

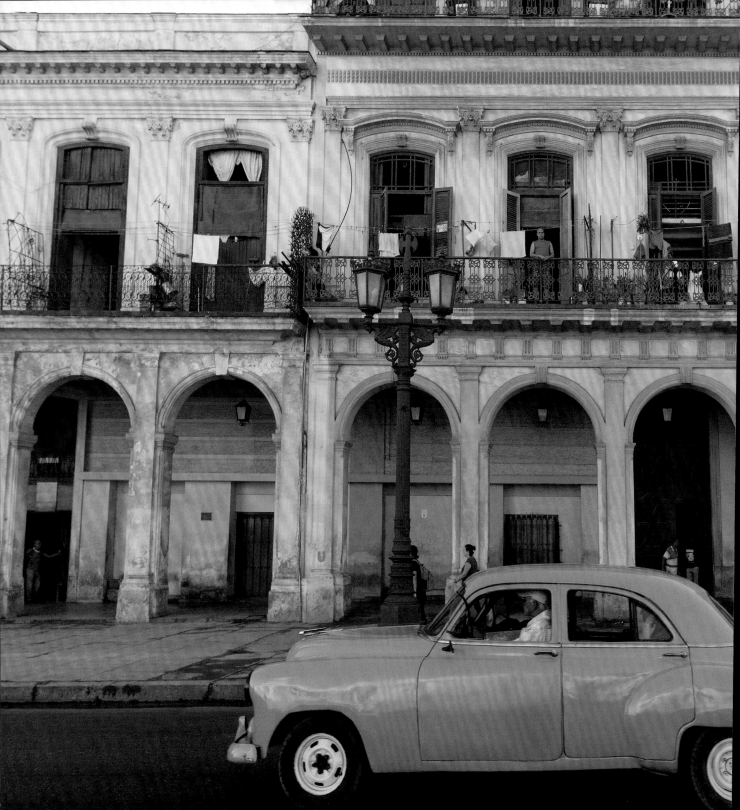

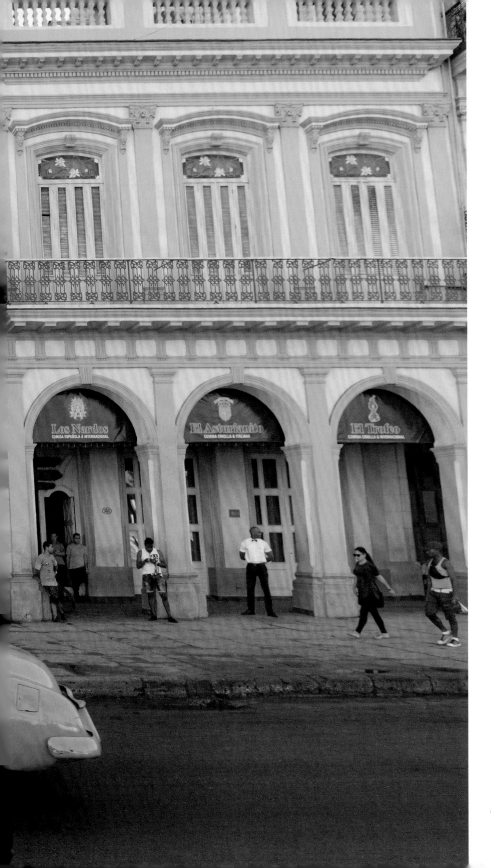

Chevrolet, 1951, Paseo de Martí, La Habana

KÖNEMANN

© 2019 koenemann.com GmbH
www.koenemann.com

ÉDITIONS
PLACE DES
VICTOIRES

© Éditions Place des Victoires
6, rue du Mail – 75002 Paris
www.victoires.com
ISBN: 978-2-8099-1756-7

Concept, Project Management: koenemann.com GmbH
Translation into French: Julie Fillatre
Translation into English, Spanish, Portuguese and Dutch: koenemann.com GmbH
Layout: Katrin Zellmer
Colur Separation: Prepress, Cologne
Picture credits: Karl-Heinz Raach

ISBN: 978-3-7419-2328-9 (international)

Printed in China by Shyft Publishing / Hunan Tianwen Xinhua Printting Co. Ltd.